Digital Creature Rigging

Digital Creature Rigging

The Art and Science of CG Creature Setup in 3ds Max

Stewart Jones

CRC Press
Taylor & Francis Group
Boca Raton London New York

CRC Press is an imprint of the
Taylor & Francis Group, an **informa** business

AN A K PETERS BOOK

First published 2013 by Focal Press

Published 2019 by CRC Press
Taylor & Francis Group
6000 Broken Sound Parkway NW, Suite 300
Boca Raton, FL 33487-2742

ISBN-13: 978-0-240-82379-9 (pbk)
ISBN-13: 978-0-240-82406-2 (ebk)

Library of Congress Cataloging in Publication Data
Jones, Stewart, 1984–
 Digital creature rigging: the art and science of CG creature setup in 3ds max/Stewart Jones.
 pages cm

1. Computer animation. 2. Figure drawing. 3. Characters and characteristics—Computer simulation. 4. Three-dimensional imaging. 5. 3ds max (Computer file) I. Title.
 TR897.7.J664 2013
 777'.7—dc23
 2012022601

Typeset in Myriad Pro by: diacriTech

Visit the Taylor & Francis Web site at
http://www.taylorandfrancis.com

and the CRC Press Web site at
http://www.crcpress.com

Contents

Contents

Contents

Preface

This is the start of the *Digital Creature Rigging: The Art and Science of CG Creature Setup in 3ds Max*, a book I hope will inspire you, make you think and learn, and that you will keep for reference. Above all, I really hope you enjoy what has taken me a lot of time to write and compile.

Ironically, as I write this for the beginning of the book, my adventure of writing the book and creating the assets is just about over. Yes, I am writing this as I am putting together the final touches to what has been months of an interesting journey to create a digital creature rigging book for 3ds Max. It is incredible to see where a simple book proposal started and where it has ended, what has been added, what has been removed, and what I have learned along the way.

Creature rigging is one of those topics rarely covered, yet it seems to play a large role in visual effects movies, feature animations, and video games. While preparing a creature rigging presentation for some of my work colleagues, I realized there was not a lot of resources out there for creature rigging in 3ds Max. I could definitely find information for biped and humanoid rigging, but nothing that really covered creatures specifically. My rigging presentation included a few hand-outs for the attendees, and, in those reference sheets, I found some inspiration to expand and develop those notes into something I could use as the basis for a talk at a later date. Those notes increased, and I started to include more topics, more demonstrations, and more tutorials specifically aimed at those who had an understanding of 3D applications and rigging; however, I wanted to advance their knowledge even further.

These more structured notes and tutorials formed the basis of this book and its proposal.

My respect for other authors—fiction, fact, or other—has increased immensely. As I started out on my writing journey, I really had no idea what I had gotten myself into. Sure, I had an idea that it would not be an easy task, but the sheer volume of information I have tried to compress into just ten chapters has been more difficult and more time consuming than I had first thought.

There are so many topics and techniques I did not get a chance to cover in this book. Choosing which elements to include was a difficult decision, but what has been covered is a broad spectrum that touches on at least most of the elements that go into creating a realistic and believable creature for film, TV, and video games. I hope you enjoy your journey through this book and that the tips and tricks can enhance your creations in the future. Let the creature rigging commence!

Acknowledgments

I have plenty of people I am grateful to for the help and support along my various journeys, but, without the help of a few specific awesome humans (not creatures), this book would not have been possible, and I would like to mention some of them here:

Oliver Hilbert, Alex Crowhurst, Bhakar James, Chi-Hung Cheung, David Hansen, and Kalvin Lyle, thank you for taking the time to review the book proposal, as well as your support in the past.

I would like to thank Chris Rocks for the modeling and surfacing creation of "Belraus," the main creature we use throughout this book. Thank you for your hard work and putting up with my changes and direction, I really appreciate everything.

Nathan Newman for the use of your face, along with the use of your photography equipment and your time spent helping out, thank you.

I thank Volker Pajatsch for your technical editing of the manuscript. Thank you for taking the time to work through this with me and helping me when I needed it.

Kirsty, for your continuous love and support, thank you. You are amazing.

I thank Mom and Dad for always being there and keeping me on track with everything.

Finally, thanks to David and all the others at Focal Press who helped me out along the way.

Contributors

Without their time and dedication, this book would not be possible. In their own words, here are the biographies of the main contributors.

Chris Rocks

I am a Digital Artist from the United Kingdom with a degree in Computer Animated Graphics from Dublin, Ireland.

Having seen early computer graphics in films like *The Last Starfighter*, *Labyrinth* (The flying owl at the start), *Flight of the Navigator*, *Tron*, *Young Sherlock Holmes*, *The Abyss*, and *Terminator 2* (that last film especially) sealed my desire to pursue a career in computer graphics.

In the early 1990s, there were no universities or colleges providing digital art courses outside of the United States, what there was in the United Kingdom were more math based than art.

By pure chance, I happened on an article in a computer magazine on a new college course starting in Dublin, Ireland (please note this course is no longer in existence). It was a sister course to the highly successful, traditional animation course setup by the American animator, Don Bluth, combining traditional animation and figure drawing with the latest in computer graphics modeling. I graduated from the course early, having accepted a job offer from Rare while recruiting students from the final year of my course and saw my work – this started my career in the games industry.

Now I am a veteran of the games development industry, having worked on more than twenty projects since 1996, with some of the United Kingdom's most renowned games development companies on multiple platforms and genres.

I originally started as a general artist working on environments, character, buildings, vehicles for both modeling and texturing, as well as the occasional bit of animation, and, on more than one occasion, I have actually written the manual for a game.

With the progression to the current generation of games consoles, the teams have gotten larger and the artists' roles more specialized. I opted to follow the character artist path and did so for almost ten years. That path evolved from purely art, to leading art teams, liaising with press/media, managing outsource teams, tutoring new artists, and creating art pipeline documentation/guidelines as well as prototype for the latest technologies.

Ultimately, this led me further from purely doing artwork, which I enjoy, so in late 2010, I sought new creative challenges to futher develop my art skills, which has since led me to work freelance in many different digital media fields. I have had the good fortune to work with some great clients during this time on a variety of projects, including advertising (print/online/TV), toy concept sculpting, architectural 3D rendering, and TV commercial previsualization.

Stepping away from the digital art world I had known for so long to work on projects as diverse as I have and to work with artists outside of my previous industry has been amazing. Their work has inspired and influenced me greatly. It has helped me develop as an artist in both technique and approach, and I have learned so much in this time.

I truly believe you never stop learning. Most people plateau and never realize their full potential. I love nothing more than challenging myself to achieve the highest possible results within the time, resources, and budget available. Yes, at times it can be scary, I won't lie, but it is ultimately rewarding.

So, when Stewart mentioned he was developing this book and was seeking a work model, I was more than happy to contribute the model you see featured

in this book. I knew that to meet the complexity of the rigging requirements that Stewart had in mind for this model would be a new challenge. It has been a learning journey for me, and one I have thoroughly enjoyed.

I consider myself very fortunate to be doing what I love and hope you find the information and techniques Stewart and myself share in this book both useful and inspiring for your own projects.

Volker Pajatsch

German born, I dreamed of becoming an animator from the first time I saw the film *Jungle Book* as a child. I was given my first Super 8 camera at the age of twelve and started making my own stop-motion short films and experimenting with different styles of animation.

I began working professionally in the animation industry back in the early 1990s in Berlin, working on *Asterix in America* in the special effects department. Starting as an assistant animator, I was quickly promoted to the role of junior animator. Certain that this was the career path for me and keen to further my knowledge, I enrolled in a one-year traditional animation course run by Bjorge Ring, who is well known for his animated short films.

I then moved to London to work on the film *Balto* for Amblimation Studios, later known as Dreamworks. My next job took me to Paris, where I worked at Disney Studios on *The Hunchback of Notre Dame*. When Warner Bros opened a studio shortly afterward in London, I was invited to work on *Space Jam* and *The Magic Sword*. Following the closure of the London studio, I was among those chosen by Warner Bros to relocate to Los Angeles to work on *The Iron Giant* directed by Brad Bird.

When the whole traditional feature animation "bubble" burst in the United States, I decided to move back to Europe, where I worked as a freelance animator on several European 2D feature projects like *Help! I'm a Fish*, *El Cid*, and various others. In early 2000, I trained in 3ds Max animation software and subsequently started working within the United Kingdom games industry, initially based in the North of England. In 2003, an opportunity came to work on the *Action Man* feature based in London, which also afforded the opportunity to learn Maya software. Following this, I moved to Cambridge to work for Frontier Developments on the *Wallace and Gromit* game.

For the past eight years, I have been living in Brighton/United Kingdom with my wife and daughter, working first at Kuju on Sony's *Eyetoy* and later for Relentless Software on the *Buzz* franchise. In 2011, I completed the highly acclaimed Animation Mentor's Diploma in Advanced Studies of Character Animation. Currently, I am working on a pilot for a children's TV series that uses Softimage XSI.

01 02 03 04 05 06 07 08 09 10

Introduction

"Creatures, not characters!"

Stewart Jones

Welcome to the world of digital creature rigging. This book is a collection of theories, as well as a practical guide, to developing a better understanding of what it takes to bring believable CG creatures to life.

CG creature setup is the understanding of how to take static geometry and turn it into an articulated, living creature (of course it is not always creatures; it could be anything, such as animals, space ships, cars, humans, anything!). At the very core of it all, the task is to design and create a system of control that allows for animator input, believable deformations, and pipeline management.

Rigging is a term used to describe the creation of a system that allows animators to animate. It is the control mechanism that is not seen, at least not by the audience the final animation is intended for. In turn, a "rigger" commonly describes the people who take a lifeless 3D model and create the articulated control setups for animators to work with. There are many titles for this role in the industry, and it changes from studio to studio. Some are called "Riggers," others are known as "Setup Artists," "Technical Animators," "Technical

1

Artists," "Animation Technical Directors (TD)," "Character TDs," or "Creature TDs." For the purposes of this book, we call them "Creature TDs," but, regardless of the name, these people are often skilled in many disciplines, and it is not uncommon for a Creature TD to model, rig, animate, simulate, and program.

Creature TDs often have a large role in defining the way a creature and animation pipeline flows during production. In fact, they may be responsible for the pipelines entirely. Each and every production is different; the ability to adapt and create is definitely a trait needed to excel in this role.

This is an ever-changing field, but the foundations have changed little. A production pipeline is chaotic, but organized (at least some of the time). Everything this book covers has been designed with this sort of crazy production environment in mind. Whether you rig for games, TV, visualization, or feature film, this book covers chapters and topics relevant to your field of interest.

"Belraus" (pronounced "bell-row-us") is the name of the chosen creature that I rig throughout this book. However, the text is written in both a "making of" style and practical tutorials that make for some rigging reference you can follow along and apply to your own creatures.

Admittedly, this book is based on, and discusses techniques specific to, Autodesk 3ds Max; however, the fundamental concepts presented are universal and can be followed regardless of which software you use now or in the future. A great creature rig is created by great Creature TDs.

Why a Book?

There are many choices when it comes to obtaining rigging information, all of them valid, and we all have preferences as to which we like best. As I thought about each company I have worked with or visited, one thing I noticed is that there are always a number of books and manuals available. Some written by staff that is specific to the pipelines and practices of the company and others written by authors of books like this one. Personally, I have a few favorite books I take with me to the office, and, although I have already read them, they serve as a great way to reference ideas and techniques quickly and easily.

This book is designed to be read, a good thing really, being a book! It has also been created to be a practical reference guide for creature rigging, one you will hopefully take with you and refer back to often.

Other methods for rigging reference are also great, but, for me, a book is the most practical and convenient.

Custom Rigs vs Auto-Riggers

Digital Creature Rigging: The Art and Science of CG Creature Setup in 3ds Max specifically covers a custom rigging method and steers away from auto-riggers. The Biped and Character Animation Toolkit (CAT) auto-rigging solutions are

already built into 3ds Max and both provide great solutions for various rig setups. In fact, any creature could easily be rigged using either of these systems.

So, why are we focusing on creating custom rigging solutions throughout this text? Simply put, custom rigging is the best way to build and understand a creature system. It allows ultimate control over all aspects of the rigging process, from the tools provided, the tools you create, and the control systems you build. There are no extra hassles or quirkiness of auto-rigging systems; it also comes with no extra baggage or artificial limitations that can be present in pre-built solutions. Additionally, it also enhances your knowledge of not only the rigging systems available in 3ds Max, but also other aspects of the application, as well as the production pipeline you are working in.

Of course, there are pros and cons to a custom rigging solution, as there are pros and cons to the auto-rig solutions available. Sometimes the needs of a production either require you to work with an auto-rigging solution or it may be the only viable option because of timescales and delivery schedules. With that said, it is important for us to have an understanding of the pros and cons of all of the available rigging solutions found within 3ds Max:

Biped

Biped has been an excellent tool for many productions: it is very quick and easy to set up and, as not many things can be changed, there is not much that can go wrong. Oh, and Biped provides a pretty nice motion

FIG 1-1 A generic Biped rig.

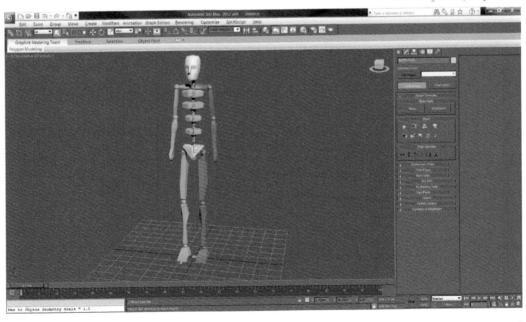

capture solution if you do not have access to anything more powerful, such as Autodesk Motion Builder. However, there are some serious issues that become apparent when you start using Biped. Note that I use the word "issues" deliberately, as they are not necessarily problems with the software.

The default rotation controllers are quaternions, which is something that, for an animator, is very undesirable in a rig. Legacy interfaces and menu scrolling, as well as counter-intuitive tools, slow down animation. There are limitations on how you can place the bones, and this forces you to accept a solution that is not necessarily what you really want. There is also no way to change the base hierarchy of Biped without destroying the rig completely. What this means is that you may have to come up with an elaborate solution to a problem that may ultimately force you to use a custom rig attached to the Biped.

Lastly, scripting for Biped is, well, not great, to say the least.

PROS
- Net-up is quick and easy.
- Not much can go wrong initially.
- It generally works well for motion capture.

CONS
- Quaternion controllers are default (not intuitive for animation).
- Legacy interface elements and counter-intuitive tools slow down animation production.
- There are bone placement limitations.
- Base hierarchy cannot be changed.
- Scripting for Biped is not easily accessible.
- You have to work the way Biped wants you to work, both from a rigging and animation point of view.

Create a Biped

Create Tab > Systems > Standard > Biped or Create Menu > Systems > Biped

Character Animation Toolkit (CAT)

CAT uses modular components that can be connected together to create the final rig. This adds a lot more flexibility that you do not find in Biped. It is also more customizable when compared to Biped, as the modular components are mostly built on the default 3ds Max controller system. Of course, this means the initial setup could take a bit more time when compared with using the Biped system.

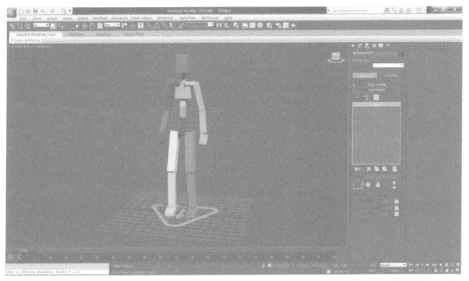

FIG 1-2 A pre-existing CAT rig.

Changes can be made to the hierarchical structure of CAT so that you are able to create a semi-custom rig solution; however, I have found that this feature can make a CAT rig very unstable, in turn, either crashing 3ds Max or breaking some other features that may be needed (such as not being able to accept motion capture data).

Motion capture data is accepted by CAT, and it behaves relatively nicely too. There are also a number of built-in tools that make animation much easier, such as a pose saver, for saving specific character poses; a rig saver for saving a newly created rig for use later, or to be shared with others; and finally, a clip saver, for saving clips of animation. These are really great to have right away without any effort.

Although pretty accessible, my general quibbles with CAT are its stability issues, which include random crashes and general quirks.

PROS
- It has modular components.
- Changes can be made to the hierarchy.
- It accepts motion capture data relatively well.
- It has great built-in tools.

CONS
- There are stability issues.
- General quirkiness and limitations disrupt usability.

Create a CAT Rig

Create Tab > Helpers > CAT Objects > CATParent

5

Custom

Creating custom rigs gives you the most control and options over your rigging. What is presented is a blank slate; it is entirely up to you and your preferences how the object in question is rigged. You can do whatever you want or need to get to a specific rig solution. There are no limitations, no extra "baggage" in the scenes/nodes, which gives you the power to create intuitive rigs with no predefined workflows that need to be followed.

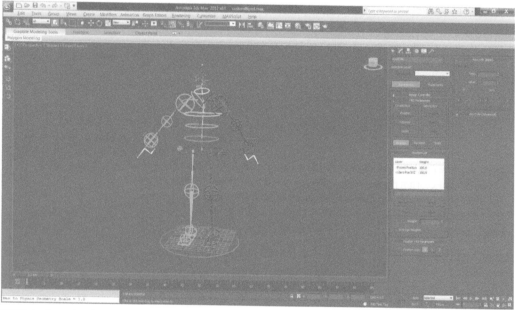

FIG 1-3 A unique custom rig.

Each and every node, control, interface, and behavior can be customized, scripted, and edited without fear of breaking something you have no knowledge of, or little to no control over.

Custom rigging goes far beyond just general rigging. Once you understand it well enough, you can use those same methods to rig and set up anything from a car to a tree. The possibilities of custom rigging really are endless.

The main issue with the creation of custom rigs is that it takes far more knowledge, and generally more time, to both learn and set up, although a greater knowledge of rigging can be seen as both a positive and negative.

PROS
- Your knowledge and rigging skills will increase.
- It gives the most control over rigging options and preferences.
- There are no limitations (except your own knowledge and experience).
- It is a blank slate, do whatever you want.

- There are endless possibilities.
- It is fully customizable.
- There are no legacy features.
- It is easily scriptable.
- You have full control to change, script, edit, and create.

CONS
- A greater knowledge of rigging is needed.
- It generally takes more time to complete a custom rig solution.

It is worth pointing out (and I'm sure I will again) that there is no perfect rigging solution. Knowledge of rigging and scripting helps you no matter which tool you decide or have to use. Personally, the advantages of being able to create whatever I want, customize however I want, rig pretty much anything, and implement controls I have full control over by using custom rigs far outweigh the fact that it may take a little longer to complete.

Who Should Read This Book?

This book is aimed at those who wish to further their understanding and skills in the artistic and technical world of digital animation and rigging.

Creature TDs will gain the most value from this book. A full creature production pipeline is covered from concept to completion, with valuable tricks and tips picked up along the way. There is also information and thoughts on extending current and existing toolsets to help with the creature rigging process.

Animators will find this book a fantastic way to learn more about creatures and dig into the technical aspects of believable creature motion that can enhance and improve their work. They will also gain some invaluable insight into how a rig is constructed, its limitations, and how to work around them.

Those in other disciplines of 3D production will get a glimpse into the in-depth thinking and strategic planning that goes into creating digital creatures. Some of the tools and techniques used in this book are not always specifically designed for rigging and could be applied as they help create breathtaking 3D scenes that interact with characters and creatures.

Production staff can gain insight into using a similar base-rig all the way from the beginning to the end of a production for games and high-end 3D projects. Thoughts on streamlining workflows give food for thought as to how their own productions could implement new ways of thinking and new tools.

Last, but certainly not least, educators, students, and hobbyists alike will gain a lot from reading this book. A solid understanding of Autodesk 3ds Max and some basic production experience and knowledge is needed first, but this book will enhance and broaden their understanding of a creature animation process, helping them with their own projects and productions while supporting them in preparation for careers ahead.

Oh, and you don't need anything but 3ds Max, no extra plug-ins, no other fancy software, just Autodesk 3ds Max. Don't have 3ds Max? Well, just go to the Autodesk website and locate the FREE 30-day trial!

http://www.Autodesk.com/

Who Should Not Read This Book?

Those looking for an introduction into 3ds Max should read something else to start. This book is directed toward users with at least an intermediate level experience of Autodesk 3ds Max. If you are moving to 3ds Max from another application or have no experience with digital animation at all, I suggest you take the time to learn the basics of 3ds Max and its operations before continuing with this book. The built-in 3ds Max help is a great place to begin if you are just starting out, just open the application and hit that F1 key.

All of the topics presented throughout this text are clear and concise, but 3ds Max knowledge is assumed. There are many fantastic sources out there covering the basics of 3ds Max, and this book assumes that you have prior 3ds Max knowledge.

Chapter Overview

This book is organized into ten chapters. Each chapter tackles various creature rigging-related concepts, theoretical approaches and discussions, as well as practical exercises for some of the more specific rig setups.

- Chapter 1: Introduction
 - Welcome! You are reading the introduction to this book right now. Here, we take a look at what this book covers, who should read through this text, helpful contributors, and some basic advice and guidance before starting the journey into digital creature rigging.
- Chapter 2: Foundations
 - Chapter 2 looks into some fundamental principles for rigging, as well as covers some basic tools we use throughout the rest of the book. Even if you have been rigging for a while, this is a great place to get an insight into how I like to think about things, both from an artistic and scientific point of view.
- Chapter 3: Research and Development
 - This is, perhaps, the most important part of rigging. This chapter takes the theoretical approaches discussed in Chapter 2: Foundations and applies them to our digital creature.
- Chapter 4: Base Rig
 - Now we start the rigging process. The base rig forms the structure of our creature that will be used for all media and output. Getting this stage right is vital to the successful completion of the creature project.

- Chapter 5: Animation Rig
 - Building on from the base rig, Chapter 5 takes the structure we have and builds an intuitive interface for the animators to work with.
- Chapter 6: Face Rig
 - Complex, detailed, and difficult face rigs demand our full attention. Chapter 6 takes a look into generic methods for creating great face rigs and works out how to enhance our face rigs for use with creatures.
- Chapter 7: Deformation Rig
 - A solid structure, exciting animation controls, and a custom face system: now we need to make sure that the surface of this creature deforms correctly. Using traditional methods, Chapter 7 works on making sure our creature looks as realistic and as creepy as possible.
- Chapter 8: Finaling
 - Chapter 8 covers how to put the finishing touches on our creature from both a theoretical and practical view.
- Chapter 9: Streamlining and Automation
 - With our creature finished, there have been a number of hoops we have had to jump through, as well as some repetitive tasks that are less than entertaining. Chapter 9 spends some time discussing, analysing, documenting, and then finally resolving these processes, which should save us time and effort in our next creature rig… leaving more time for anything that is more fun.
- Chapter 10: Outro
 - The final chapter of this book includes an overview of what has been covered, as well as some information on where to go next.

Companion Website

Training books like this one often come with a resource DVD, files, and training materials. At the risk of being overly controversial, this book has no DVD. This prompts you to follow along with the practical guides, applying it to your own creature models.

Of course, not giving you access to extra resources would be more than unfair; so, next time you are surfing the web, check out www.digitalrigging.com, our companion website for this book.

www.digitalrigging.com

Qualities of a Good Rig

Coming up with rig features is quite simple, but working out what qualities actually make a good rig is a little more tricky. The first thing I need to point out is that no rig is perfect. Many productions create a number of different rigs for one creature, depending on various movement requirements and

shots needed. This allows the animator to have more control over what is important for the specific scene. Games developers generally do not have this luxury and usually have to deal with a "one rig fits all" scenario.

A good rig is always trying to balance at least three aspects:

- The performance requirements of the creature
- The manipulation and interaction needs of the animator
- The technical requirements of the creature

So, a bad animation rig would be one with confusing interaction and difficult to find controls, which does not meet all the technical requirements needed and limits the performance of the creature. Therefore, a good animation rig balances all of the above correctly, and possibly includes a few more key points, such as:

- Being easy to use
- Having consistent behavior
- Giving enough control
- Being fast
- Enabling the right amount of interactivity
- Including intuitive animation controls

Qualities of a Great Creature TD

Much like coming up with the qualities that make a good rig, the qualities of a great Creature TD are endless. However, a few things really stand out in great Creature TDs.

- Personality/Attitude
 - For me, personality is the main factor that really makes a great Creature TD, or any colleague for that matter. A great personality and attitude really helps during the good times, bad times, and the long hours.
- Adaptability
 - Creature TDs work in an ever-changing field. The ability to adapt to new software, techniques, situations, and directorial changes is an essential skill.
- Problem Solving
 - Problem solving is really what a Creature TD has to do every day. Whether it be working out a new creature pipeline or solving vital and important issues the animation team may have, problem solving is the number one skill for anyone working in this field.
- Feedback
 - The ability to take constructive criticism and feedback is a difficult skill to master. Just remember, no rig is perfect, and, by listening and acting on feedback, you have the chance to increase and improve your skills and your rigs.

- Anatomical Understanding
 - You do not need to be a biologist, but a deep enough understanding of general anatomy will help you to create believable creatures.
- Animation Experience/Understanding
 - As a Creature TD, your task is to create a great control rig for animation. Having knowledge of animation increases your skill as a rigger and allows you to understand the controls and nuances that an animator desires.
- Continued Education
 - Whether its learning something directly related to a new rigging technique, learning to animate, or just reading up on the theory of film making, continued education broadens your knowledge of life. We are giving life to our creatures, so we have to understand what that means.
- Scripting
 - Like it or not, scripting is a big part of being a Creature TD. It not only enables us to speed up rig creation, but can enhance workflows for others and improve projects.

Like I said, this is not an exhaustive list, but it promotes a few key points to think about.

The Best Piece of Advice Ever

Everyone comes from a different background, has different life experiences, and has knowledge to share.

I like to ask the question (to anyone willing to listen), "What is the best piece of advice you were ever given?" The answers you will find are amazing. Of course, sometimes the person in question looks at you blankly or is not able to come up with an answer, but if they do… it can be something fantastic!

Think about this, and answer it for yourself. There has to be something. It does not have to directly relate to rigging, but would be handy if it does.

I have my answer. Unfortunately, I can't remember who told me to do this, but I do remember what it is, and I follow it daily. Now, it is not an amazing tip, a revolutionary technique, or a mathematical formula. In fact, it is so simple and basic it could seem silly. So what is it?

"Keep a notebook, and write stuff down!"

Unknown source

Yeah, that's it! Do I follow this advice? Yes, I do. I keep a notebook with me most of the time, and it's a lifesaver… Well, not literally, but it does help me remember everything from an important meeting, to mathematical formulas, scripts, quick sketches, various resources, such as websites and book lists, to my random thoughts and eureka moments (I don't have many of those

mind you!). In fact, a lot of what is in this book can be found somewhere in the pages of my multiple notebooks, not in any order, just there as notes and scribbles. Actually, if I keep looking through my notebooks, I think I might find some measurements to a photo frame I needed at one time.

So, before we go any further, put this book down, go grab a notebook (and some writing apparatus of course), and try it. Do not rely on taking notes on a laptop. A small pocket-sized notebook is much easier to carry and scribble on when the time arises. You never know, you might be amazed at how much you learn and remember from simply taking a few notes.

oundations

out good knowledge of the basics of any craft, you will never be able to master it. Solid understanding and implementation of the foundations of and science form the structure of any experienced and talented Creature TD.

ure rigging takes a significant role throughout a full production pipeline, here are many principles, disciplines, and techniques that need to be ed and understood. These topics are varied and complicated, involving different skills that combine an artistic eye and a scientific brain. It interesting concept to think that everything we do in 3D is actually ramming, albeit at a very high-level language.

bility to create a finished rig with great controls and good deformations ly part of what a Creature TD is responsible for. Once in a production onment, it is essential that a finished rig is stable and clean. A correctly tructed creature rig should have a perfectly clean file that fits into the

The Periodic Table of Rigging Elements

*Not Really!

1	2	3	4	5	6	7	8	9	10

RIG ¹ — Rigging

JNT ² ₁ — Bone / Joint

GRP ² ² — Group

IK ³ ₂ — Inverse Kinematics

LOC ³ ² — Locator

EXP ³ ³ — Expression

PSD ³ ₅ — Pose Space Deformation

MB ³ ₆ — (Motion Builder) Maya Binary

FBX ³ ₆ — FBX Format Filmbox

FILE ⁷ ² — Files

MTN ⁸ ² — Motion

BS ⁹ ² — Blendshape / Morph Target

ANIM ¹⁰ — Animation

CRV ¹⁰ ² — Curve

FK ⁴ ₁ — Forward Kinematics

CONT ⁴ ² — Constant Value

HUB ⁴ ₃ — Hub Node

MAX ⁴ ₅ — 3ds Max Native Format

MA ⁴ ₅ — Maya ASCII

SCRPT ⁴ ₆ — Script

PCAP ⁷ ₇ — Performance Capture

FX ⁸ ₃ — Effects

DATA ⁹ ₃ — Data Node

IPT ¹⁰ ₃ — Input

SPIK ⁵ ₁ — Spline Inverse Kinematics

ETM ⁵ ² — Expose Transform

COG ⁵ ₃ — Center Of Gravity

3DS ⁵ ₄ — 3ds Max Native Format (Legacy)

XML ⁵ ₅ — File Format: Extensible Markup Language

LI ⁵ ₆ — Light

LINE ⁵ ₇ — System / Size

CAM ⁸ ₄ — Camera

CTRL ⁹ ₄ — Control

OPT ¹⁰ ₄ — Output

MSCLE ⁵ ₇ — Muscle

WIP ⁵ ₈ — Work In Progress

SKEL ⁹ ₅ — Skeleton

ATTR ¹⁰ ₅ — Attribute

Legend:
- Components
- Platform
- Animation
- Rigging
- Foundation
- Storage

All data not accurate at all!

FIG 2-1 The Periodic Table of Rigging Elements.

production pipeline without issue. To achieve this, we need to learn and understand the foundations of our craft as this is something that we will refer back to time and time again.

Art and Science

Rigging is a true art form, but the journey and steps taken to create an amazing creature or toolset requires a lot of scientific thinking and processes. It is your responsibility to create creatures and tools that are visually appealing and technically robust, mixing both art and science equally.

Mixing both these disciplines can be a difficult process because of how our brains function. The left and right hemispheres of our brains process information in different ways. The left hemisphere calculates information in a scientific manner, whereas the right hemisphere prefers an artistic solution. The issue is that we tend to favor one side or the other. It is important to understand which side you prefer, and then spend a little time strengthening your less dominant hemisphere.

FIG 2-2 Left or right? Artistic or scientific? Which are you?

Take a look at the following table to get a better understanding of how each hemisphere of our brains handles the data it is given.

Left Brain Functions	Right Brain Functions
Linear	Holistic
Sequential	Random
Symbolic	Concrete
Logical	Intuitive
Verbal	Nonverbal
Reality Based	Fantasy Orientated
Words & Language	Symbols & Images

(Continued)

15

Left Brain Functions	Right Brain Functions
Present & Past	Present & Future
Math & Science	Philosophy & Religion
Knowing	Believing
Acknowledges	Appreciates
Order/Pattern Perception	Spatial Perception
Knows Object Names	Knows Object Functions
Strategies	Possibilities
Practical	Impetuous
Safe	Risk Taking

These are just some examples of the differences that exist between the left and right hemispheres, but it shows a definite pattern. Both have strengths and weaknesses, and we need both sides to create a fantastic creature. So, train that brain!

Principles

As an animator, one of the first things you learn is the twelve principles of animation:

1. Squash and stretch
2. Anticipation
3. Staging
4. Straight ahead/Pose to pose
5. Follow through/Overlap
6. Slow in/Slow out
7. Arcs
8. Secondary
9. Timing
10. Exaggeration
11. Solid drawing/Rigging
12. Appeal

It is interesting that these principles stay with each and every animator throughout his or her career, and it forms a basis for a dialog that can be used to converse with one another. These principles form such a big part of the animation foundations that they are second nature to animators all over the world.

I love the idea of a set of basic principles that allow creators in the same discipline to converse and have consistent goals. An important thing to remember about these principles is that they are just that—principles. They are

not hard and fast rules that must always be followed and never broken; it is more like they act as general guidance for each person in the animation field.

Creature TD and rigging does not have these kinds of principles in place already, but it seems like it could be a great idea for all disciples to have something in place that forms a foundation to follow. We could create our own right now though…

1. **KISS! — Keep It Simple Stupid**!
 This is something I picked up as an animator, and, for me, it can and should be a key principle for all 3D disciplines. Yep, it really is that useful! So, whatever the task, whatever you do, always remember to break it down and keep it as simple as possible. Do not overcomplicate anything.

FIG 2-3 Things are complicated enough, keep it simple!

2. **Planning**
 Planning is everything and can be the success or the failure of a project. Without a good plan, your job will be much more difficult and will take a lot longer. It is better to spend time planning things at the beginning and having the foresight to see problems when you can deal with them, rather than leaving them until the last minute when it might be too late.

FIG 2-4 Planning at the beginning allows you to keep track of your progress as you journey throughout the production.

3. **Research, Development, Resources**

 Do not just jump straight into setting up a creature. Check your plan. Do you know how to deal with everything? What looks like it could cause problems? Take these areas, research them, develop them in isolation, and learn how to adapt the solution. Do not make the mistake of developing these unknowns on a full creature setup.

FIG 2-5 Check your plan, then research and develop solutions to possible problems. Use all of the resources available to you: books, Internet, colleagues, friends, family, notes, and anything else at your disposal.

4. **Anatomy**

 Anatomy is a branch of biology that looks at the structures of living things. It is incredibly important to have a good understanding of this. In fact, it is so important that the fundamentals gained from studying anatomy feed into the topology of our models, joint placement, muscle and ligament systems, rig behavior, dynamic motion rigs, and flesh-deformation surfaces. Having said this, you do not need to be an expert biologist, but the more you know the better when setting up creatures.

FIG 2-6 The study of living organisms, including their structure and distribution directly relating to the skeletal, muscular, and vascular placements in our CG creatures.

5. **Biomechanics**

Biomechanics is the study of biological and medical systems by using the methods of engineering mechanics. I like to think of this principle as the analysis and creation of movement inputs in our rigs. This can relate to the degrees of motion joints have or the changes and adaptations we have to make to anatomical reality to better fit our CG rig. Both biomechanics and anatomy are closely related; however, when we talk about them in relation to creature setup, they are very different topics. For instance, an anatomically correct human skeleton consists of 206 bones, more than half of which are found in the hands and feet. Accurately reproducing every single bone is a major pain to set up, almost impossible to animate, and overall a worthless task to endure. So, rather than trying to replicate realism, it is best to use biomechanics to simulate the range of motion available. By splitting sections of the rig into clearly defined hierarchy, or modules if you will, we can accurately simulate reality without having to replicate everything found in reality.

FIG 2-7 Research creature movements and their direct relation to animation controls needed in CG.

6. **Flesh-Surface Deformation**

Flesh-surface deformation simply refers to how the skin or the surface of a creature deforms as the creature rig is controlled and manipulated. Observation is your friend here, and, by studying as much reference as possible, you can get an idea of what you need to recreate to sell the believability of the creature. This topic feeds into a number of areas in creature setup. From the initial skinning/binding of a creature, to muscle systems, "sticky" weights, blendshapes/morph targets, cloth, hair, and fur.

FIG 2-8 Depending on the type of surface your creature has, it will require varied techniques when it comes to deformation.

FIG 2-9 The animator or animation team is our main client. An understanding of what the team has to do and how it does it is incredibly important.

7. **Animation**

To setup a creature, you do not need to be an animator. An in-depth knowledge of animation is important, and, if you can animate, it is a huge bonus to the animators who use your creations. After all, being able to animate means you can converse with your animation team better, have a greater understanding of how to setup simple but powerful animation controls, and have a much better knowledge of how your actions affect them.

8. **Modeling**

It is more important to understand and direct modelers than to model to a fantastic level, but the ability to edit geometry is a must. From

creating blendshapes/morph targets to modeling muscle systems, it is important to have at least a general level of modeling skill. An understanding of edge looping for deformation is without doubt one of the most valuable skills needed as you work through creature setups. Technically, you do not have to do it (although it helps), but having the understanding and the ability to confidently direct a modeler is of the upmost importance.

FIG 2-10 Correct geometry edge looping is important to help with great deformations.

9. **Pipeline**

As a Creature TD, you are stuck right in the middle of a pipeline. When setting up digital creatures, you need to have an intricate understanding of what is going on around you and have the confidence and ability to direct and work with others. A production pipeline is a huge topic, and a little too expansive for this book, but here is a non-exhaustive quick list of what you may have to deal with:

- Concept art
- Cameras
- Prototyping/Previs
- Modeling
- Rigging
- Deformation
- Animation
- VFX
- Simulation
- Rendering

FIG 2-11 The flow of data from the start to the end of a production.

10. **Dynamics**

 Dynamic objects and deformers need to be taken care of at some point. This could be as simple as creating an automated antenna to something more complex like muscle or fat jiggle.

FIG 2-12 Dynamically driven overlapping action can enhance a creature's believability. It is also not out of the scope of a Creature TD to be asked to rig dynamic environments that interact with characters, objects, and creatures within the scene.

11. **Scripting**

 This principle comes into play at various times. From animation transfer to automating a process during rigging or in the production pipeline, it is an important skill to have and understand.

FIG 2-13 Scripting is not exactly machine-code, but definitely digging under the "hood" of our 3D application.

12. **Mathematics**

Yeah, I am no good at mathematics either, but I am trying to learn! Mathematics links closely with scripting and could be used for automating fish swimming, to swarms of insects, to rotating a wheel. Do not worry though, our computers have a handy calculator application that really helps, as well as some built-in functions that 3ds Max has direct access to.

FIG 2-14 E = Evil Mathematics!

Tools and Workflows

I am expecting you to have a good understanding of using Autodesk 3ds Max and that what we are about to cover in this Tools and Workflows section will be mind-numbingly boring. But, for clarity-sake, let us take a brief look over some of the main tools and workflows we use to create our creature.

Viewports and UI Setup

OK, we are not going into how to navigate the viewports or the viewport configuration options. However, customizing the viewports and the UI is a great way to get the most from your rigging experience. One thing I do recommend is increasing the size of the Command Panel.

You can do this by clicking and dragging the edge, in turn, adjusting and extending the Command Panel. This makes viewing the many menus found in our modifiers a lot easier. Of course, this decreases the viewport size a little, but, while rigging, this should not be too much of an issue.

FIG 2-15 The generic 3ds Max view.

You can create your own custom toolbars and modify existing toolbars if you wish; for instance, I like to have a custom quad menu that contains quick access links to the custom and regular tools I use the most (or am currently using a lot for whichever project I am working on). I also have a few custom hotkeys I have setup, which makes things quicker to access, but generally I tend to use the default hotkeys that Max already comes with.

FIG 2-17 Customized quad menus can be created to enhance the already built-in quad menus.

Finally, it is important to understand your unit setups. Depending on your production needs, you may have to change or keep consistent with your unit setup. It is very important to note the distinction between System and Display units. Display units affect how geometry is displayed in the viewports, whereas System units determine the actual scale of geometry. So Display units are what you see, and System units are what are being calculated. System units should only be changed before you create your scene or import files, but Display units can be changed whenever and to whatever is most comfortable for you to work with or what is needed.

Unit Setup Options

Customize Menu > Units Setup > Units Setup Dialog

FIG 2-18 The Display units and System units are different; make sure you understand their differences.

Modify Panel and Modifiers

Finding the Modifiers

Command Panels > Modify Panel > (Modifiers)

We are going to spend a fair amount of time in the Modify Panel, either adding modifiers, adjusting parameters, or creating custom attributes. It is a good idea to try to learn about as many of the modifiers as possible. Of course, remembering what they all do is next to impossible, but testing them at least once may spark a creative solution to a problem you may have while rigging.

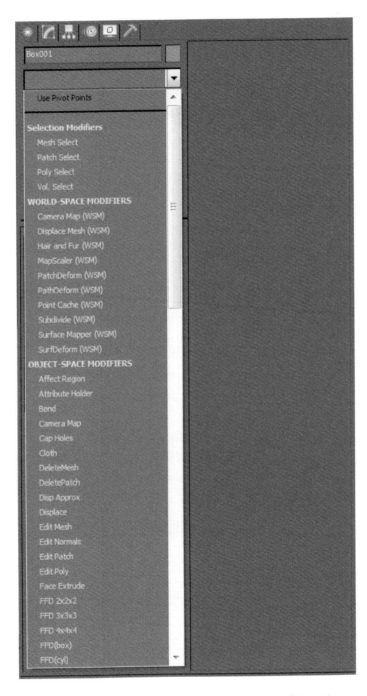

FIG 2-19 The Modify Panel with a lot of different modifiers.

Oh, and on a side note, I have never added any buttons to this section for easier access to modifiers I use most. I do not mind scrolling through the list, as I prefer to have as much space for attributes and parameters as possible.

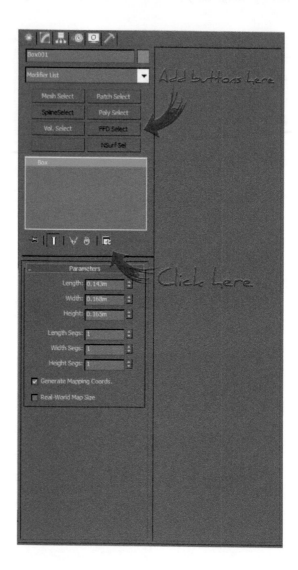

FIG 2-20 You can add your most used modifiers to the Modify Panel if you wish.

Hierarchy Panel

Finding the Hierarchy Panel

Command Panels > Hierarchy Panel

The Hierarchy Panel gives you access to tools that can adjust the hierarchical linkage between objects. This includes the pivot points of objects in your scene. It also allows access to interactive IK properties and lock transformation controls that can restrict the movement and inherited movement of objects in a particular axis.

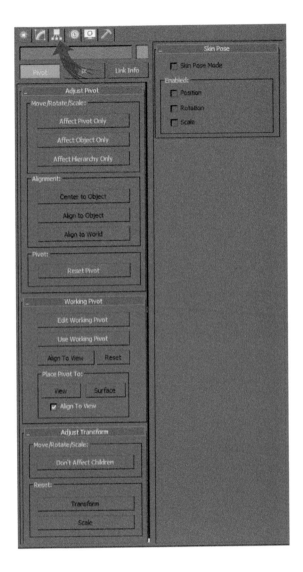

FIG 2-21 The Hierarchy Panel can be an interesting place to look around.

Motion Panel

> Finding the Motion Panel
>
> Command Panels > Motion Panel

This panel provides tools and adjustment parameters to change the motion of a selected object. As well as providing an alternative to Track View for assigning animation controllers, extra rollouts are displayed here if the assigned animation controller has parameters associated with it.

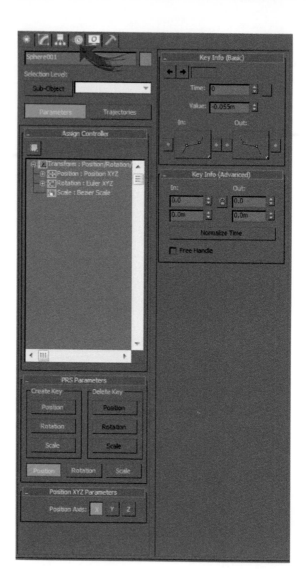

FIG 2-22 The Motion Panel gives you an alternative view for assigning animation controllers to an object's transforms.

Display Panel

Finding the Display Panel

Command Panels > Display Panel

If you need access to tools that control the display of objects in a scene, then this is the place to look. Use the Display Panel to alter display characteristics, speed up your viewports, and get an extra level of control on hiding, unhiding, freezing, and unfreezing objects.

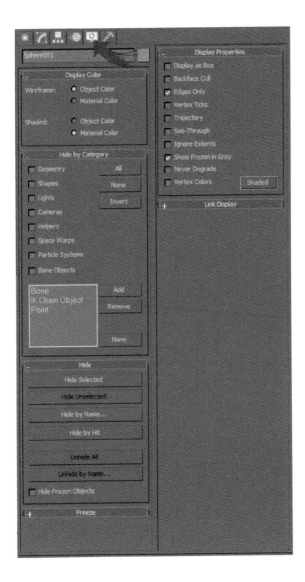

FIG 2-23 FIG 2-23 An additional place to edit the display of your scene's objects.

Utilities Panel

Finding the Utilities Panel

Command Panels > Utilities Panel

This area is often forgotten, as it is one of those places we look at only now and again (unless you are specifically creating plug-ins and utilities accessed from this section). All 3ds Max utilities can be accessed from here, as well as some third-party developed plug-ins and utilities.

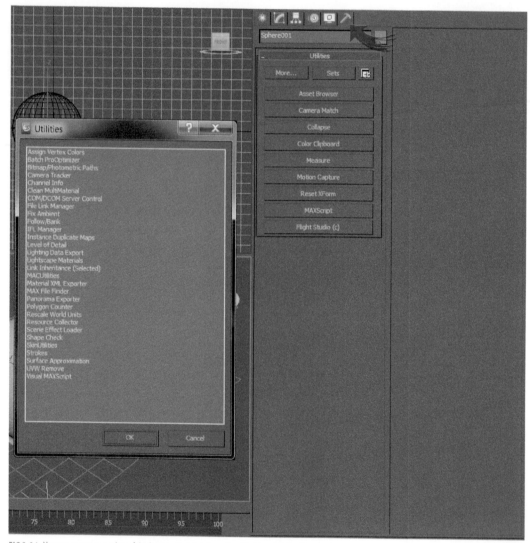

FIG 2-24 You can access a number of third-party plug-ins, as well as 3ds Max utilities, from here.

Time Slider and Animation Tools

> **Finding the Time Slider**
>
> Status Line > Time Slider

FIG 2-25 We hang out here a bit during our rigging time.

At the bottom of your Max UI, you find your time slider; the time slider shows the current frame and lets you move to any frame in the active time segment.

Obviously, the time slider is most commonly used by animators for animation-related tasks, but rigging sits so close to animation that it is important for us to have a good understanding of how the time slider works, as well as related tools.

One important aspect of the time slider for rigging is the "Filters…" options. This allows us to choose what attributes are keyed once we assign a keyframe to an object. For the purposes of rigging, I like to have "All" selected. This means that, when setting a key, each and every attribute has a key assigned to it. Setting "All" before rigging can save valuable time and troubleshooting as we move along.

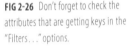

FIG 2-26 Don't forget to check the attributes that are getting keys in the "Filters…" options.

Bone System and Bone Tools

Accessing the Bone Tools

Create Panel > (Systems) > Bones or Animation Menu > Bone Tools

FIG 2-27 These look like dinosaur bones… kind of.

A Bone System is a jointed, hierarchical linkage of bone objects commonly used for animation. Bones can be renderable objects and have several parameters that can be used to define the shape the bone represents.

In 3ds Max, bones are not classed as "special" objects. They just have special behaviors that allow them to act as a jointed-bone hierarchy. This means any object you create, from a box to a helper, can operate as a bone; simply click the "Bone On" option in the Bone Tools floating window.

Skinning Tools

> ### Accessing the Skinning Tools
>
> Command Panels > Modifier Panel > Skin (Modifier)

FIG 2-28 The envelope shows the area of influence that the Skin modifier has over the encapsulated vertices.

The Skin modifier is a deformation tool that allows you to influence the mesh of an object with another. Applying a Skin modifier to an object and then assigning bones gives each bone a capsule-shaped "envelope" that controls an area of influence over the encapsulated vertices. Where these envelopes overlap, vertex motion is blended between envelopes. Alternatively, it could be blended with a non-influenced (enveloped) area.

Constraints

> ### Getting Access to Various Constraints
>
> Animation Menu > Constraints > (Various Constraint Types)

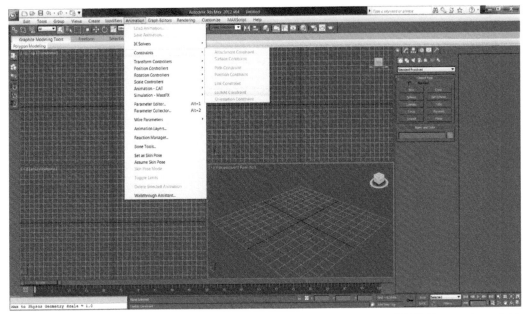

FIG 2-29 There are various constraint types found in this menu. It is a good idea to get familiar with them before applying them to a creature rig.

Constraints can be used to control an object's position, rotation, or scale through a binding relationship with another object. These special types of controllers require an animated object and at least one target object with the target imposition animation limits on the constrained object.

Keyframe animation can be used to toggle the constraints binding relationship with its target using a percentile.

Wire Parameters

Accessing the Wire Parameters Options

Animation Menu > Wire Parameters > Wire Parameters

Or

Quad-Menu > Transform > Wire Paramters

Wiring parameters creates a special connection from one object to another in the viewport. You are able to setup one-way and two-way connections between specified object parameters or to control one or more objects with another object containing the desired parameters. This is a special and unique tool that can be thought of as another "constraint"-type option.

FIG 2-30 There are two ways to get to the Wire Parameters options. It is up to you which you want to work with as they both do the exact same thing.

Reaction Manager

Finding the Reaction Manager

Animation Menu > Reaction Manager

FIG 2-31 The Reaction Manager is a powerful tool that we can utilize to enhance our creature rigs.

The Reaction Manager dialog gives you access to the setting up and modifying of Reaction controllers. From here, you can add and delete masters and slaves, define states for the reactions, use a graph editor to view and modify reactions with curves, and manually edit created Reactions.

Schematic View

Finding the Schematic View

Graph Editors > New Schematic View

FIG 2-32 The Schematic View gives you the ability to see everything in your scene.

The Schematic View is a node-based scene graph that gives you access to all object in your scene, as well as their properties, materials, controllers, modifiers, hierarchies, and non-visible scene relationships, such as wired parameters and instancing. I find this one of the most practical ways to view and edit hierarchies, as well as to make sure my rig file is "clean" for animation.

Layers

Accessing the Display Layers

Tools > Manage Layers

FIG 2-33 Onions have layers, and so does 3ds Max.

The Manage Layers dialog allows you to create and delete layers, view and edit settings for each layer, and add or remove objects from them. This is a great way to keep your scene clean and tidy, making it easier for other users and yourself to use.

MAXScript Windows

> ### Finding the MAXScript Windows
>
> MAXScript > MAXSCript Listener
>
> Or
>
> F11
>
> Or
>
> Found at the bottom-left corner of the main screen.

MAXScript is the built-in object-orientated scripting language for 3ds Max. There are a number of dialog windows that allow you to create, edit, or view MAXScripts and operations that are happening while you use 3ds Max. Chapter 9 discusses MAXScript and its related windows in-depth.

This is by no means a definitive list or a detailed explanation of how to use each of these tools, but it serves as an explanation of the places we spend a lot of time while working on our creature rig.

FIG 2-34 Speak to the computer like a computer.

Joints and Bones

Ah, the backbones of our creatures… Sorry, I really had to!

About 90% of the time, a skeletal structure is the main base of any creature setup. This means that all motion and deformation is driven from the skeleton.

Depending on which 3D application you use, joints may be called bones or bones may be called joints. They are actually the exact same thing, but I like to think about joints and bones a little differently.

> Joints form the pivot point/location of the node, and bones are the connection (length) between two joints.

There are a number of reasons to distinguish these as separate "objects." First, it is anatomically more correct; second, on a technical level, we can discuss the properties on both sections that make up a joint chain (the joint and the bone). In fact, the 3ds Max help files even suggest thinking of bones as joints:

"It might be useful to think of bones as joints, because it is their pivot placements that matter, more than the actual bone geometry. Think of the geometry as a visual aid that is drawn lengthwise from the pivot point to the bone's child object."

—*3ds Max Help Files*

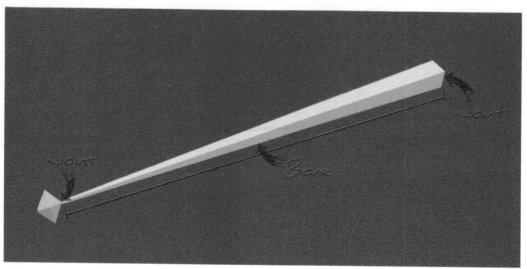

FIG 2-35 The connection between two joints is the bone.

Transformations

Understanding transformations in 3D space is important but can be a little tricky. For instance, some transformation values of an object can be misleading when viewed using such methods as the "Transform Type-In." This is simply due to the fact that you have the ability to change the context in which you view the transform, but only one specific way is recorded by the computer. In fact, the only way to be sure what value you are seeing is accurate and correct is to use the "Track View," "Dope Sheet," or "Curve Editor."

So, having as much knowledge as possible on this subject can be super helpful when setting up your creature and for troubleshooting problems both when rigging and when involved with other aspects of the production. Transformations are a complex topic and can sometimes be a mind-boggling aspect of 3D and mathematics. To make things a little easier to understand, take a look at the main transformation methods and how they are evaluated from an artistic point of view.

Scale

Calculated in the local space of an object, scale is by far the easiest transform to understand. If you scale X, you get a true representative value of that X axis scale. This is the same for both Y and Z as well, and the positional and rotational values of the object have no influence over the scale values displayed.

Difficulties with scale transformations come with hierarchical structures. For now, we leave this issue alone, as it can get complicated quickly and we can discuss this problem in the "Hierarchical Structures" section coming up.

FIG 2-36 A true representation of scale values is shown.

Position

An object's position is calculated as an offset from the center of world space or from the center of its parent should it be in a hierarchy. Remember, there are no true "local" values.

FIG 2-37 Both of the cubes have a parent X position value of 25 meters. Cube A is parented to the world, giving it a world X position value of 25 meters. Cube B has a world X position value of 50 meters; this is because its parent is another object that has a world X position value of 25 meters.

Rotation

This is when things get a little crazy. Animators (and many 3D software users) prefer to use "Local" as their preferred choice of coordinate system for rotations. This makes a lot of sense, at least from a usability point of view. By setting the

coordinate system to "Local," 3ds Max displays function curves that represent the three axes of rotation and allows for easy editing. In turn, this gives the illusion that the user is rotating in local-space, when, in fact, there is no such thing in any 3D application.

OK, so how does that work then?

Well, rotations are calculated the same way that positions are, as an offset from the parent object. The default method (controller) we use in 3ds Max for rotations is the "Euler XYZ" controller (pronounced "Oiler").

By using the Euler XYZ controller, 3ds Max displays function curves that represent the three axes of rotation, making our lives a little easier for understanding the rotational values of the object. However, as previously discussed, they do not always give a "true" reading of an object's rotation. The default Euler controller works by adding up the X rotation, then the Y rotation, and finally the Z rotation to calculate the final rotation.

$$X + Y + Z = Rotation \text{ (Again, this is based on the parent object orientation.)}$$

This adding-up of axes is what is known as the "rotation order." So, instead of XYZ, we could have ZYX or YZX. This would change the above equation to:

$$Z + Y + X = Rotation$$

Or

$$Y + Z + X = Rotation$$

Alright, so how does this not give a true representation of rotational values? Let us do a little demonstration to see where this way of rotating objects can "break."

1. Set your rotation coordinate system to "Local."
2. Create a Box and align its position to [0,0,0] world space.
3. Turn on Auto-Key and set a keyframe at frame 0.
4. Move to frame 50.
5. Rotate the Box 90 degrees in the Y axis.
6. Move to frame 100.
7. Rotate the Box 90 degrees in the Z axis.

Now, when you scrub through the timeline, your animation plays as you expect between frames 0 and 50. However, between frames 50 and 100, the cube rotates in a manner you are not expecting. Take a look at the Curve Editor and notice how we supposedly only rotated the Y and Z axes, yet the X axis has been rotated as well. This is where the "Local" coordinate system breaks, and what you are experiencing right now is what is called Gimbal Lock.

FIG 2-38 Yikes! I just hit Gimbal Lock.

This is the reason animated rotation often do not in-between correctly between key frames, or at least they sometimes won't in-between as you would expect them to do so. Any other coordinate space is just for visual purposes. My advice: rotate in Gimbal mode. It may not be as user friendly as you would like, but it gives that true rotational representation that, for a rigger, is a must and, for an animator, is extremely helpful.

1. Reset your scene.
2. Set your rotation coordinate system to "Gimbal."
3. Create a Box and align its position to [0,0,0] world space.
4. Turn on Auto-Key and set a keyframe at frame 0.
5. Move to frame 50.
6. Rotate the Box 90 degrees in the Y axis.
7. BANG! Gimbal Lock.

As we are rotating in Gimbal mode, we see that two of the rotation axes (X and Z) have crossed each other. We have hit Gimbal Lock.

There are a number of ways to combat Gimbal Locking. One such way is to change the rotation order and pick the best order for that object. For the Box example above, I would choose XZY for the Axis Order. There are other solutions to the Gimbal Locking issue, but we will cover those once we start rigging our creatures later in this book. Be aware that, if you are rotating in all three axes, there will be times that Gimbal Lock will occur, and, in certain specific cases, the parent of an object can actually Gimbal Lock its child.

FIG 2-39 By setting our rotation coordinate system to "Gimbal," we can clearly see when we run into rotation problems.

With careful planning and forethought, you can keep Gimbal Lock to a minimum. Oh, I have this written down in my notebook, which I find pretty helpful for remembering how the axis order affects rotations and what axis affects what:

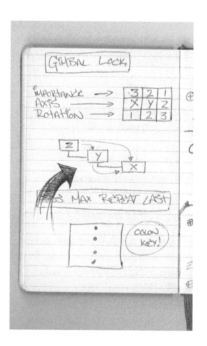

FIG 2-40 This scribble can be found in my notebook.

I'm sure this is enough food for thought on rotations for now.

Models and Modeling

Even if your only job is to rig the creature, it is important to understand modeling concepts and principles so you can highlight and fix geometric issues before you get too far into the rigging process. As a rigger, your input to the mesh will only be technical revisions, such as topology changes. Now and again, you will be able to have input on aesthetic changes, like revising the overall structure and anatomy of the creature, so a good understanding of models and modeling comes in handy.

Take a look at some key modeling concepts that should help you when it comes to rigging your creature:

Reference

Does the creature model match the reference? Obviously, this is a simple step to check, but an important one none the less. If the creature does not match the reference, then the director will not be too happy. Therefore, it is best to get this sorted out as soon as possible.

FIG 2-41 I know you asked for a box, but I thought this would be better.

Default Pose

Make sure the creature is in a default relaxed pose, including the face. Should there be an extreme pose the creature must hit, it is a good idea to model it in that pose first, so you can be sure there is enough geometry to create that extreme. From there, it should be simple enough to reshape the model back to a neutral pose.

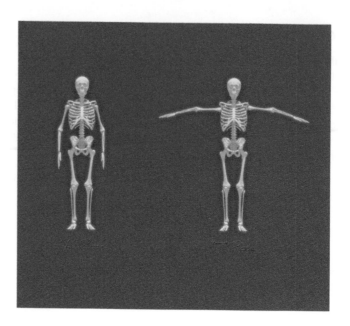

FIG 2-42 There are mixed opinion as to if an "A" pose or a "T" pose is best to use as the default pose. I usually prefer a "T" pose for a cartoon creature or character, as I usually find it gives better deformations for stretching and squashing. But I don't mind which pose is chosen, as long as it has been previously agreed as to what will work better for the rig and deformations.

Edge Loops

Edge loops are one of the most important things for creating realistic and believable deformations. To do this correctly, you must concentrate on modeling according to muscle flow (see how our anatomy studies come into play all the time?). Be sure to have an anatomy book next to you, and use it for reference as much as possible. Even though we are creating fictional creatures, you should be able to extract basic organic concepts and apply these to your geometry. These edge loops help define and maintain the location of the creature's muscles. Things can get a little tricky at times, so, before jumping in, be sure to sketch the main muscle edge loops on paper and follow them. From there, it is just like a jigsaw puzzle, and you need to fit everything together.

FIG 2-43 Edge looping can be a difficult puzzle to work out at times. As a rule of thumb, try to stick as closely to the muscular flow as possible.

46

Uniformly Spaced Geometry

Subdivisions of the mesh not only occur at modeling time, but also at rendering, and spacing your geometry uniformly gives the most predictable surface possible when subdividing the creature's mesh. Evenly spaced geometry also gives the minimal amount of texture stretching and makes skinning the creature a lot easier, as weight values can be distributed uniformly as well.

FIG 2-44 Uniformly spaced geometry is better for everyone.

Topology

Quad topology should be kept as much as possible. It gives a predictably smooth surface when subdivided; it minimizes texture stretching and allows easier distribution of weights when skinning the creature. There are times when you just cannot work out how to get rid of a triangle or two. When that happens, do not panic, just try to hide them in unobtrusive places on the creature. N-sided polygons should never really be seen. It is difficult to predict how these polygon surfaces will react, and it can lead to flickering during animation. If you do have them, they should be split manually. I would take a triangle over an N-sided polygon any day.

FIG 2-45 Quads are the best, tris for the rest! (N-sided polygon should never be seen.)

47

There will be times when following all of the concepts mentioned will not be viably possible, especially when modeling according to anatomy and muscle flow. It is, at this point, up to you or the modeler to decide where to terminate some of the loops and create triangles.

Hierarchical Structures

Probably the most important part of any setup we do is how the hierarchy is structured. It can really make or break a setup, and, often, some of what seems like the most advanced controls are actually just really great hierarchical setups. Creating hierarchies is as simple as linking and unlinking things together, creating parent and child relationships.

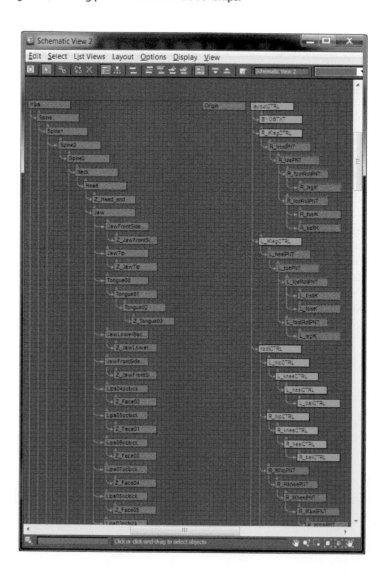

FIG 2-46 A great hierarchy can make working with your rig a dream.

As discussed previously, hierarchies have dramatic effects on the positional, rotational, and scale transformations of an object. Take a look at one of the effects that can happen with the transforms of objects in a hierarchy.

Occurring Problems with Hierarchical Structures

1. In a left viewport, create two joints, and end with one nub joint.
2. Select the first bone in the hierarchy.
3. Change to the scale tool, and set the coordinate system to "Local."
4. Scale the first bone in its X axis.
5. Grab hold of the second bone in the hierarchy, and rotate it.

FIG 2-47 Uh oh! Skewed!

Notice how the second joint/bone skews as it rotates. Well, without jumping to deep into mathematics, this is due to the fact that rotation and scale values are contained in the same set of numbers calculated in a matrix. Once we scale that first bone, that scale factor is passed to its child objects. When we rotate the second bone, it takes on that scaling value.

For this reason, scaling any object is not really a good idea as things like this can happen very easily. There are solutions to this problem, and we cover them as we work on the rig for our creature.

Broken Hierarchies

Do not mistake broken hierarchies for actually being broken and unusable; this term simply refers to hierarchies not directly linked or parented together in one long hierarchical chain. These separate hierarchies can be linked together via constraints or some other methods that make them behave correctly, but they retain separate hierarchies not connected in any other way.

49

By using broken hierarchies, it allows us to create separate or modular sections of the rig that not only make it easier for us to create, but allow us to "transplant" those modules to other areas of the creature or even to other rigs completely.

As a side note, some real-time game engines do not allow for broken hierarchies, but do not worry if that is your intended media. Our creature rigs will not have any problem, you will see!

Icons and Controllers

A good creature rig must be easy to use. Although it is possible to animate joints and bones directly, this can be problematic. If the creature is even remotely complicated, it can be extremely difficult to work with the joints.

A better alternative to working directly with joints is to use custom-built iconic representation, or controllers. By creating controllers, an animator never directly works with joints, rather they use more intuitive controller objects that we, as Creature TDs, have designed.

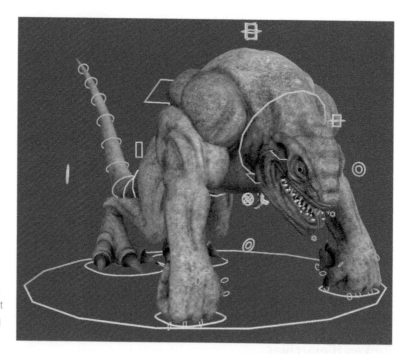

FIG 2-48 Iconic controllers can be as basic or as advanced as you need. Just make sure they do not distract the rig user too much.

Creating interfaces is fun. Some productions have a specific interface style that you must adhere to, but you may be able to create your own controller styles and spend time designing easy-to-use icons. Remember, the most important thing is that the controllers are clear, easy to find and select, and control and affect the rig correctly.

Colors

Coloring controllers and other parts of the rig can help alleviate some of the viewport clutter, define certain rig elements, and differentiate between sides or locations of a rig.

Borrowing from aviation and sailing, I like to color objects on the left (port) side of the rig in red and object on the right (starboard) in green. For aircraft and maritime vehicles, this helps distinguish which vessel has right-of-way. This coloring convention is generally accepted as being standard throughout the CG industry, with a change made for Maya users as they color their right (starboard) side in blue because of the default color being green when selecting an object in the viewport.

Objects found in the center, I usually color yellow. For additional objects, I like to use blue, and anything else, well, it is whatever I feel like. This is a quick reference table that helps explain my coloring convention for rigging:

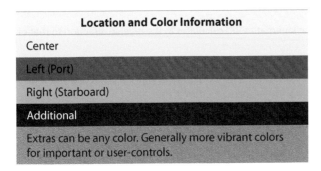

Location and Color Information
Center
Left (Port)
Right (Starboard)
Additional
Extras can be any color. Generally more vibrant colors for important or user-controls.

Adding colors to your rig does not take very long and can really improve the viewport visibility for the user. It also makes using the rig a little easier, as you can intuitively tell which side of the rig you are working on, regardless of the camera angle.

Kinematics

At its most basic, within our 3D applications, kinematics refers to how we apply animation to our joints and bones. There are three main kinematics systems:

1. Forward kinematics (FK) uses a top-down method to evaluate the joint and bone animation. It begins by calculating the positioning and rotating the parent objects and works down the hierarchy, positioning and rotating each child. This is exactly the same way we have to work with FK, by positioning and rotating the parent, which in turn affects its children, and then moving down the hierarchy positioning and rotating each joint on the way until we run out of joints and bones. With an FK system, the children inherit the transformations of the parents.

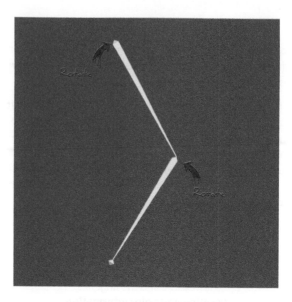

FIG 2-49 FK joints.

2. Inverse kinematics (IK) calculates in the reverse direction to that of FK. Rather than manipulating the parent and working down the hierarchy for each of the children, we edit an IK goal found at the end of a joint hierarchy that will affect all of the bones influenced by the IK chain, working from the bottom and moving to the top of the chain. With an IK system, the parent objects are determined by the position and orientation of the child objects.

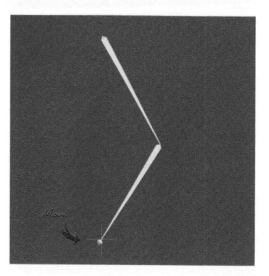

FIG 2-50 IK joints.

3. Spline inverse kinematics (Spline IK) uses a spline to determine the curvature of a series of joints. The vertices of the spline can be moved and animated to change the curvature of the spline, which in turn changes the curvature of the joints. This is a powerful IK system but requires careful setup so it is not unwieldy to use.

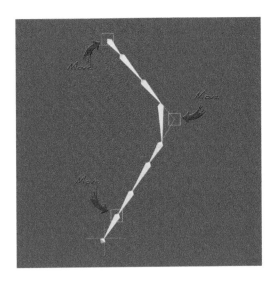

FIG 2-51 Spline IK joints.

Skinning

Skinning refers to the binding of the mesh of our creature to an underlying skeletal or hierarchical structure, allowing for deformations of the mesh. 3ds Max allows us to deform one object with another object by using the built-in "Skin Modifier." This modifier is pretty versatile and can be attached to NURBS, meshes, patches, bones, or even splines.

FIG 2-52 Editing the vertices via the Weight Table in the Skin modifier.

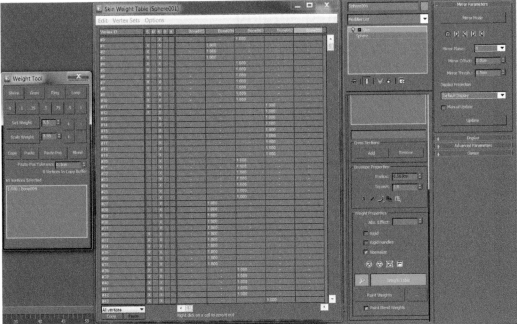

Blends and Morphs

Blends and morphs are deformers that allows you to blend or morph a base mesh into a specified target model. Used for a number of reasons from face shapes to corrective body shapes, they are a powerful tool to have at our disposal. We cover how to use them in-depth during our face-rig creation and creature finaling steps.

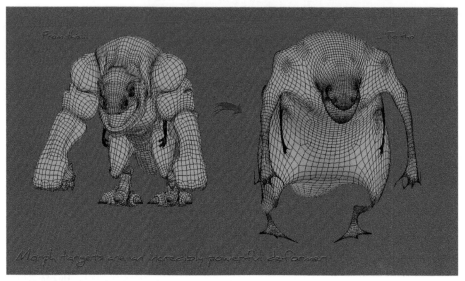

FIG 2-53 Deforming the mesh via the powerful Morph Target modifier.

Layered Rigging

Not to be mistaken with the "Layers" or "Layer Manager" in 3ds Max, layered rigging refers to a methodology I like to use when rigging.

FIG 2-54 The pyramid diagram shows how the lower layers affect the upper layers, and any subsequent changes to the lower layers have an adverse effect on the layers above. This is true for our layered-rigging approach.

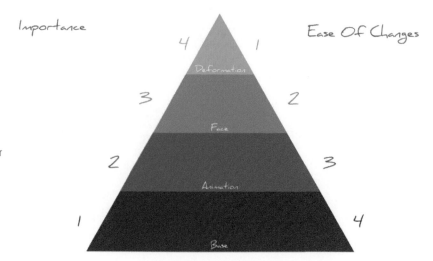

Think of it like an onion. An onion has many layers; you have to peel away the first layer to reveal the next, and so on. This is how we should approach our rigging process. Why? Well, it allows us to keep what can become a complex network of nodes manageable and easier to navigate. It also allows us to "lock" the layers we do not want other users of our rigs messing around with—yeah, I am looking at you, you mischievous animators! In truth, when leaving something unlocked and open for a user to play with, well, you are really asking for trouble.

You could also think about layered rigging as various rig stages, or fully completed sections (layers) of a rig that can be pulled apart without affecting one another. In fact, if you work in a bigger production, you may be accustomed to this sort of methodology anyway. For instance, you may be rigging the creatures body, while a colleague creates the face rig, and these separate rigs simply fit together to form the completed creature rig once both sections have been completed.

To get a better understanding, take a look at the layered rigging approach we use in this book and the creature rigs that we are about to create:

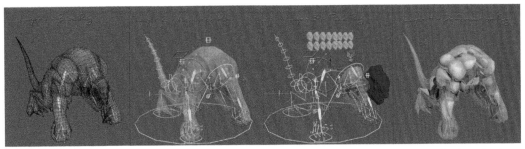

FIG 2-55 Four layers of rigging.

1. **Base Rig**
 The base rig is the foundation layer for the rig. This layer affects all other layers in the creature rig and acts as the foundation and reference point for all other layers. Therefore, changes to the base rig can cause big problems for all other layers. On this layer level, we add the base skeleton and basic skinning for the character, making sure everything is correctly placed, positioned, and within a hierarchical structure.

2. **Animation Rig**
 The animation rig is the stage after the base rig at which we add all of the control mechanisms for the animation team. Once this layer has been completed, we go ahead and hand this to our animators to work with. Changes at this layer level affect animation, and work may have to be re-done, so make sure it is locked down before sending this on to the animation department.

3. **Face Rig**
 Alongside the animation rig is the face rig. In this layer, we add the control mechanisms for the facial motion. This layer must follow along with the animation rig layer.

55

4. **Deformation Rig**

The final layer is the deformation rig at which we can look at adding the extra controls and techniques for the flesh-surface deformations. Things like corrective shapes and muscle systems are added in at this point.

Naming Conventions

At its most basic, a "naming convention" is used for naming things (now there is a surprise!). A dedicated naming convention allows useful information to be deduced from the names based on regularities.

A well-chosen naming convention can dramatically help a user navigate larger structures and scenes, as well as distinguish what could be a complex hierarchy of nodes in our files and, specifically, our rigs.

If you are working in a production, there may already be a naming convention already in place that you will have to adhere to. If you are working on your own or you have been tasked with creating the naming convention for your company, then you have an important task to do.

An example of a bad naming convention would be to simply leave the default naming 3ds Max gives you when you create an object.

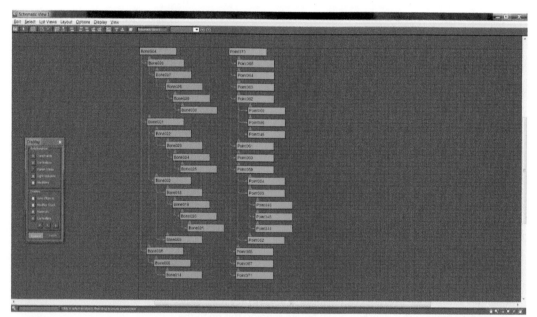

FIG 2-56 3ds Max provides generic names when it first creates an object. Although we can guess what this object is, we have no idea why it is in the scene.

So, a good naming convention would allow us to see what objects are and give us an idea of what they actually do.

FIG 2-57 By using a naming convention, a user can clearly identify what and why a node exists in a scene.

The above "good" naming convention may be difficult for you to understand at the moment, but, by taking a look over a cut-down version of this naming convention, it all becomes crystal clear.

Naming Conventions	
CATEGORY_itemNameNumber_SIDE_TYPE	
CATEGORY (Required)	
CAM	Camera
CH	Character
ENV	Environment
FX	Effect/Particle
LI	Light
PROP	Prop or Object
GUI	Graphic User Interface
GLOBAL	Shared by multiple categories

(Continued)

itemName (Required) (Multiple)	
Item names can be up to you. Multiple item names can be split using a minus symbol (-); use sparingly.	
itemNumber (Optional) (Single)	
Item numbering always uses three digits (000).	
SIDE (Optional) (Single)	
Sides can be combined if more clarity is needed.	
L	Left
C	Center
R	Right
LWR	Lower
UPR	Upper
TYPE (Required) (Multiple)	
LOC	Locator/Dummy
CAM	Camera
LI	Light
LINE	Spline/Curve/Line
PFX	Particle System
TEMP	Temporary Item
BS	Blandshape/Morph Target
DATA	Data Node
RIG	Rigging Specific
JNT	Joints/Bones
CTRL	Controller
IK	Inverse Kinematic Chain
UTIL	Utility Node
ANIM	Animation
AS	Animation Set
AT	Animation Tree
PA	Physics Asset
MAT_(D,N,S)	Material (Diffuse, Normal, Specular)
ROOT	Hierarchical Parent (No other type suffix required)

This is a condensed version of the naming convention I like to use, and I use this as we work through the rigging process of our creatures. By all means, feel free to use your own naming conventions or create your own right now. The naming convention does not change how we rig the creature, just the names of the components that go into the built rig.

Research and Development

"If we knew what it was we were doing, it would not be called research, would it?"
Albert Einstein

"Research is creating new knowledge."
Neil Armstrong

"I need to know what came before so I can break the rules."
Vera Wang

Often overlooked when in a hectic production schedule, research and development can, and should be one of the most interesting, entertaining, and important steps as we move forward on our journey to creating intuitive creature rigs.

Although mostly theoretical, this is the time we get to go a bit crazy. We can become mad scientists for a while, and no one cares. Now, I do not mean that we are going to run around a science lab creating some strange and amazing chemical. I do not even mean wearing a white lab coat, holding a clipboard, or looking super intelligent. What I do mean is that it is our time to identify the possible problems, issues, or concerns we may have as we start to rig our current creature.

By identifying these problems before we start rigging, it gives us enough time during this research and development phase to start working out creative solutions to the technical problems. In fact, it is the place we get to learn the most, invent new techniques, talk to our colleagues about what they need from the rig (if in a production environment), and practice new and existing skills.

Should you be working in a production with other Creature TDs, this is by far the best opportunity to learn and share techniques with your comrades. It is also the time to really dig deep into your production pipeline and processes so you have a better understanding of where assets come from and go to. Remember, you might be tasked with helping with pipeline-related tasks down the line, so getting some hands-on time right now will definitely be a benefit. It is also the time you get to read through a script or story and understand when, who, what, where, and how this creature came to be. All of which form the characteristics of your creature and affect its movement and behavior, in turn, directly affecting your rig, its biomechanics, and your control input system.

For the purposes of this book, I am rigging one creature, and we are able to follow this creature from concept to completion. This not only gives us a great overview of a real creature rig running from the start to the end of production, but also allows us to dig as deeply as possible into each and every section of its creation from both a theoretical and practical view. Your creature may be completely different and require different properties and controls, but the fundamental creature rigging processes and techniques stay relatively similar, no matter what you rig. Let us get started!

A Quick Disclaimer

Rigging is a confusing and often misunderstood procedure in the production pipeline process. It is extremely challenging, yet very rewarding, and it is often on you to solve problems, create workflows, design and make tools, and simply get everything to work.

There are countless ways to create a rig, and each different technique has multiple benefits and downfalls. No solution is perfect, but it is your job to figure out which techniques work best for you and the project at hand.

Every creature you come across is unique, as are the needs of each of the animators you work with. For each creature, you should always ask yourself certain questions:

- What does the creature physically resemble?
- What does the creature need to do in terms of movements throughout the production?
- Are there special rigs or shot-specific rigs that need provided for a few specific shots? If so, in what way do they need to be special?
- Who is animating the creature, and what do these artists like in their rigs?

Once these questions are answered you need to decide what is most important for the creature. Is it the needs of the animators or the needs of the show?

Creature Overview

Bio-File CH_01937

Name: Belraus
Age: 3 years
Sex: Male
Type: Reptillian/Multi-breed
Intelligence: Low
Temperament: Hostile
Territorial: Yes
Height: 5 feet / 1.524m (approx.)
Height (standing): Unknown
Weight: 2.1 tonnes / 2100kg

Hobbies:
Growling. Snarling. Drooling.
Biting. Chomping. Roaring.
Screeching. Snorting.

Interests:
People-watching. People-biting.
People-eating. Rocks. Trees.
Nature. Birds. Fish. Sleeping.
Walks in the park at night.

Favorite foods:
People. Meat. Fish. Pizza.
Tacos.

Favorite drinks:
Water. Soda. Coffee.

FIG 3-1

FIG 3-2 Although Belraus is trapped in a man-made tropical enclosure, he would be pretty awesome storming a city Godzilla-style.

Getting a general sense of whom this creature is, where it came from, where it is going, and its usual mannerisms is an important step to take before thinking about the rig a creature will need. At this stage in development, we need to think about three main things:

1. Movement
2. Behavior
3. Reaction

Understanding these three areas allows us to create the best possible control system so the animations of this creature are realistic. Take a look over the creature's profile that I am going to be rigging:

Creature Brief/Information

Name: Belraus
Age: 3 human years
Sex: Male
Height (General Posture): 5 feet/1.524 meters (approximately)
Height (Standing (Hind Legs)): Unknown
Weight: 2.1 tons / 2100 kilograms (approximately)
Distinguishing Features: 4 eyes, 4 arms, over-sized upper body
Profile: Powerful and resilient, Belraus is a genetically engineered, Frankenstein-like creature. Created by science, in a never-ending attempt to develop a super-breed, Belraus is free to roam in his custom made tropical enclosure. Ever plotting and attempting its escape, but so far it has been unsuccessful.

From this simple and very short profile, we extract some basic information and take a good guess at how Belraus moves, behaves, and reacts to situations.

1. **Movement**
 Slow and sturdy most of the time because of his stature and weight. However, as he has been genetically engineered, I imagine he is significantly agile and can have bursts of intense speed when needed.
2. **Behavior**
 Animalistic, hunter, and survivor—these three words come to my mind. Perhaps not the most intelligent creature, he relies on instinct rather than brains, but what he lacks in intellect he makes up for in brawn and brute strength.
3. **Reaction**
 He is a prisoner and will, therefore, be guarded at all times. Trusting nothing and no one, especially his captors, humans. His reactions to us and to anything new or unknown will likely be hostile.

Your creature may be completely different, so be sure to create your own profile for the creature you are rigging. If you are working in a production

environment, this kind of in-depth creature profiling may already be
available, so be sure to study what information is provided for a solid
understanding of both the creature and an initial impression of what sort of
rig may be needed.

Anatomical Research

As the provided profile explains, Belraus is genetically engineered by
scientists. Although like nothing we have seen in reality, parts of his anatomy
resemble animals and reptiles in existence today. By viewing and studying
the anatomical structures of these available resources, we can start to place
together an anatomical structure for the creature that has some solid basis in

FIG 3-4 Belraus is a fictional creature,
but his body parts relate directly
to creatures we can find in the real
world.

reality. Not only will this allow us to understand his movement and motion, but it gives the audience something to relate to when they see this fantastical creature animated.

General Creature Attributes

Quickly glancing over the creature's features, it is easy to see that he shares a lot of similarities with various reptiles. His default pose, posture, and structure also confirm this as he stands strong and proud.

Taking a deeper look at the general attributes, this creature shows a lineage to prehistoric dinosaurs. This also fits with his reptilian-like features and can provide a good match for references.

As humans, we are designed, or have evolved, to walk around on two legs. These leg muscles are usually bigger, stronger, and more developed than our arms. This creature, Belraus, seems the opposite, with bigger, stronger arms that carry most of its weight and smaller rear legs that are lean and muscular but underdeveloped in comparison.

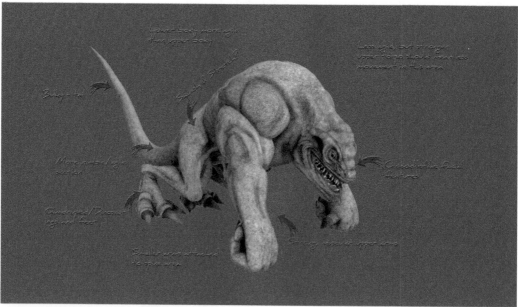

FIG 3-5 Some quick reference annotations thinking about the pose, posture and anatomy of the creature.

Head and Face

In keeping with the reptile-like features, the head and facial features closely resemble a crocodile's head. The jaw-area, in particular, is extremely similar, differences in the lower-jaw shape are apparent, and the "snout" is shorter.

The structure of the creature's face and skull, as well as the teeth, lips, and jaw, hint at the fact that this creature must not be able to speak. That is not to say that he cannot make noises or express itself vocally. It just seems as though he would not be as articulate as a human. Again, this fits with its reptilian characteristics.

The eyes of this creature are very different, as having two eyes (four eyes in total) on either side of the skull is not usual for reptiles, at least I cannot seem to find any. Although the movement and behavior of the eyes may be left up to the animator, this is one area in which we have to think carefully about how to rig, as there is no specific reference available to work with.

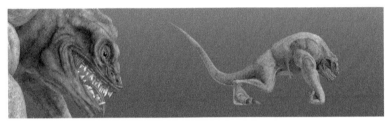

FIG 3-6 The head.

Upper Torso

The creature's upper torso is strong and bold. His muscular structure is more animal and humanistic than reptilian, and he seems to rely on this powerful section for both balance and general movement. The long thick arms resemble that of a gorilla or ape, and the imposing structure replicates that of a bear or an about-to-charge bull.

As this section has a lot of muscle mass, we have to spend some time working with the flesh-surface deformations to create believable muscle simulation.

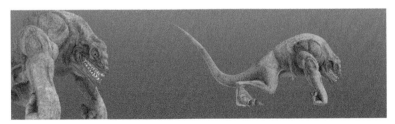

FIG 3-7 The upper torso section.

Central Torso

The central torso is leaner than the upper torso, but, on examination, it looks as though there is some fat around the belly.

The overly large chest and rib-cage overlap into this section, but there is enough room for us to think about spinal compression for some squash and stretch during the creature's movement.

Small, more delicate velociraptor-like arms hang to the sides of this area. Because of their size and placement, it seems as though Belraus uses these to hold or examine objects, whereas the bigger more muscular arms in the upper torso are used for balance and movement.

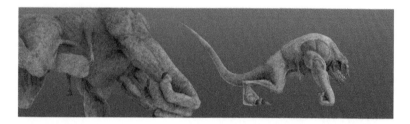

FIG 3-8 The central torso also includes the smaller arms of this creature.

Lower Torso

The lower torso feels like it is going to be the most nimble and agile section. Both its position and posture lean toward the prehistoric dinosaur resemblance once again, and the muscles seem strong but very lean.

As the upper torso and upper limbs seem to take the mammoth-share of the weight distribution, it feels as though the lower torso is used more for direction and additional balance.

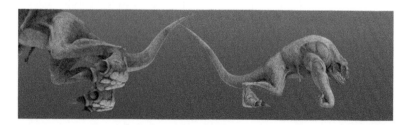

FIG 3-9 The lower torso looks more nimble and athletic when compared to the larger upper torso.

Tail

With a thick upper section and thin lower section, the creature's tail also resembles that of a lizard, or maybe a rat. No matter which, I do not feel as though the creature would have too much control over the tail and, because of his size and weight, would not be curling it around a tree branch, hanging around by it. To me, it seems as though the most logical reason this creature has a tail is for additional balance should he need to use his hind legs to stand or maneuver.

FIG 3-10 The tail of Belraus starts relatively thick at the base, but ends in a much smaller, thinner point.

Biomechanical Input

Creatures, especially creatures like Belraus who have little to no basis in reality, require more thought and preparation than that of an existing creature.

The biomechanical input for creatures like this have to be bolted together from real sources, our imagination and what is found in the story in which the creature is found. For instance, we may be required to change joint positions, include additional animation or deformation controls, or even allow for the "breaking" of parts of the creature so that, although not necessarily true to life, the visual appeal and realism of the creature is kept intact.

Biomechanics are a large part of the rigging process as we dive into the structure and controls of Belraus. For now, we cannot tackle this area directly, but we can take a look at a few areas of the creature's anatomy, make some notes, and create some sort of plan that should help us later.

Head and Face

The eyes of the creature behave exactly the same as we would expect, the only difference being that there are four of them. His nostrils should be able to flair, so extra control is needed in this area.

As the jaw is a dominant feature of the creature's head, it makes sense to add additional control so we can manipulate both the upper and lower sections. This allows for jaw dislocation just as that of a snake. To close the mouth fully, we may need to give additional control to allow for the deformation and scaling of the teeth.

Upper Torso

This section of the creature should keep a close resemblance to our anatomy studies. An independent chest control allows weight shifting to occurring without affecting the lower sections of the creature. Additional bones could be used to help with deformations over the shoulder, and a muscle system along with corrective shapes should be used to allow more realistic flesh movements. An auto-clavicle system would help in this area as well.

Central Torso

We need to create a stretchy joint chain for the spinal column here. This is obviously not realistic but will allow a lot of control over the spine area, making the creature more flexible. As there is another set of arms attached to this section, it might be a good idea to think about allowing them to "float" away from the spinal hierarchy so they can be moved around as needed to fit whichever pose the creature is in.

Lower Torso

There should be independent hip controls to allow basic weight shifting. The legs of the creature include a three-joint chain, similar to that of a horse. We can use a similar technique to the auto-clavicle to enable an auto-thigh movement triggered by manipulation from the rest of the leg.

Tail

As the tail seems fairly rigid and is used mostly for balance, we can keep this as a simple animator-control with some automated-dynamics.

Planning and Preparation

We have a good idea of the who, what, when, and why of Belraus. Let us start applying this to our CG creature directly and start creating, organizing, and documenting our thoughts in a more formal practical plan of action.

Print Screen

> Keyboard > PrntScr (Print Screen Button)

First things first. We need to get a few screen captures of our creature, both from multiple views and with and without wireframes showing. "Print Screen" is our friend here, no need for any fancy rendering. The views I like to get hold of are:

- Isometic (Perspective)
- Front
- Back
- Left
- Right
- Bottom

In total, we should have twelve images, six with wireframes showing and six without.

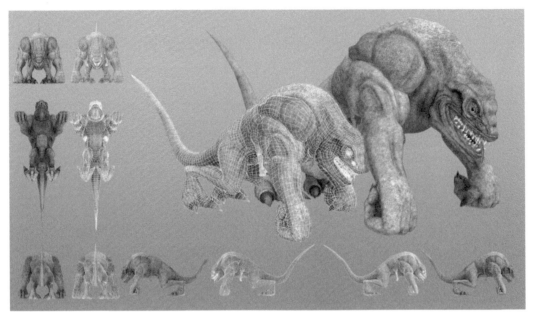

FIG 3-11 My collection of print screen images.

Thumbnail Sketching

Pencil + Paper + You + Time = Thumbnail Sketching

Should you be working in a production environment, thumbnail or creature sketches may be provided for you already. For the Belraus creature, it is all up to me. So, I am going to spend some time creating some thumbnail sketches of possible extreme action poses that Belraus should be able to recreate in 3D. Obviously, I am using my print screens of the creature for reference, and I am doing these sketches on paper. No need to be at a computer for this task, so it is a good point to go get some sun while still working.

Joint Placement Diagrams

Using our anatomy research, we can overlay joint placements on our print screens for great reference when we actually start rigging the creature. I explicitly call these diagrams as it is the perfect chance for us to get an idea of the sort of hierarchy we may want to use for each section. Take your time on this, and use the anatomy references we have collected as a guide. If you think a joint may work better in another position, change it. We need to think about biomechanics at this point too, so experiment.

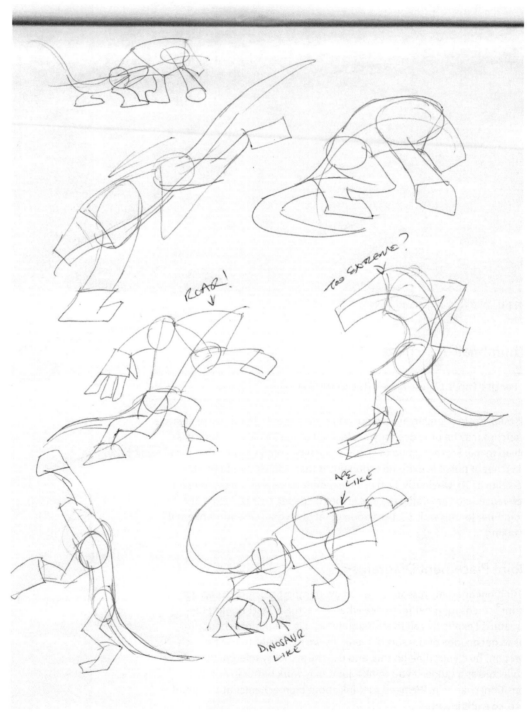

FIG 3-12 I am not the greatest draftsman, but these thumbnails get the job done.

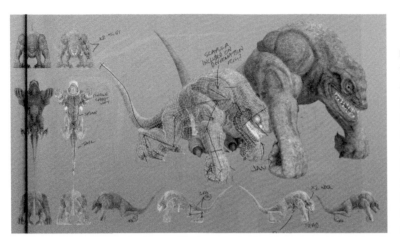

FIG 3-13 It is often a good idea to draw a "cut" line over the main articulation points of the creature to help you understand where it will have some of the biggest deformations, as well as an approximation of where the joints have to be placed. For this diagram, I have quickly thought about where I want the joints placed relative to those loops by using the wireframe of the creature.

Controller Diagrams

With our joint placements in position, we can focus on controller placement and make notes of any special controls we may need to include for the animators. These controls could change as we start to rig this creature, but having some controls planned out before we start could save us time and effort later.

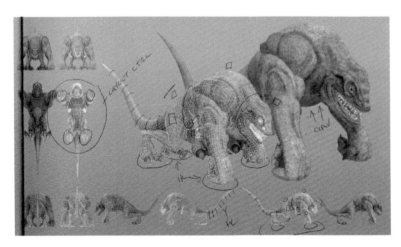

FIG 3-14 I am really focusing on where I need to give special controls to the animators, as well as making the controls as unobtrusive as possible. This kind of quick scribble helps me work out where I want to position the controls, rather than what the controls are actually going to look like.

Topology and Looping Checks

Maintaining quad topology as much as possible is recommended for organic creatures. Quads benefit everyone in the pipeline, from enabling predictable smooth surfaces when subdividing to minimizing texture stretching and allowing evenly distributed weights for skin weighting deformations.

FIG 3-15 Quad-geometry should be maintained as much as possible. They benefit everyone in the production pipeline and help immensely with surface deformations while the geometry is animating.

Checking for correctly looping lines is relatively simple, as long as the model is following correct muscle flows in accordance to your anatomy planning and research.

If you or your modeler needs further direction or just some general help to allow better deformations, it is a great idea to plan the edge loops out on paper. By taking the print screens we have of our creature mesh, we can easily sketch over these and work out the best placements for muscle flow edge loops.

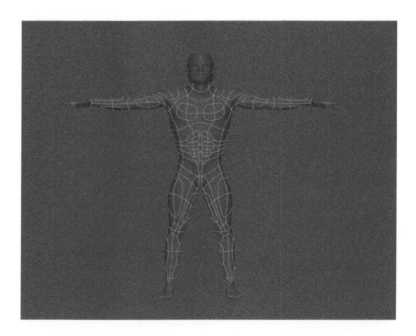

FIG 3-16 Main edge lines based on underlying muscles.

When looping edges correctly, it is possible for the model to dictate how surface deformations should appear. The main edge lines show where the main muscularity of the creature is based. Smaller muscle structures can then be defined quite easily and should show us separated sections, allowing us to understand the creature anatomy better and, therefore, change how we approach "smooth" skinning in certain areas.

FIG 3-17 Using a flow like this can indicate both where certain muscles are and how they should deform as one whole "unit."

Model and Scene Clean

With the topology and edge loops corrected, we can jump into cleaning the geometry and scene so there are no nasty surprises when we start to rig and bind this creature to our control system.

There are a number of steps we can take to make both the model and the scene as clean as possible, so let us get to it!

1. **Polygon or Triangle Limits**
 Should you be working to a polygon or triangle limit, this should be the first thing you should check before going on any further. You can simply show statistics in the viewport (hotkey "7") or you can go to your Utilities Tab, hit the "More…" button and open the "Polygon Counter" utility. I like to use this tool, as it allows you to set a budget for either triangles or polygons and visually see where on the scale everything is.

FIG 3-18 Working to a smaller polygon count can save time over the whole production. Should your creature be rendered for something other than real-time use, you can simply smooth the creature's geometry when it is time for rendering. Just make sure the model has enough "holding" edges so it does not lose too much form during the smoothing process.

Polygon/Triangle Limit Checking

Hotkey "7"

Or

Viewport Options ([+]) > Configure Viewports… > Statistics

Or

Utilities Tab > More… > Polygon Counter

2. **Units**

This is a very important step, and it is a step you need to do right now, before digging any deeper into the rigging process. Your units need set to either your preferred setup, or it may be dictated to you by your production.

For the purposes of Belraus, I am going to set my units setup as Metric and Meters (lighting units as international if you are interested), with my System Units Setup to 1 unit equals centimeters.

Once this is set, DO NOT CHANGE YOUR UNITS AGAIN! Oh, and in case you forget—DO NOT CHANGE YOUR UNITS AGAIN! I hope I am making myself

clear, as any changes to your units setup at a later stage could cause you no end of problems with your rigs later on.

FIG 3-19 This is the unit setup I am using while creating the rig for Belraus. Oh, and this WILL NEVER BE CHANGED AGAIN!

Unit Setup

Customize > Units Setup…

3. **Redundant Object Removal**

It is possible that you, or your modeler, may have left some objects in the scene that were useful during modeling but no longer serve any purpose. Should there be anything in the scene that is not needed, go ahead and remove it now. Just be careful that it is not going to affect the geometry, or possibly something needed farther down the production pipeline that you may be unaware of.

4. **Creature Scale**

The scale of objects can always cause problems if we are not careful about our unit setup, as well as having scale references available. A 6 foot human stands at 1.828 meters, and I like to create a Biped, making sure its height is set to 1.828 meters, which gives me great reference of how the creature will look when beside a human. Belraus' default posture stands at about 5 feet, or 1.524 meters approximately. To ensure he is at the correct height, I can use the "Tape" tool to measure his height from top to bottom in a front or side viewport.

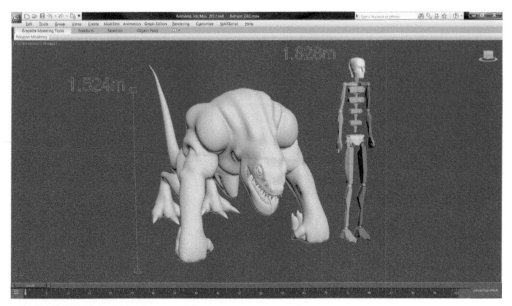

FIG 3-20 Belraus with his measuring tape and a generic 6 foot tall human.

Creating a Tape Helper Object

Create Tab > Helpers > Standard > Tape

FIG 3-21 My boring color choice for rigging. Why boring? Well, so I can quickly see what everything is.

5. **Geometry Coloring**

Honestly, this is just a personal preference and nothing else: If it is not already grey with the wires showing as black, I change it. This really is an optional step; I just thought I would share it with you.

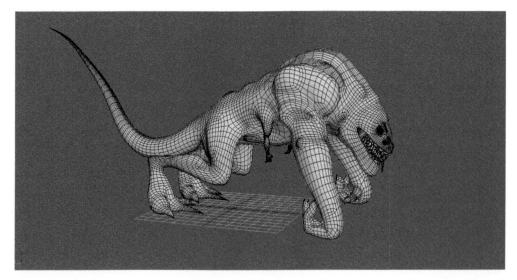

6. **Geometry Naming**

 Using the naming convention we discussed in **Chapter 2**, this is a good point to rename the geometry if it has not been named correctly already.

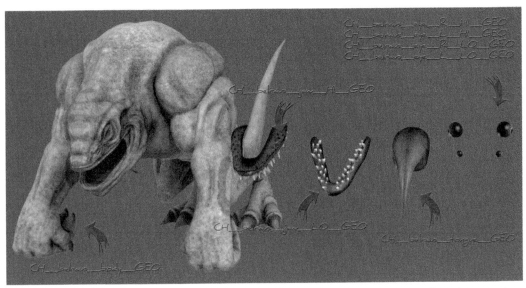

FIG 3-22 Renamed geometry using the correct naming convention.

7. **Geometry Hierarchy**

 I want to make sure the geometry sits under one main hierarchy so, when it comes to the rigging, the Schematic View is clean and tidy. This is simply a case of creating a point helper at the center of the scene (position XYZ [0,0,0]) and parenting the geometry underneath. Oh, and of course, renaming the point correctly.

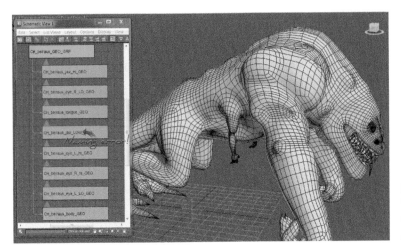

FIG 3-23 Making the Schematic View tidy once more. Actually, there is a naming error in there too. Better change it now.

8. **Pivot Points**

 I like to make sure each geometry object in the scene has its pivot point reset to world space and positioned at the center of the world ([0,0,0]).

FIG 3-24 Setting all geometry pivot points to world space [0,0,0].

9. **Resetting XForm**

 Resetting the XForm of your geometry can stop complications at a later stage during rigging development.

FIG 3-25 Saved temp file, then a resetting of all geometry transforms keeps everything neat and tidy.

Reset the XForm

It's a good idea to save a copy of your scene just before resetting the XForms on the geometry. This is a precautionary measure just in case anything goes wrong.

(Select Geometry) Utilities Panel > Reset XForm > Reset Selected

With the XForm reset, move to the Modify Panel and collapse the geometry to an Editable Poly; unfortunately you need to do this for each geometry element of your creature.

Right-Click Geometry > Convert To: > Convert to Editable Poly

10. **Freeze Transformations**

Freezing the transformations on an object sets the positional, rotational, and scale values to zero. Do this on all of the geometry elements for the creature.

FIG 3-26 Frozen transformations are not needed on the geometry at this point, but these steps are a ritual that has to be completed.

Freezing Transformations

(Select object) Alt and Right-Click > Freeze Transform > Click "Yes" in the newly opened popup window

11. **Save Selected**

Instead of regularly saving the scene, I prefer to specifically select only objects I need to take forward into the rigging process and save them in

a new file. This ensures that, if I have missed anything that is not needed while I was preparing the geometry, those objects will not transfer to the new saved file.

FIG 3-27 Save only what is needed by using "Save Selected" from the menu.

12. **Merging**

By merging in the file that I explicitly only saved selected means the scene will be as clean as possible. To do this, either reset 3ds Max or close it and open it again. With a blank scene now showing, we can simply merge in our save selected scene to this new one.

FIG 3-28 Merge your "Save Selected" file into a brand new scene.

13. **Display Layers**

There are a number of layers I like to create so navigating the rig is easier once we start. The table below shows which layers I create and what those layers are generally used for:

Layer Name	Description
0 (Default)	This layer is automatically created and non-removable. I usually work in this layer when I need a specific selection to be available easily.
ANIM	This layer contains animation, or animator-specific nodes. This could be anything from position location information to nodes used for animator-controlled constraints.
BS	This layer is used for Morph Targets or "Blend Shapes" only.
CAM	Should this rig have any cameras attached to it, this layer is where I would place them.
CTRL	This layer is used for any and all rig controllers.

(Continued)

Layer Name	Description
DATA	This layer is used for data-specific nodes, such as motion-capture nodes.
FX	Visual effects related nodes are found in this layer.
GEO	This layer is used for all geometry for the rig. This is where I will place the geometry for the creature we are rigging right now.
LI	If the rig has anything that requires specific lighting solutions, then this layer is where it goes.
RIG	This layer is used for most components directly relating to the rigging.
SKEL	This layer is used for the base skeleton, which is covered in Chapter 4.
WIP	This layer is a place simply used for anything that is "Work in Progress." Should I be forced to send this rig out before it is fully completed, anything that I am in the middle of fixing will be placed in this layer. I often use this layer while working on the rig.

As you can see, the above layer naming relates directly to the node naming conventions I use. This keeps everything easy to understand and extremely organized.

Your production may require you to use a different approach to layers, but, for me, this is the preferred layer naming and grouping method.

FIG 3-29 Setting up the layers does not take too much time or effort and helps keep everything in order later on.

The Final Save

That is it! The geometry and scene are ready for rigging. All that is left for us to do is hit that "Save As…" button, name our file accordingly, and save it.

FIG 3-30 Use the naming convention for the file name too, and save your creature. We are now ready to begin. (Insert evil scientist laugh here for dramatic effect!)

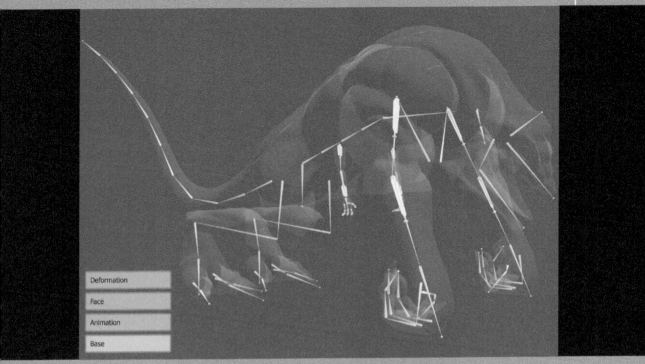

Deformation

Face

Animation

Base

Base Rig

"All fantasy should have a solid base in reality."

Max Beerbohm

The base rig acts as the first layer of our multi-layered rigging approach. This is by far the most important layer, and it consists of three main components:

1. Joints and bones
2. Skinning
3. Exported versions

Nothing flashy, exciting, or particularly complicated lives in the base rig. However, get something wrong at this stage, and all subsequent layers will inherit the problems, sort of a domino effect.

At its core of the rig is the skeletal system that is used to drive the creature's flesh-surface deformations. Correct placement of joints and bones is what matters here. Using our research and development, as well as anatomical studies, should allow for optimum placements to allow the best articulation to be achieved. Changes to the skeletal structure at a later point cause a lot of repercussions, not only to the other layers, but to the components that make up this layer also.

Skinning is the basic component of flesh-surface deformations. Obtaining perfect results with skinning alone is pretty much impossible, but spending time at this stage refining the skinning to look as good as possible allows us to reap the rewards later, as well as makes some additional deformation inputs easier to create. If this creature is destined for a real-time game engine, then skinning may be the only option available for creating great deformations. Take your time at this stage, and you can have a skinned character that looks fantastic without additional deformers.

The final section of this base rig is the exported files we can create once the joints and bones have been placed and the skinning is complete. You may have a custom exporter, you may be using a built in exporter, or you may need to assign "tags" so the creature can be exported later. No matter which solution you are using, it is a good idea to throw this creature through some exports and get it into the pipeline. The sooner you do this, the quicker you can tell if there will be any problems.

So, with all that said but not done, let the rigging begin.

The ROOT Node

This should be the first thing you create when starting your base rig. Our ROOT node is the very "top level" or "parent" of all other nodes in our rig. In other words, anything node that can be found under this ROOT node should be a component of our creature.

There are a number of benefits to having a ROOT node for our rigs:

1. It keeps the schematic view clean and tidy.
2. Anything that belongs to a certain rig can easily be found.
3. It can be a place to store information and custom attributes.
4. It is often needed by production pipelines, crowd simulation packages, or real-time engines.

A ROOT node can be anything you want it to be, from a sphere or a Point Helper to a custom controller, it does not really matter. However, as we store information and custom attribute data on this node, I prefer that a user of the rig does not have direct and easy access to the ROOT. For this reason, I prefer to use an "ExposeTM" helper to be the ROOT node for my rigs. This allows me easy access to important information that this special helper node already provides.

ROOT Node Creation

1. Create an "ExposeTM" node position at the scene world center ([0,0,0]).
 Create Tab > Helpers > Standard > ExposeTm
2. Change its appearance to suit your needs (I prefer an "Axis Tripod," "Center Marker," and "Cube").

FIG 4-1 The ROOT node is very important and acts as a place to store and retrieve information.

Create this ROOT node right now if you have not already.

Custom Attributes

We use "standard attributes" all the time. Creating a simple box gives us access to the "Length," "Width," "Height," and a number of other standard attributes that have various affects.

Custom attributes are similar to standard attributes. However, a custom attribute has to be created by us, the user/artist/programmer. Advantageously, a custom attribute allows us to store data and information that can be used for a number of various applications, from a simple information storage location that we can access and query at a later point to a value with the ability to drive something else within the scene.

Creating a Custom Attribute Via the 3ds Max UI

1. Start with a new scene, and create a sphere.
 Create Tab > Geometry > Standard Primitives > Sphere
2. Select the sphere, and, in the Modifier List, add an "Attribute Holder." This will clear the Modifier Panel so it is easier to view the custom attribute we are about to add.
 (Select Sphere) > Modifier Panel > Modifier List > Attribute Holder
3. Open the "Parameter Editor."
 Animation Menu > Parameter Editor... (Alt+1)
 The Parameter Editor UI can be a little daunting at first, but it is pretty simple once you get the hang of it.
 At the top of the rollout, we have the "Attribute" section, which allows us to dictate where the attribute will be placed, place and edit the attribute, and change the type, visual appearance, and name of the attribute.

FIG 4-2 The Parameter Editor allows us to add and edit additional parameters (or custom attributes) to our selected object.

The second section of the UI, the "Float UI Options" area, allows us to change the parameters of the custom attribute placement, ranges, and alignments, as well as some visual appearance matters.

Finally, we have the "Testing Attribute" section. This is simply a place to view and test your custom attribute before pressing that "Add" button at the top and assigning it.

4. Simply press the "Add" button, and you see that a new custom attribute section has been added to the Attribute Holder on the Sphere, as well as "Param1," which is the default name for the custom attribute we just added.

If you need to change the properties of a custom attribute added or delete it entirely, simply click the "Edit/Delete…" button.

We take a look at the practical applications for custom attributes as we work through our creature rig.

Joint and Bone Placement

Although every rigging artist seems to have his or her own joint placement conventions, we can all agree on the basic layout for bipedal characters. When it comes to creatures that do not fit into the biped-mold, we have to get creative. I am relying heavily on the research and development we have already looked over, as well as our previous planning for the joint and bone placements for this creature. So, if you have skipped ahead and have not done any preliminary anatomy research/work, step back and head in reverse (Chapters 2 and 3). Researching the anatomy and bone placements for your creature will save you much more time than powering ahead.

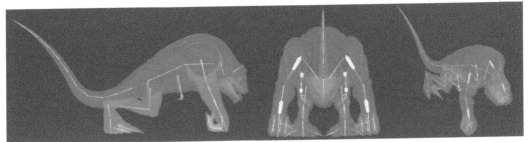

FIG 4-3 The completed joint and bone placement for Belraus.

Creating Bones in 3ds Max

Systems > Standard > Bones

Or

Animation Menu > Bone Tools… > Create Bones

With our research and development ready and at hand, the first step to work out is where the center of gravity (COG) is for our creature. The center of gravity is the theoretical point at which all the body weight is concentrated. If the body is of even density and has a relatively symmetrical shape, the center of gravity is at the geometric center. If the body is not symmetrical and/or does not have even density, it is much more difficult to work out where the center of gravity should be placed. In humans, the center of gravity shifts with each body movement, and this is true of creatures as well. When the distribution of a character's or creature's body weight changes, the center of gravity moves toward the greater weight concentration. However, in a neutral standing pose, and in terms of CG character and creatures, we usually place the center of gravity at the hips. This allows us to think of the hips as the defining section of the body that all movement emits from. Of course, this is not scientifically true, but it gives us a great starting point for both rigging and animation.

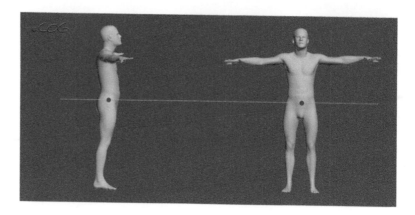

FIG 4-4 Realistic representation of the center of gravity (COG) of a generic human.

Of course, Belraus is somewhat different. Most of his mass sits across his upper torso area, meaning that, in a default pose, his center of gravity is somewhere around the chest and shoulder area. This would be a fine area for me to start from; however, as we are able to create animatable pivots, I have decided I would prefer to keep the center of gravity for Belraus at his hips. In turn, this means that, should the animator want to have the creature's center of gravity up at the shoulders, he or she could easily do so by moving the animatable pivot before starting to animate.

With the center of gravity point decided, we can go ahead and start with the first of the joint and bone placements, which are a simple two-joint chain, starting from the center of gravity location to just outside of the lower torso geometry. This will become the "hips" of our creature.

FIG 4-5 The first joints created for this creature, and any other creature, run straight down from the center of gravity location to just outside of the lower torso geometry.

COG Location

Making sure to mark the center of gravity (COG) location by a simple two-bone joint chain can help us remember that this is one of the most important areas of the creature.

Moving on from the hips, I like to concentrate on the spinal joints for the creature. Realistically, this spinal column should have many joints that run from the hips to the head. Each bone may be of different length, and the spine will curve with the contours of the back. I will use four joints that run evenly spaced from the hips (COG location) through to the base of the chest. Keeping the spine perfectly straight and evenly spaced should make the spine behave in a more manageable way. I am relying on biomechanics to make the creation of this section a little easier, and, although it may not be anatomically accurate, it will recreate believable movement once animated.

To get the even spacing between each joint easily, I find it best to use Point Helpers to mark the locations for both the center of gravity (COG/Hip) and the base of the chest, where we want the spinal column to end. With this locations correctly marked, we can use other Point Helpers that are position constrained accordingly to find the center points.

Creating Evenly Spaced Point Helpers

1. Create Point Helpers for both the COG/Hip location and the base of the chest/end of the spinal column.
 Create Tab > Helpers > Standard > Point
2. Create an additional Point Helper and Parent constrain that helper between the COG/Hip and chest location Point Helpers. This gives you the exact central location between the upper and lower sections of the creature (even if you move the COG/Hip and chest location Point Helpers).
 Animation Menu > Constraints > Position Constraint

FIG 4-6 Point Helpers can be constrained together to give exact points between specific locations.

3. Another two Point Helpers should now be created and position constrained accordingly to find the center point between the lower and middle Point Helper and the upper and middle Point Helper.

With the Point Helpers showing the locations for each of the joint locations, we can create the joint and bones by snapping them to the Point Helper pivot points.

FIG 4-7 Snapping the joints to the Point Helpers means that your joint chain starts and ends at the correct locations and is spaced evenly between one another.

Working our way up from the spine, I use a single bone through the chest with its starting position at the very end of the spine and the end joint at the base of the neck. By using just one joint for the chest and rib cage, it allows us to keep the rib cage area as rigid as possible. We could add extra joints in this area, but, really, we would just be causing ourselves more work and possibly more problems.

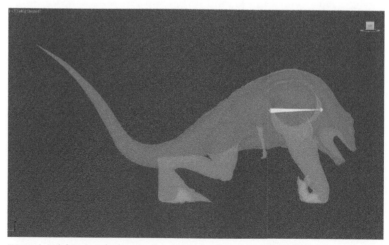

FIG 4-8 A single bone is used to keep the rib cage and upper torso area as rigid as possible.

The neck for this creature is going to run from the end joint up to the base of the skull. Although this creature has a very short and stubby neck, I want to have two evenly spaced bones so we can get a bit of stretching and squashing during deformation when the creature turns his head. I use the same Point Helper method we used for the spine creation, but obviously with less Point Helpers this time, as there are not as many joints. Once the positions are set, we create the bones for the neck.

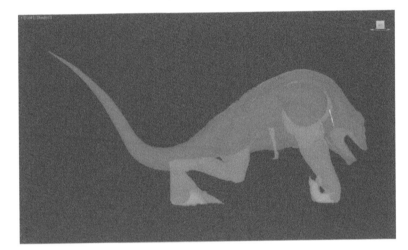

FIG 4-9 The neck joints are in place between the end of the chest and the base of the skull.

I like to keep the head/skull area rigid and rely on the face rig (covered in Chapter 6) to give deformation control to the animators. So, just like the chest, I use a single bone that runs from the end of the neck/base of the skull up out of the top of the head geometry.

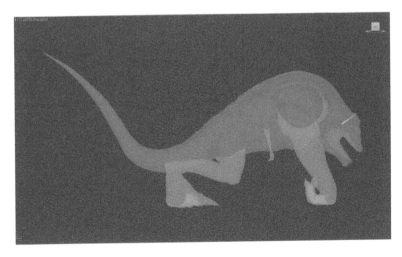

FIG 4-10 The head bone runs from the end of the neck joints up out of the top of the head geometry.

Moving back down the body, I place the joints for the tail. Unlike the spine and neck, this long joint chain cannot be straight because of the geometry. So, to ensure our joints run evenly spaced throughout the tail, we simply create a line that mimics the tail curvature from the center of gravity to the end of the tail geometry. Once this has been created, it is simply a case of creating a few Point Helpers and using a Path constraint. This attaches the Point Helpers to the line and allows us to change their percentage along the line. I am using ten joints, so we need a Point Helper positioned at every 10% along the line… 10%, 20%, 30%, and so on.

Creating Point Helpers along a Path

This technique comes in handy for more than just measuring a percentage along a line. In fact, it is a big component of our custom Spline IK system covered in Chapter 5.

1. Create a line from the start of the tail to the end that follows the curvature of the tail geometry.
 Create Tab > Shapes > Splines > Line
2. Create a Point Helper.
 Create Tab > Helpers > Standard > Point
3. Constrain the Point Helper to the line using a Path constraint.
 Animation > Constraints > Path Constraint
4. With the Point Helper selected, remove all animation from the time slider.
5. Copy the Point Helper as many times as you wish.
 Ctrl + V
 Or
 Shift + Left-Mouse Click Drag
6. Change the "% Along Path" attribute to your desired percentage.

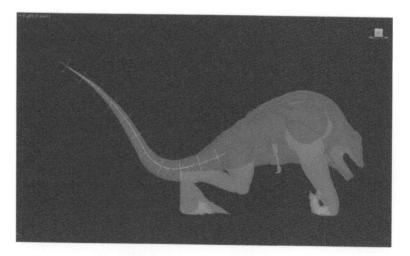

FIG 4-11 Point Helpers, which are path constrained at 10% intervals along the line.

With this line and Point Helper system in place and showing us where to position the joints, all we need to do is put some joints in and snap them to the Point Helpers.

FIG 4-12 The final tail joint chain.

With the joints created for the main sections of our creature, we can move onto his limbs.

Using a left viewport, I am create a three-bone joint chain that runs from the top of the thigh down to the foot of Belraus.

FIG 4-13 These three joints are used for the legs of Belraus.

It is now a case of using the "Bone Edit Mode" to edit the positions of these joints in the perspective viewport and line them up correctly within the leg geometry. If the end nub bone points at a strange angle after editing, simply delete it and use the "Create End" tool, found in the "Bone Tools" rollout.

Create an additional joint chain for the foot that runs from the end of the leg to the outside of the foot geometry. This will be the creature's foot joint. So, with the leg and foot created, we need to add additional joints and bones for the creature's toes. I am using a two-bone chain for each toe so we have a little more control over both the wiggling of the toes and the spread.

FIG 4-14 Wiggly toes and foot roll woes!

Let us leave the leg, foot, and toes there for now and move to the larger upper arms of the creature.

Again, using a left view, we quickly create a two bone joint chain for the arms and use the "Bone Edit Mode" to align and adjust their positions in the perspective window. These joints and bones now form the main articulation areas for the arm; however, we need to add additional bones to control twisting on both the upper and lower sections. By using a Point Helper position constrained between the start and end joints of both the upper and lower arms, we mark their central points easily. With those locations easily accessible, we create a single bone chain for both sections, which will help with twisting deformations later.

FIG 4-15 Arm joints in place with Point Helpers indicating the central points for each bone length.

Using our anatomical reference, we have to surmise where the clavicle will be placed for the creature. This is going to allow us to have shrugging actions and more flexibility in the upper arms. The starting point for the clavicle should be toward the front and center of the chest with the end joint positioned at the start of the upper arm.

FIG 4-16 Clavicle bones in place.

The hand bone can be added from the end of the main arm joint chain to just outside the knuckle geometry. This bone acts as both the main hand bone and the wrist.

Each of the fingers requires at least three joints for articulation, with an additional joint created for the "pinky" to allow for easier "cupping" of the hand.

FIG 4-17 At least three joints are needed on each finger, with an additional upper joint for the pinky finger to allow for cupping.

101

The thumb only requires two bones, but I like to add an additional upper bone to allow better deformations.

With the larger upper arms created, we can use the same techniques for the smaller arms. The only difference is that we do not need to include a clavicle joint for these arms, as they are not needed.

FIG 4-18 Smaller arm bones created just like the larger arms, minus the clavicle joint, as it is not needed.

That is all of the joints created for the base rig of this creature. However, if we take a look at our Schematic View, it is not looking too clean, as we have a lot of different hierarchies for each of the joint chains created.

To rectify this, we have to start linking these joints and bones together into some logical hierarchical structure. Depending on your creature's skeletal structure your hierarchy may be a little different from what I am doing. However, the process for linking joints and bones is the same, and the outcome is that of a clean, manageable hierarchy.

Just like the geometry hierarchy, I like to create a Point Helper and position it at the center of the scene ([0,0,0]). This becomes the "top level" of the skeleton hierarchy group. So, with that created, it is time to start linking everything together. It is important to ensure that we only link the upper joint of one hierarchy to another. Linking all of the joints in the hierarchy to another object makes them lose the correct hierarchical structure that we need for the rig, production, and animation pipelines. Your creature may have a completely different hierarchical skeletal structure, but, for clarity, here is what I am linking together:

1. The spine to the hip
2. The chest to the spine
3. The neck to the chest
4. The head to the neck
5. The upper leg joint and talk joint the hip joint
6. Each of the toes to the foot, with that foot joint linked into the leg chain, which, in turn, should finish the leg joint completely

7. The clavicle to the chest
8. Upper arm joint to the clavicle
9. The hand joint to the lower arm, and the fingers to the hand
10. Twisting joints to their respective arm bones
11. The smaller arms to the chest joint
12. All other bones relating to the smaller arm can be linked in a similar way to the larger arm.
13. The hip joint to the Point Helper group we created as the skeleton group parent
14. The geometry group to the ROOT, if you have not already, and then the skeleton group to the ROOT

That should make everything pretty darn tidy.

This seems like a lot of steps, but linking things together is very easy and not too stressful for at this point. Your hierarchy at the moment should be clean and simple to navigate.

It is useful to note that I have not linked any of these bone chains to the very "end" joints of any section of the creature. This reduces the amount of bones in the creature, which is handy for reducing the amount of calculations in both real-time game engines and crowd simulation software.

An often forgotten or overlooked aspect of joint and bone creation in 3ds Max is the local rotation axis (LRA) for each joint. Because of the way that 3ds Max works with bones, the LRA of each bone is not as well documented as that of other 3D software applications. For instance, in Autodesk Maya, we can even display the LRA of a joint, not something that is as easily accessible in 3ds Max without a script of some sort.

Display a Joint's Local Rotation Axis (LRA)

Please Note: This tip is for <u>Autodesk Maya ONLY</u>. It is not available in 3ds Max.

(Maya) Main Menu > Display > Transform Display > Local Rotation Axis

As our application of choice is 3ds Max, we can simply rely on using the rotate tool and switching it to a "local" rotation mode. First, freeze transformations on all of the joints in the skeleton. Then go through each of your created joints, and see how they rotate individually and as a group (for instance, all of the pinky finger joints). You may notice that some of the joints do not rotate the way you would expect or want. They may rotate the opposite way or rotate at an angle not suitable for what you need for your creature. Should you have any of these issues, it is a simple case of heading to the "Bone Tools" rollout and turning on "Bone Edit Mode." From there, simply rotate the "twisting" axis of the joints to better suit your needs. Then check the rotation again, and repeat if necessary. Finish each edited joint rotation by freezing its transformations once more to "reset" the rotation. This is the best way to get

FIG 4-19 Linked hierarchy.

the sort of forward kinematic (FK) rotation you would expect from your joints. Oh, and as a side note, the default twisting axis is the "X" axis.

Editing a Joint's Local Rotation Axis (LRA)

1. Use the rotate tool in "local" mode.
2. Turn on "Bone Edit Mode" in the 'Bone Tools' rollout.
 Animation Menu > Bone Tools… > Bone Edit Mode
3. Rotate the joint on its twisting axis.
 Finish editing a joint's local rotation axis (LRA) by freezing the transformation on the selected joint you have just edited.
 Alt + Right-Click > Freeze Transform > Popup Menu (Yes)

Now that we have the right-side of the creature's joints and bones in place and their local rotation axis (LRA) correctly orientated, we can create the opposite side bones and joints. Luckily, we can use the "Mirror" tool found on the "Bone Tools" rollout to quickly mirror the bones to the other side. You may need to unlink the mirrored bones to place them correctly, so, if you have to do this, remember to re-link them once you have finished relocating them.

Mirroring Bones/Joints

Always use the Bone Tools rollout and the "Mirror" option when mirroring your joints and bones.

Animation Menu > Bone Tools…

FIG 4-20 Mirrored and linked joints completing the skeletal setup for Belraus.

This completes the base skeleton for Belraus. Before moving any further, we need to spend a bit of time renaming all of the bones/helpers and removing any unwanted/unneeded Point Helpers left in the scene.

I use the previously discussed naming conventions for this creature to rename accordingly. Here is my renamed skeleton and hierarchy layout:

FIG 4-21 Finished skeleton and hierarchy.

Location Information Data Node

Should you need location or positional information for where this creature is in the scene, it is worth setting up a data node that can capture this information. This may be handy or even needed for game engines or motion capture, so it is a good idea to make sure this node is added as soon as possible.

A location data node needs to send positional ground-plane information to some sort of system (this obviously changes depending on what you are using this information for). This information includes the side-to-side movement and the forward-to-back movement, or X and Y movement in 3ds Max.

FIG 4-22 A location information data node can help track the location of a creature or character.

105

Creating a Location Information Data Node

1. Create a Point Helper positioned at the scene world center ([0,0,0]).
 Create Tab > Helpers > Standard > Point Helper
2. Align the Point Helper node's pivot to the center of gravity for the creature (in my case, this is the hip joint).
3. Link the Point Helper to the creature's center of gravity (hip joint).
4. Use the "Hierarchy Tab" and the "Link Info" section to lock the Move, Rotate, and Scale of the Point Helper.
5. Still in the "Hierarchy Tab," make sure the Point Helper only inherits the "Move X" and "Move Y" transformation information from its parent.

FIG 4-23 All locks applied and only the X and Y inherit information is enabled on the node.

6. Create a single joint/bone at the location of the Point Helper and link it. This gives some form of pivot reference information on the ground level.

Test Skinning

The aim of the test skinning is to get smooth geometry deformations; this becomes the starting point for your flesh-surface deformations in the later stages of the rigging process.

As we are skinning the creature so early in the process, it should outline any issues with joint placement, as well as show any topology and looping problems we may have missed while checking geometry. At this stage, we are still able to fix, change, and refine any issues without having done too much work already.

For now, I am going to hide the creature's eyes, teeth, gums, and tongue. These can all be dealt with later, and they really do not matter too much at the moment, as we are only interested in the main body for this stage of the rigging production.

Applying the Skin Modifier

1. Create a box with at least ten height segments.
 Create Tab > Geometry > Standard Primitives > Box

FIG 4-24 Create a cube with at least ten height segments.

2. Create a two-bone chain in the center of the cube with the joints positioned at the beginning, middle, and end of the geometry.
3. Add a "Skin" modifier that includes the first two created bones to the cube.

FIG 4-25 The two-bone joint chain allows us to test some basic deformations spread between two bones.

4. Animate the second bone bending so the deformations are visible.

Alright, time to grab the geometry and add the "Skin" modifier. With that modifier applied, we go ahead and add all the bones created for this creature minus the "end" bones that will not be needed to deform the creature's geometry.

FIG 4-26 Adding all of those lovely bones we created to get this creature to deform correctly.

I am going to save this file so there is a good starting point for our skinning.

By adding joints to the Skin modifier, 3ds Max has given us some basic skinning that is calculated by the length of the bones and their envelopes. Envelopes envelope the joint, and anything geometry that falls inside the enveloped area is affected by the joint movements. If we grab some of the joints and rotate them, we notice that, although "skinned," the creature does not deform well at all.

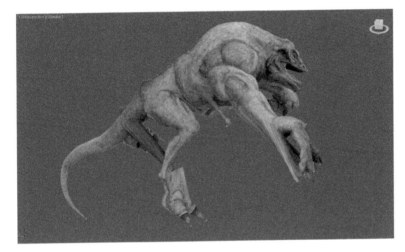

FIG 4-27 Default skinning is bad. The default envelopes created by 3ds Max are usually not great and need some manual editing.

In fact, it is kind of awful. Many new users of the Skin modifier would, at this point, start editing the envelopes to help smooth out the deformation.

Editing Skin Modifier Envelopes

1. Create a cube with at least twenty height segments.
 Create Tab > Geometry > Standard Primitives > Box
2. Create four or more bones that are placed inside of the geometry.
3. Add a "Skin" modifier to the cube, and attach all of the bones to this modifier.
4. Animate the bones so they deform the geometry.
5. With the cube's geometry selected and the Skin modifier highlighted, click the "Edit Envelopes" button.
6. You can now access and manipulate the envelopes of the Skin modifier.
7. Use the bone list to switch between the affecting bones and experiment by changing the envelopes of different bones to see the results.

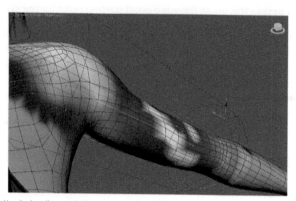

FIG 4-28 Use the handles to edit the envelopes of the Skin modifier.

Editing the envelopes of the Skin modifier is a very fast way to get kind of OK results; however, I have found that it is best to directly edit the vertices, rather than the envelopes. This technique takes a bit longer, but it produces much better results in the long run, and the amount of control when compared to enveloping is substantially better.

Editing Specific Vertices of the Skin Modifier

1. Select your geometry that has the Skin modifier and bones attached to it.
2. Turn on "Edit Envelopes."
3. Click the "Vertices" button found just underneath the Edit Envelopes button.
4. (Optional) In the "Display" rollout, turn on "Show No Envelopes" to hide all envelopes from displaying in the viewport.
5. Open the "Weight Tool" by clicking the spanner icon on the main rollout of the Skin modifier.

FIG 4-29 Turn on vertices editing, remove the envelopes from view, and open the Weight Tool for some serious skinning action.

6. You can now select the vertices of your geometry and use the options in the "Weight Tool" to manipulate their skin values.

I like to start my skinning process by grabbing all of the vertices of the geometry and setting the vertices skin weighting to 100% of the hip or COG joint. This removes all previous weighting information from the geometry.

FIG 4-30 100% vertices weighting to the hip joint of my creature, Belraus.

You will notice that, when we select a single vertex, the Weight Tool displays the weighting information for both the hip joint, as well as any of the previous affecting joints. Even vertices with a zero weight value are evaluated, so this is a good point to remove that information from our Skin modifier.

Removing Zero Weights from the Skin Modifier

1. Select all of the vertices on the geometry.
2. Jump to the "Advanced Parameters" rollout on the Skin modifier dialog.
3. Click the "Remove Zero Weights" button.

Once the zero weights have been eliminated, only the hip joint should appear in the Weight Tool dialog table.

This is also a good point to check your "Bone Affect Limit." This is not necessarily too important for film or TV assets, but it is incredibly important for real-time or gaming assets. What is the "Bone Affect Limit"? Well, this option refers to how many bones can have a weighting effect on a single vertex. Many real-time engines limit the amount of these, and I have found that the general standard is currently at four bones per vertex.

Changing the Bone Affect Limit

1. Head over to the "Advanced Parameters" of your Skin modifier.
2. Change the "Bone Affect Limit" option as needed.

111

Should you be required to work to a specific Bone Affect Limit, change this right now so there are no errors or issues when exporting out to your game engine.

FIG 4-31 Remove the zero weights from each vertex, and set you Bone Affect Limit if you have one.

With each vertex of the creature's geometry having a 100% weighting to the hip joint, it is time to start "blocking" out the skinning. This requires us to run through each and every bone in the Skin modifier and assign 100% weighting to the exact vertices we want them to affect. I usually do not weight the clavicle at this point. I add it in much later.

Working from the hip to the spine, the chest, neck, the head, and then jumping down to the tail, I use the Weight Tool exclusively to assign the weighting for each joint/bone. Once the main sections of the creature are complete, I move onto the limbs, starting with the legs, feet, and toes, moving

onto the upper arms and hands, finally finishing with the smaller arms and hands. Be sure to use the vertices selection tools found at the top of the Weight Tool so you can easily shrink, grow, ring, and loop your selections.

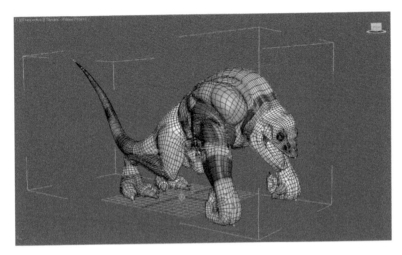

FIG 4-32 One side of Belraus fully blocked. I deliberately miss blocking the clavicle joint and take care of that section later.

Of course, with my creature, Belraus, being perfectly symmetrical, it allows me to mirror the skin weighting to the other side easily by using the "Mirror Parameters" tools found within the Skin modifier.

Mirroring Skinning Information Data

1. Find the "Mirror Parameters" rollout in the Skin modifier.
2. Click the "Mirror Mode" button to enable it.
3. Edit the options to fit your needs (you can try leaving these as default to start with if you are unsure).
4. Use one of the five buttons found above the options to mirror your skin weighting.

FIG 4-33 Mirroring skin weights can help speed things up a lot.

If your creature is not symmetrical, you have the slightly longer and more difficult job of skinning each side individually.

Now that both sides are blocked out, we quickly check the deformations by rotating the joints and taking a look at the results. This obviously does not look great just yet, but it shows how the main bulk of the geometry is going to move along with each of the joints. If you notice any stray vertices moving around that should not be moving, it is easy enough at this point to click them and set their weights accordingly.

Once you are happy with this blocked-out skinning deformation, grab all of the vertices once again and remove any zero weights, making sure to save your work.

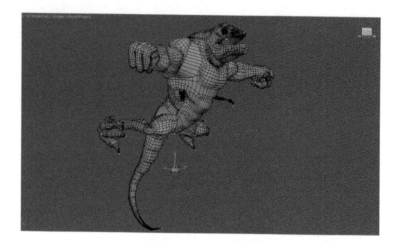

FIG 4-34 Blocked-out skinning does not look great, but it shows exactly how the main mass of the geometry is going to behave when the creature is articulated.

Should you be working in a production pipeline, this is a great point to stop rigging and check if your creature works correctly for the job at hand. So go ahead and export him out and send him into the big huge world. If there are any issues, they should be a relatively simple fix as we have not jumped too far ahead just yet.

After our pipeline checks have been completed and any issues fixed, we can concentrate on making the skinning a little nicer by smoothing out the harsh deformation between each of the bones affecting the geometry.

I like to keep this section pretty regimented, and, as we are only at the base rig stage, there is not too much skill needed to smooth out the blocking. It can take a little time though, so be prepared.

Smooth Skinning Basics

Like everything in 3D, there are numerous ways to do the same thing and get the same results. I find that the following technique gives good deformations for minimal effort and time, which is perfect for a production environment.

This method works on the principle that you find the pivot position between two joints, and that "loop" of vertices should be assigned a 50/50 weighting split (50% to one bone, 50% to the other) between the two closest joints. We can then work away from each joint, depleting the influence amount at a 25% interval, and finally a 10% interval. This leaves the other joint at a 75% and 90% influence.

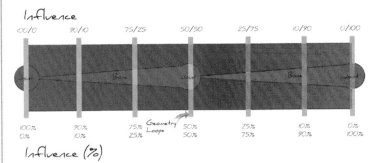

FIG 4-35 Weight distribution for the smooth skinning basics method.

Simple enough right? Another advantage of this technique is that we can use the quick-access weighting buttons on the Weight Tool to apply these values quickly and easily.

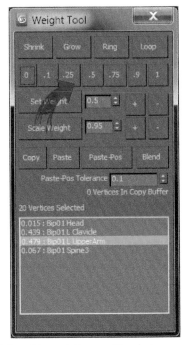

FIG 4-36 The Weight Tool gives quick access to these weighting values.

What this does is give us an even weighting between two bones. It did not take us long to do, and the results are a huge advantage over the blocking stage we just completed.

FIG 4-37 Distributed weighting between two bones using a 10%, 25%, 50%, 75%, 90% weighting method.

We can now start doing this for every joint that has an influence on the geometry. As we start working our way up through the spine and into the other sections of the creature, notice that these weights are not always in a perfect 10%, 25%, 50%, 75%, 90% sequence. In fact, add another joint into the mix, and it will be nothing like that sequence of numbers at all. Do not worry! Although we are keeping a pretty strict routine for this section of the skinning process, it does not mean the output will be as perfect. This is totally fine, just remember that, once you complete the skin smoothing take, articulate the skeleton once more and see how the creature is deforming. It does not have to be perfect by any means, but it should be a vast improvement over our blocking, should smoothly deform in most areas, and there should be no rogue vertices moving around anywhere.

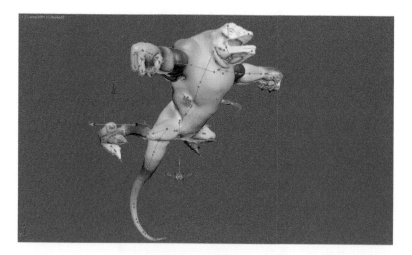

FIG 4-38 Example of smooth skin weighting over the creature Belraus.

Once you are happy with the results, grab all of the vertices again, remove zero weights to tidy things up, and do not forget to save your progress at this point too.

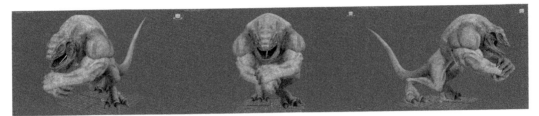

FIG 4-39 Pretty nice smooth skin deformations.

The shoulder area of a creature or character is known for being one of the most difficult and challenging areas to skin correctly. Getting deformations to look great in this area can take some time, and if you are not limited to just smooth skinning as a deformation method, we can apply all manner of deformers and techniques to correct bad deformations. At this stage, these deformers are not needed, and we can stick to just using the Skin modifier for now.

I like to use a different technique for the clavicle joints. Although I do use the Weight Tool, I find it is a good idea to grab the area I think will be affected by the clavicle and add a 10% weight to it (from the clavicle joint of course). This gives a good starting point for the clavicle bone. From this point on, it is just a case of increasing or decreasing the amount of influence this joint has over the geometry until it looks as good as possible. Make no mistake, this joint could take just as much time to skin as all of the other joints in the skeleton.

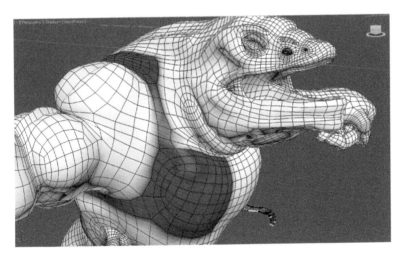

FIG 4-40 The clavicle skinning process is a little different from the usual smooth skinning technique.

Once you are happy with the skinning results for the clavicle and the rest of the creature, grab all of the vertices and "Remove Zero Weights" once agin, just to be sure the skinning information is super-clean. That is it; we are finished skinning. Make no mistake, this is not the final flesh-surface deformation, nor is it the last time we will use the Skin modifier. We are far from finished, but it is time to move on… So save, save, save!

117

Save Skinning

Now that we have spent a bit of time skinning the creature and possibly changing joint and bone positions (should they have needed it), we save the skinning information to a separate file. By doing this, we keep the data in a safe backup, should the worst happen to one of our working files, such as file corruption, yikes!

There are three methods for saving our skinning information, and, in my opinion, it is worth doing them all.

First, save a copy of my current creature's scene so you have a backup of the whole thing, including the skinning information. If you are like me, you already have a lot of other saved files you have been collecting as we have been working on our creature rig. This is totally fine, but I make one special save that I place in a separate location just for this skinning information, which can be extremely valuable.

Save Skinning Method 1: Saving as a New Scene

OK, this method is pretty logical. Simply make another save of your scene as a backup for the skinning information. I know, not rocket science, but hey, it's worth a mention.

Second, keep a separate geometry model in our scene which contains the skinning data information by using the "SkinUtilities" 3ds Max comes with.

Save Skinning Method 2: Skin Utilities

1. Head over to the "Utility Tab."
2. Click the "More…" button, and select "SkinUtilities" from the popup menu.
 Utility Tab > More… > SkinUtilities

FIG 4-41 Skin Utilities.

3. Once the "SkinUtilities" have been selected, this should bring up a new "Parameters" rollout in the Utility Tab.
4. There are two buttons in this rollout, and they are pretty self-explanatory. One allows you to extract skin data information to a separate mesh within the scene. The other imports skin data from an extracted mesh to other geometry in your scene.

Once you have clicked the "Extract Skin Data To Mesh" button, it is important to place this mesh into the "Data" layer and hide it away, as we do not need this at the moment.

Pretty neat, huh? Well, yes and no. This should be the greatest skin-data-saving tool ever; unfortunately, that is not always the case. Most of the time, this should work just fine, but I have had instances in which the skin data just will not transfer, or transfers incorrectly, even when the geometry is exactly the same. I really do not know why this happens, but it does, every now and again. So why bother saving the skin data this way? Well, it is a pretty neat backup, and, when it does work, it works very well. I mean, if it is there, it is easy to use and it could help, so why not?

Finally, as a third backup of our skin data, use the "Save" and "Load" skinning options found in the Skin modifier. Yeah, you guessed it; these buttons save and load skin data.

Save Skinning Method 3: Skin Data File

1. Enable "Edit Envelopes" in your Skin modifier.
2. Grab all the vertices of your skinned geometry.

FIG 4-42 Bake Selected Verts and save your skin data information to file.

3. Bake down the skin information to each individual vertex by clicking the oven cooker icon button. This button should have a tooltip that says "Bake Selected Verts." Fail to do this and your saved skin data will be pretty useless as it will rely on the envelopes rather than the vertex information.
4. Click the "Save" button on the Skin modifier to save your skinning information to file (Use the "*.envASCII" format).

Oh, just a quick note on the file formats when you save the skin data this way: The first option is simply a binary (*.env) file. The second is an ASCII (*.envASCII) file. Save it as the second, ASCII option. This allows you to open the file in a Notepad or Wordpad type program and read the stored data. This can be pretty handy once you start creating tools that can parse through text files and read this sort of information.

FIG 4-43 Save skin files as ASCII, not binary.

Bone Shaping

A lot of 3D packages create bones as a "special" sort of object/node, with specific bone-only properties that no other node in the application has. One of the unusual, but very awesome, features of 3ds Max's bone system is that any object can become a bone, grab hold of all the properties and attributes that make it a bone, and behave exactly the same. I still prefer to use bones when creating a skeleton, but the option to use anything we want is sort of cool.

When it comes to currently selecting the joints and bones that make up our creature's skeleton, it is a bit cumbersome, as we have to select through the mesh. As we do not have any controllers in place or an actual rig setup just yet, that is really the only thing we can do for the moment. However, as bones are not classed as a "special" sort of node within 3ds Max, we can edit their appearance to make selecting them easier.

Of course, we could jump into the Bone Tools options and turn on "Fins" adjusting them to better fit the mesh, but this would be a waste of time, as we can do something much better. With a bone of your choice selected, head over to the Modify Panel and add an "Edit Poly" modifier to the bone. With the Edit Poly modifier applied, we are able to go into all of the parameters, attributes, and options for the modifier and edit the look of the bone. What this means is that we can reshape every bone in the skeleton to fit our creature very closely.

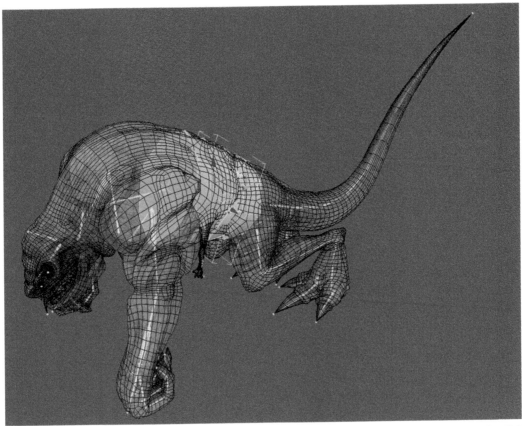

FIG 4-44 An Edit Poly modifier added to the bones of Belraus and reshaped to fit the geometry.

Make sure to keep this as a very low-poly edit so the bones can evaluate quickly in the viewports. By doing this, not only has this made selecting the bones easier, but it has also created a low-poly "cut" version of the creature. In later stages when this creature is placed into an environment, the skinned geometry may cause the scene to slow down, and this can make the animation process incredibly difficult, as if it was not difficult enough already. By having this low-poly cut skeletal version of the creature, the animator can hide the geometry and use this instead. Obviously, this will not give the animator access to view the deformations of the creature with the geometry hidden, but it should speed the viewport up and give a very good representation of the size and mass of the creature as it moves and interacts with the environment. I usually leave the fingers out of this bone reshaping step, both because it can end up taking too long and because it is not overly beneficial for the animators at this stage.

Oh yeah, and you can mirror to the other side too! Simply copy the "Edit Poly" modifier from a completed bone, paste it to the other side, then add the "Mirror" modifier and adjust the parameters so it fits correctly.

121

> ### Reshaping Bones
>
> To reshape the bones of your creature, simply add an "Edit Poly" modifier to each bone and edit away. You can easily mirror to an opposite side by copying the modifier to the other bone and adding a "Mirror" modifier and adjusting the parameters so it fits correctly.

To complete this reshaping, it is a good idea to color the bones using our coloring convention. Although these bones may not be seen at all when we introduce the animation rig, we still want them to be easily distinguishable while in this base rig phase.

Range of Motion (ROM) Files

Range of Motion files, or ROM files, allow us and the animation team to understand the full range of motion the creature is going to get itself into. The best way to obtain this information is to hand our creature over to an animator (preferably a supervisor or lead if you are working in a production environment), and ask them to animate the creature into the most extreme positions they are going to need.

Creating a ROM file should not take a lot time. Be sure your animator understands that you do not need finished animation, but rather you are simply looking for the most extreme poses with only the most basic transitions between them.

Am I forgetting something?

Oh yeah, we do not have a rig for this creature! As we do not needing amazing quality animations, we do not need to provide the animator with a rig just yet. The reshaped bones, along with some basic skin deformations, should be enough for the animator to get started. He or she can use any tools available that can make the job easier. For instance, simply rotating in FK, scaling joints, or even adding in some basic IK chains is more than acceptable. Remember, we are interested in the motion, not the rig, at least for now.

While waiting for the animation to be completed, this is a great time to do some research and development on some areas of the creature rig you thought could be troublesome. Of course, you may need to help with some other production or pipeline issues, or you may have to create the ROM file yourself. Just remember that you do not need great transitional animation for this file. It is the poses that are important.

Once the animation for the ROM file has been completed, look over it. When we come to taking a deeper look at the creature's flesh-surface deformations, we use this information to help get the best possible deformations.

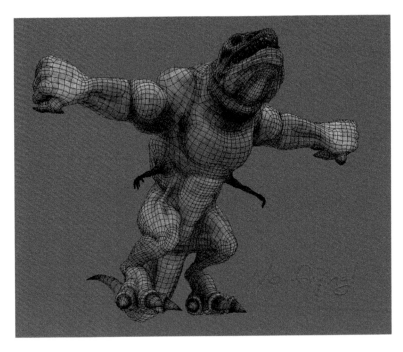

FIG 4-45 ROM file creation should not take too long. It just needs to be functional.

We now need to bake down the animation to the joints, remove any basic rigging created by whomever worked on the Range of Motion (ROM) animation, and save the animation as an animation file.

We have a number of options to choose from when we need to bake the animation to joints in 3ds Max. The most robust way I have found is to write your own custom animation baking tool and exporter. By doing this, you have complete control over what information is stored and retrieved from the animation data. For the purposes of this text, we are do not dive into scripting just yet, so let us take a look at two different methods for baking animation already found within 3ds Max.

FBX Export

Autodesk's built-in FBX exporter has great options available for baking animation.

1. Select all of the joints of your creature.
2. Use the Max Icon button at the top left of the application and click.
 File (Max Icon) > Export > Export Selected
3. Make sure you are exporting an FBX file, and name it accordingly.
4. Click the "Save" button, and a new FBX Export options dialog will open.
5. Set the "Current Preset" to "Autodesk Media & Entertainment."
6. Open the "Animation" rollout followed by the "Bake Animation" rollout.
7. In the "Bake Animation" rollout toggle on the "Bake Animation" option.

8. Set your start and end frames.

9. Set the number of "steps" to the exact amount of frames you have. The amount of steps when baking animation correlates to when keys are set over the specified start and end time. For instance, steps of ten would be a key on every tenth frame. Or, if you have one hundred frames and one hundred steps, you get a key for every frame, which is what we want in this case.

10. When you are all set, click the "OK" button at the bottom of the FBX Export screen. This saves an FBX file.

FIG 4-46 FBX Range of Motion file export.

Trajectory Baking and Animation Saving

This option allows you to bake the animation directly in the scene without relying on an external exporter.

1. Select all of the joints of your creature.
2. Head over to the "Motion Panel," and then click the "Trajectories" button.
3. You will notice that the trajectories for all of the joints have appeared in the scene, and this is the information you are going to bake down.

So, similar to the FBX exporter, you need to set the start and end times, as well as the number of samples. Do this now.

4. Make sure that "Position," "Rotation," and "Scale" are selected in the "Collapse Transform" section, and then click the "Collapse" button.

5. You will now bake the animation to the selected joints. How long your animation is will dictate how long this process takes.

6. Once the process is complete, click the "Parameters" button to stop the display of the trajectories for each joint.

7. Saving this information is relatively simple, so, once again, select all of the joints of the creature if they are not already selected.

8. Head over to the "Save Animation…" menu.

 Animation Menu > Save Animation…

9. A new window appears, which allows you to save your ROM information as an XML Animation File (*.xaf). Check the options at the side before continuing, and, should you need to include any custom attribute data, you can do so in the lower section. With everything ready, click the "Save Motion" button.

FIG 4-47 Trajectory baking and animation saving Range of Motion file export.

Now that we have our ROM file saved to file, it is a good idea for us to test the animation by importing the ROM file onto a clean rig. So, reset your scene, and reopen your creature rig that contains no animation. From there, you need to import your ROM file.

FBX Import

1. Accessing our ROM animation is pretty simple. Import your FBX file into the scene.

 File (Max Icon) > Import

2. An FBX Import window will appear, and you need to make sure the "Current Preset" is set to "Autodesk Media & Entertainment."

3. In the "Include" rollout, the "File Content" should be set to "Add and update animation." Change it if it is not.
4. Click "OK."

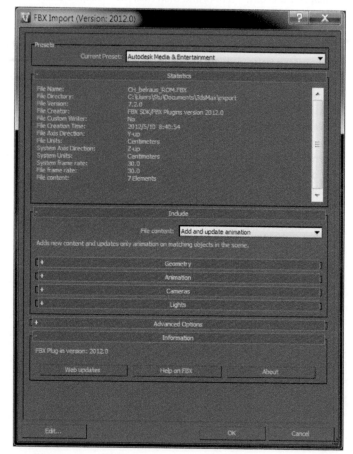

FIG 4-48 FBX Range of Motion file import.

Trajectory Baking and Animation Saving Import

1. To apply your "xaf" file that contains the ROM information, you need to select all of the creature's joints first.
2. Head over to the "Load Animation…" menu.
 Animation Menu > Load Animation…
3. Find your saved ROM file.
4. Check the options that are available, and click the "Load Motion" button.

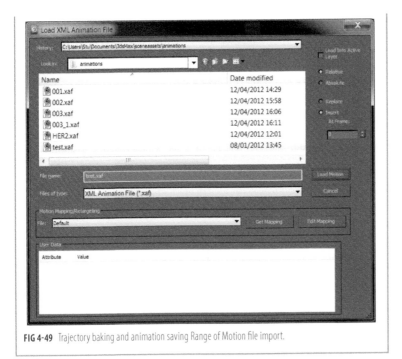

FIG 4-49 Trajectory baking and animation saving Range of Motion file import.

A lot of what happens when creating these files is down to both biomechanics and largely what is needed from the creature to get the best results for the project. Do not be alarmed if some of the extreme poses your animator gives you breaks your skinning and joint setup, this is the information you need to allow you to create the best rig for this creature, and possibly highlight any shot-specific rigs that might be needed.

Motion Set List (MSL) Files

Blend trees, blend graphs, motion blending… all terms commonly associated with real-time game engines or crowd simulations. Should you be rigging specifically for one of these outputs, you may need to start thinking about your Motion Set List (MSL) files now.

How is your creature going to move between animations? Is this controlled dynamically, or do you have some control over it? What system are you using? Do you have to figure this entirely on your own, or do you have an engineer to help you? All of these questions are valid, and, although these may be dictated by your production, you need to know what is going on.

A lot of these questions are very specific, and there is no real way for us to cover all of the various systems, techniques, and applications available to us in this book. One thing that does not change is the approach we can take to creating our MSLs.

MSL File Creation Approach

1. Get a list of all movements for the creature.
2. Research how these movements will be used. For instance, are they automated? Do they require user input? Are they affected by outside forces or dynamics?
3. Create a diagram (I prefer paper and pen for this) that shows the flow between each of the movements and how they relate to each other.
4. Flag any additional animations that may be needed for transitions.

FIG 4-50 "Paperwork" example of the creation of MSL files.

FIG 4-51 A diagram of a basic idle pattern.

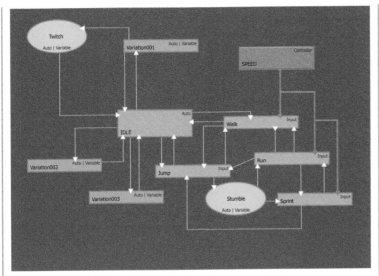

FIG 4-52 A diagram of a basic idle pattern that fits into a simple movement routine.

With these diagrams created, we have a good starting point to create the actual MSL files themselves. You should be able to create a "blank" template file using whichever system you have available for use later.

Shot Specific Rigs

It would be great if a single rig could do everything you want it to and more; unfortunately, that is not usually the case.

As I have said before, no rig is perfect (or model, or animation, or shot, or pretty much anything 3D for that matter). If it is possible, please send me a link or something, as I have yet to see one, because usually at least some elements of a rig can always be improved!

For the most part, a rig should be able to do about 90% of what you need it to, but there will be special occasions and instances in which a shot-specific rig needs a custom build just for certain scenes. For instance, in my planning for Belraus, I have not even considered being able to "flatten" him out fully, sort of cartoon style.

Honestly, I cannot see a realistic creature ever needing to do so, but, if this was a cartoon creature, it could be completely possible that this would be needed for one or two shots. When faced with something like that, you have to work out whether it is worth adding that sort of control to the main rig or if you should spend that time creating a shot-specific rig.

FIG 4-53 A squashed Belraus is not a happy Belraus!

Often, when something as extreme as a creature being squashed is needed, it is best to create a custom shot-specific rig designed to deal with that sort of manipulation, even more so if that sort of extreme deformation only happens in a couple of shots. Should the creature be required to do that frequently, you have to add that into the main rig, as it is something the animators will be looking for time and time again.

These sorts of questions should be answered during the planning and preparation phase, but this is a good point to check the ROM file to see what may be needed. For the purposes of this book, we do not cover any shot-specific rigs, as it seems more logical to focus on the main creature rig that should do most things we need it to.

Control Creation

There may not be anything in our creature to control just yet, but I like to spend a little time designing and creating the generic controllers before starting to dig deeper into the rig. More than anything, this is a personal choice. I like to keep things as visual as possible, and the controllers of a rig are very important to me. If they do not look right or obstruct the viewing of the geometry too much, my rig will not be appealing to work with, and that is definitely something I wish to avoid.

Creating the rig controllers during the actual rigging process is fine too. In fact, I sometimes miss a controller at this stage that needs to be added later. This does not cause any problems; like I said, creating most or all of them at this stage is just a personal preference.

It is a good idea to pull out those diagrams you created earlier, the diagrams that covered the general placement for our controllers, and start working from them.

I like to use simple shapes for my animation controllers and enable their rendering in the viewports as well.

Creating Animation Controllers

1. Animation controllers are fun to create, and I like to use simple shapes as they can be very expressive and unobtrusive.
 Create Tab > Shapes > Splines > (Multiple Options)
2. That is it. You can attach/combine shapes if you want to get really creative, and you can decide to turn on the "Enable In Viewport" rendering option as well. Just remember to set the "Sides" and the interpolation "Steps" to three. This ensures the viewport will keep running quickly and smoothly with little to no slowdown as it draws the controllers and everything else in the scene.

FIG 4-54 Creating animation controllers for your rigs is easy and fun. You can be as creative and as crazy as you want, as long as it is usable and unobtrusive for the animators to use.

To finish up, remember to color the controllers so they are easier to see and work with. When you are finished with the creation of your controllers and you are happy with the positioning, rename them and add them to the "CTRL" layer. These can now be hidden until later.

Exporting and Saving the Base Rig

We are just about finished with the base rig for our creature, but we do need to do a little clean-up and some final exporting and saving before call it a day for this section.

First, check your hierarchy in 3ds Max, making sure the creature's skeleton and geometry are under one hierarchy and are grouped correctly.

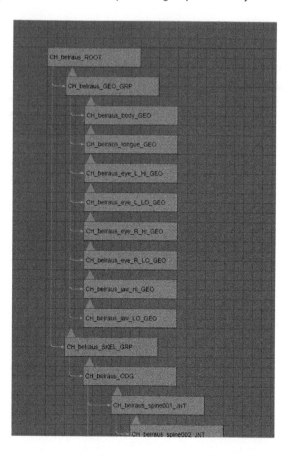

FIG 4-55 A single hierarchy containing groups for the various sections of our creature.

What we have now is the actual base rig scene we will send through the pipeline and into other disciplines. Take a final look at all of the components that make up this rig: check for correct node coloring, correct naming, and that each node is placed in its correct layer. Once all of these checks are out of the way, freeze and/or hide things you do not want users playing with for the moment.

At present, the creature I am working on has no textures and does not link or reference anything that lives outside of this scene. What this means is that I have no issues when opening this file, handing it over to someone else, or working on another remote machine. Should you be referencing or linking files (textures, for instance) that live outside of this scene, it is important that these have the correct paths so that, when opening the file, there are no problems or errors. Head to the "Asset Tracker" and make sure everything is OK.

This all may seem arbitrary and a little long-winded, but the creature you have here is the "finished article." This base rig will be here from right now until the end of the production, so you need to make sure you get this right.

FIG 4-56 Make sure to track assets and their pathing.

This is your final chance to check for error, test your ROM file, and make sure you are happy that other users of this rig will be happy. Once you are all set, bundle your assets, save, or check-in (if you are using some form of source control) to the correct location.

The Base Rig Bundle

1. Creature Rig File (Max)
2. Exported Rig File (Optional)

FIG 4-57 All of the base rig assets stored (bundled) into one location.

3. Range of Motion (ROM) File
4. Motion Set List (MSL) File (Optional)
5. Metadata (Optional) – This is pretty pipeline-specific, and you will know if you need it.
6. Notes (Optional) – Notes for other team members.

The base rig is now complete, congratulations!

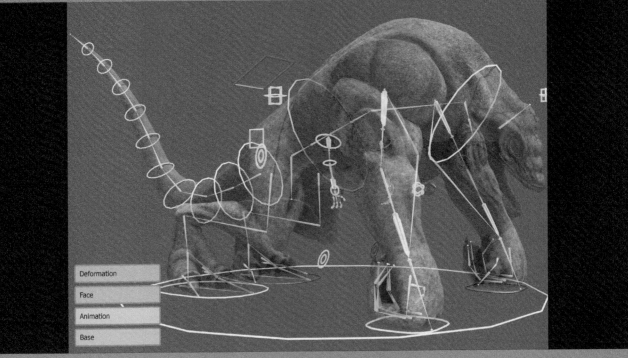

Deformation

Face

Animation

Base

Animation Rig

"Animation is about creating the illusion of life. And you can't create it if you don't have one."

Brad Bird

The animation rig makes up the second layer of our multi-layered rigging approach. We have already taken care of joint and bone placements, made a valiant attempt at basic flesh-surface deformations, created some controllers to work from, and, finally, exported and tested the creature through the production pipeline. We are now ready to control that base layer via some intuitive, more complicated, higher-level rigging techniques.

Although this layer has many components, it only has one goal or purpose, and that is to provide an interface that drives the base rig. Primarily, the animation rig takes the most "abuse" from users, from artists and animators to programmers and developers. The animation rig is usually the rig they will pick up and play with. For that reason alone, you have to make sure the animation rig can cope with 80–90% of what users will make it do; for the other 10–20%, we have to think about "special" shot-specific rigs that can deal exclusively with the problems encountered.

During our research and development, we have covered exactly what this animation rig will need to do and how it should perform. We take a look over a number of setup options as we work through this chapter, but it is really up to you and what your animators need that will decide which option or technique you need to follow for your own creature setup.

Simplicity is the key to creating a successful animation rig. That is not to say that some sections of the animation rig will not be complex. They will. It just means it is our job to mask those complex areas with easy-to-use, intuitive controls.

The Connection

Many rigs apply rigging techniques and solutions directly to the equivalent of our base rig. In other words, the joints and bones sent out to the rest of the pipeline have those rigging techniques and tools directly applied. This is a perfectly valid method of rigging, but I have found it can cause a number of headaches and issues. Things like flipping joints, double transforms (in which a manipulated object moves double the amount it is intended to), and errors on exporting are common problems when using this method.

FIG 5-1 The flow of data between our multi-layered rigging approach.

By splitting the rigging process into various stages, or layers, it enables you to focus your attention on one thing and one layer at a time. As long as you keep

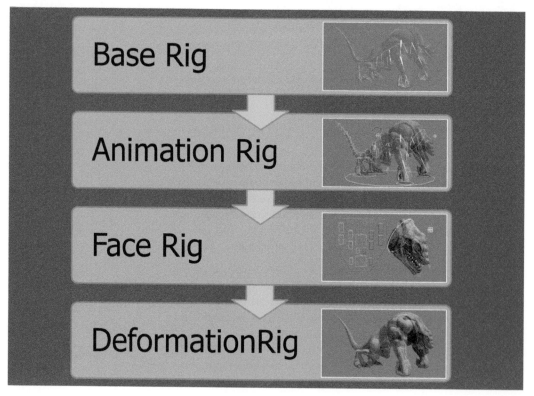

in mind that each layer acts in a "hierarchical" type structure, and that only the children, but not the parent, will be affected, a lot of your problems can be solved. Kind of a one-way data flow!

Whoa, hold up a second! Reading into the above chart, the base rig layer affects the animation rig layer, the animation rig layer affects the face rig layer, and the face rig layer affects the deformation rig layer. Leaving the deformation rig layer to go to rendering and final output… that seems to give us another problem: how do you drive the base rig layer with all of the other layers in the system?

We have a number of different options available, and they differ depending on what layer of the system you want to link back to the base rig layer. Do not worry about this too much right now, as we take a look at these connections as we work through the various layers of the creature rig.

FIG 5-2 Specific handling of data that needs to flow back to the base rig layer can be handled in a number of different ways. We deal with them as they arise.

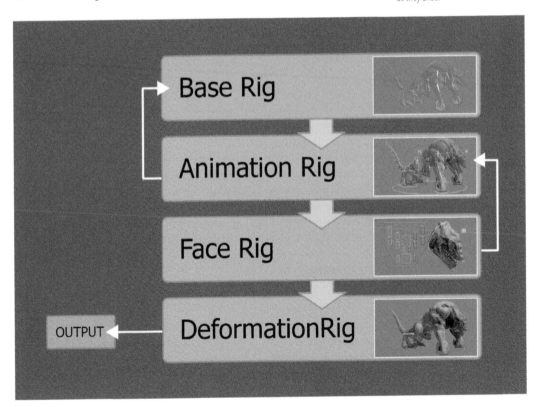

The Setup

Our base rig contains both the basic flesh-surface deformation and a single hierarchy skeletal structure for the creature.

This single skeletal structure is perfect for sending to various systems, of which could be real-time video game engines, blend tree programs, or even

crowd simulation applications. However, our animation rig will use broken hierarchies to drive the base skeletal structure.

Broken Hierarchies

A "broken hierarchy" is a way of describing a rig with a hierarchical structure not directly linked together. By having a broken hierarchy, it allows us to concentrate on specific sections of a rig by breaking the rig down into various areas. In turn, this allows independent control over those separate areas and sections.

FIG 5-3 An "unbroken" hierarchy compared to a "broken" hierarchy.

This can be a confusing concept to understand at first, and it does increase the complexity of the rig creation; however, the benefits of a broken hierarchy compared to an "unbroken" hierarchy (or single hierarchy) are substantial enough that it is common practice. Once the rig is complete, we can restructure everything so the broken hierarchy sits under one main hierarchy. This can give the impression of an unbroken hierarchy, but what we have actually done is tidy away our broken hierarchy into a more manageable structure.

We do this for a number of reasons, such as being able to concentrate and focus on specific sections of the creature, create modular components that can make up the final animation rig, and allow for an additional control system that may not be available should we try to keep this in one hierarchy.

Actually, as I worked through the creation of the base skeleton for Belraus, I kept each joint chain as a separate section, stage, or module even then. For instance, I started out by creating the hip joints. Then I moved on to the spinal column and created a separate joint chain for the chest, neck, head, and so on. It was only at the end of this joint placement process that I actually linked all of the joints together to place them into a single hierarchical structure.

Skeletal Duplication

The easiest and best way to make sure the animation rig joints match the base rig joints perfectly is simply to duplicate them. Make sure to add any duplicated bones to the "rig" layer and for clarity, and remove any "Edit Poly" and "Mirror" modifiers that may be attached to them. We only need to simulate the mass of the creature on the base rig layer, not the animation rig layer.

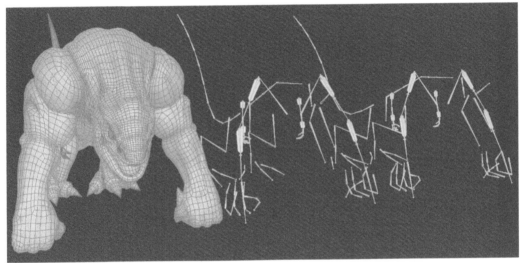

FIG 5-4 Duplication of the base rig joints allows us to get a perfect match for starting out on the animation rig joint system.

Make sure this new skeletal structure sits in its own hierarchy, and it is a good idea to rename all of these joints now so there are no name clashes.

Hip

The hip of the creature is very important, as it is not only one of the main section of the creature, but it is also our defined center of gravity (COG) area. As important as this area of the creature is, there is no special setup for the hip rig, just a simple case of getting the controller to manipulate the joints.

Hip Setup

1. Start by unlinking the hip joint and any bones attached to the hip joint so it sits in its own hierarchy.
2. The controller for the hip needs to have its pivot aligned in position, but not in rotation. Use the "Hierarchy Tab" and the "Affect Pivot Only" button in conjunction with the "Quick Align" tool to align the pivot position of the controller to the hip joint.

3. Make sure the orientation alignment of the hip controller is set to world space by using the "Align to World" button.

FIG 5-5 An unlinked hip joint and controller with the correct pivot position and orientation.

4. With the controller's pivot in place, freeze its transformations.
5. You can either link the hip joint to the controller or use the "Animation" menu to add a "Position" and "Orientation" constraint from the hip to the hip controller. If you decide to use constraints, should any of the bones rotate or flip, simply check the "Keep Initial Offset" button to correct this.
 Animation Menu > Constraints > Position Constraint
 Animation Menu > Constraints > Orientation Constraint

I know I don't really have to say this, but, after you have finished the setup, be sure to check the naming of your controller if you have not already done so.

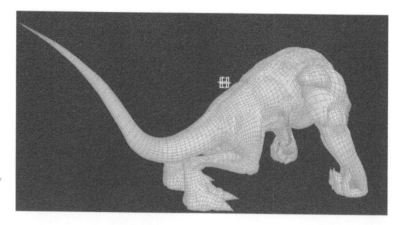

FIG 5-6 The hip rig is a simple, clean, and neat setup that takes no time at all.

Chest

The chest control is extremely similar to the hip control system we just created.

Chest Setup

1. Once again, start by unlinking the chest joints from the rest of the hierarchy.
2. The chest controller needs aligned to the pivot of the chest joint keeping the orientation in world space.
3. Freeze the controller's transformations.
 Alt + Right-Click > Freeze Transform
4. Choose if you want to link or use constraints to allow the chest joint to follow the chest controller.

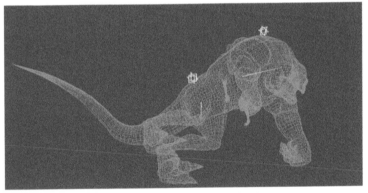

FIG 5-7 The chest control and setup is pretty much identical to that of the hips.

Spine

The spinal column is a big section of the creature and is a place that takes a lot of punishment as it needs to be manipulated regularly. This means the spine rig requires a lot of control, as well as is robust enough to support the rest of the rig.

There are always a number of options and techniques you have to choose from when you rig something. Spine rigging, in particular, has a number of commonly used options to consider when it comes to creating the spine rig.

The first "built-in" control option is a simple forward kinematics (FK) system, and this could be all you need for this spine rig section.

FK Spine Setup

This technique can be used for any sort of FK setup, not just the spine.

1. Create a five-bone joint chain in the left viewport.
2. Create and align some controllers to each of the controllable joints.
3. Link the controllers into a single hierarchy.
4. Use the "Orientation" constraint so the joints are affected by the controllers.

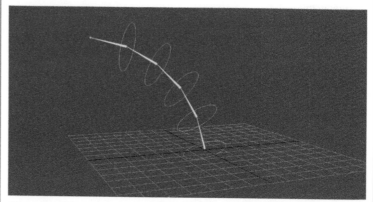

FIG 5-8 A simple FK spine. Sometimes the most basic setups can be exactly what is needed for production.

This easy-to-create setup is intuitive but greatly limits control of the spine, which means it can limit your animators if they expect more control.

A second choice could be to use a straight forward inverse kinematics (IK) system, which is also readily available from 3ds Max.

IK Spine Setup

This technique can be used for any sort of IK setup, not just the spine.

1. Create a five-bone joint chain in the left viewport that has a slight bend (the slight bend is required to give the IK solver an angle to reference for the bending).
2. Create an IK chain that runs from the first bone to the end bone. Animation Menu > IK Solvers > HI Solver
3. You can now control the spine by manipulating the IK handle.
4. To twist the bending of the bones, use the "Swivel Angle" option found under the "IK Solver Properties" rollout on the IK handle.

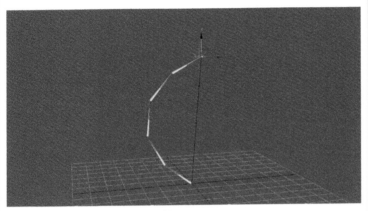

FIG 5-9 An IK spine setup is just as easy as an FK spine rig.

If your spine joints are curved, this method should be perfectly fine, assuming your animators are happy with it of course. However, if you have created your spine joints in a straight line, like I have with Belraus, then this setup method will not work at all. Actually, try it. Create a joint chain that is perfectly straight, and attach IK to it. Notice that you can move the IK handle around and the joints will follow, but you are unable to get that chain to bend.

A third and, once again, built-in option for the spine rig is the spline inverse kinematics (SplineIK) system.

Spline IK Setup

Again, this is a generic spline IK setup and has multiple uses.

1. Create a five-bone joint chain in the left viewport.
2. Create a line with vertices placed at each joint.
3. Create a spline IK system that runs from the first joint to the last joint and uses the line you have just created.
 Animation Menu > IK Solvers > SplineIK Solver

Notice that for every vertex created on the line, you now have a Point Helper cube that allows you to manipulate the joint chain by position and rotation.

To twist the joints, simply grab the spline IK solver goal and edit the "Twist Start Angle" and the "Twist End Angle" options found under "IK Solver Properties."

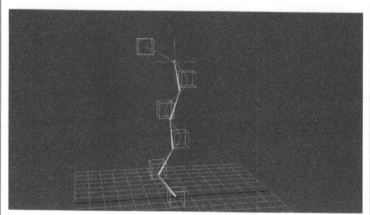

FIG 5-10 The spline IK rig takes a bit more time and is a little more complicated than an FK or IK rig, but it has a few more benefits when it comes to animating.

This setup is extremely valid for a lot of spine rigs. This technique, in particular, has a number of desirable benefits; in fact, it is one of the most common systems I have seen used in spine rigs in all 3D applications. Having said that, it is still not without its problems and its main issue is the difficulty in controlling the joint twisting.

OK, so what else do we have? Well, combining the methods provided is possible and by doing this, can give us great spine rigs with the benefits of the various setups. Alternatively, we could just create our own custom spline IK system, and that is exactly what I do for Belraus.

Although a custom spline IK system requires a little more time to setup, it provides greater control over the manipulation of the spinal column. Additionally, it allows us to create a "stretchy" joint chain used for real-time engines and non-real-time rendering by using positional information rather than the typical scale values. So, if you are using a system that does not support non-uniform scaling of any kind, this custom system allows you to get that squashing and stretching you may need. Belraus is a realistic creature, but, even so, the ability to stretch his spine can be a welcome addition when animating.

Custom Spline IK Setup

This custom spline IK solution can be used for more than just a spine rig, but, for a spine rig, it works pretty nicely.

1. Create a four-bone joint chain.
2. Create a line with three vertices: one at the beginning of the joint chain, one in the middle, and the last placed at the end of the joint chain.

FIG 5-11 A custom spline IK system starts its creation process very similarly to that of a generic spline IK setup.

3. Create a Point Helper.
4. "Path" constraint that Point Helper to the line.
 Animation Menu > Constraints > Path Constraint

5. Remove the animation automatically assigned to the "& Along Path" attribute.
6. Turn on the "Follow" attribute.
7. Duplicate that Point Helper four times, and position them evenly along the percentage of the line. In our case, this is at 25% intervals until we reach 100%.

FIG 5-12 Point Helpers Path constrained to the line and positioned at 25% intervals.

8. Add a "Spline IK Control" modifier to the line.
9. Change the "Link Types" to "No Linking."
10. Click the "Create Helpers" button. These newly created Point Helpers give direct control over the line at the exact positions we created each vertex. By manipulating the line this way, the Point Helpers that have a Path constraint attached come along for free.

FIG 5-13 The "Spline IK Control" modifier gives Point Helpers that allow us manipulate the line, bringing our constrained Point Helpers along as well.

11. Position constraint each bone to its closest constrained Point Helper.
12. The bones now follow along with the constrained Point Helpers but do not point in the correct direction. To fix this, add a "LookAt" constraint that focuses on the next Point Helper down the chain.

FIG 5-14 Position constraints and LookAt constraints need to be in place to keep the bones following along correctly.

13. For each bone's "LookAt" constraint, change the "Upnode Control" to "LookAt," rather than "Axis Alignment." Oh, leave out the end bone, however, as this one does not need to point anywhere.
14. What we have now is a custom spline IK system that allows for joint stretching by using positional information rather than scaling. At the moment, we have no way of controlling the twisting axis of these joints, and, to do this, we need to give those "LookAt" constraints and "Upnode," something other than the "World," as a target. So, duplicate the line, and move it back away from the joint chain.
15. Remove the "Spline IK Control" modifier this line has inherited.
16. Repeat the process for creating Path constrained Point Helpers for this line.
17. Add a new "Spline IK Control" and use the same options as the first line created in this setup (No Linking).
18. Link the Spline IK Control Point Helpers to their friends we created on the first line.

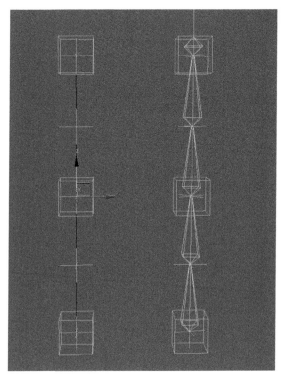

FIG 5-15 A duplicate line setup needs to sit away from the joint chain, as this is used to control the Upnodes of the LookAt constraints applied to the bones.

19. Set the Upnodes of each joint to the constrained Point Helper parallel to it on the new line.

FIG 5-16 A custom spline IK system with custom Upnodes.

149

This completes the custom spline IK setup. Manipulation of the "Upnode" components is not recommended, and controlling the spine can be done by moving and rotating the Spline IK Control Point Helpers created on the first line.

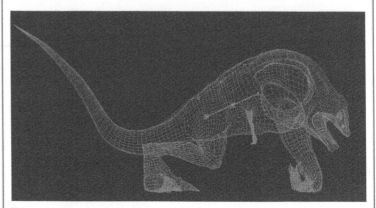

FIG 5-17 A custom spline IK system is a lot more difficult to setup correctly, but gives the animators a lot more freedom and control when animating.

If all of that was not enough, we can add to this custom spline IK setup by creating additional FK controls. For a creature like Belraus, this is very much an optional step; however, on more biped-like creatures, adding this sort of control can really enhance a spine rig and take it to a new level of awesome! Oh, and its really simple to do too!

Adding FK Control to a Custom Spline IK Setup

1. Create a four-bone custom Spline IK solution.
2. Create two Point Helpers: one positioned at the base of the joint chain, the second positioned at the most central joint.
3. Link the central Point Helper to the base Point Helper.
4. It is now a simple case of linking the first Spline IK Control Helper to the base Point Helper, and the other two Spline IK Control Helpers to the central Point Helper.

We now have FK-like control, as well as the custom spline IK control we had previously. Should you have more joints and spline IK controllers, it is a simple case of creating more FK Point Helpers and linking everything together correctly.

FIG 5-18 A custom spline IK system with additional FK controls can make your rig excel.

Belraus will get a custom spline IK system applied to the spinal column. Although the FK control is not needed for this creature, I add it anyway, as it does not take too long to setup and include at this stage.

The chest and hip sections of this creature affect the upper and lower spinal column movement. Because of this, I incorporate the appropriate controllers into the spine setup.

FIG 5-19 The chest and hips affect the upper and lower sections of the spinal column.

I have kept each of the controllers independent of one another, with the exception that when the spine control is rotated, the chest control (and area) comes along for free. This is done by some simple linking and constraints using another locator positioned at the chest joint. Nothing fancy or exciting, but this gives enough additional control that it makes a big difference to how this spine feels when animated.

FIG 5-20 The hip, spine, and chest controllers all behave independently of one another, with the exception of the spine controllers rotation, which also affects the chest control and chest area.

Neck and Head

The neck and head rig for Belraus is nearly identical to the spine and chest system we just built. This creature has a very small neck, so I use less joints than in the spine but keep this as a stretchy area, as it can help animation a great deal should the neck need to be manipulated into some extreme positions. I use the custom spline IK system we just covered for the spinal column, but I do not be include the additional FK control, as it will not be needed for this section of the creature.

Linking everything correctly is as important as ever, after all, we do not want the head and neck left behind as the shoulders move.

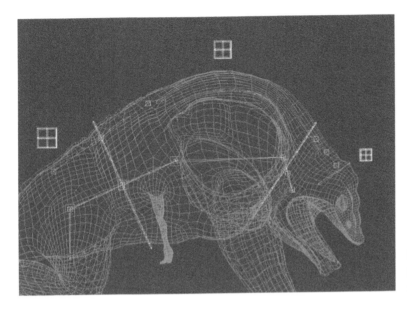

FIG 5-21 The neck rig uses the exact same system as the spine but does not include the additional FK control.

Tail

Belraus uses a simple FK system, but adding an IK, Spline IK, or custom Spline IK system is totally viable, just as it is for the spine rig.

FK Tail Rig Setup

This is a very simple setup and just requires controllers to be aligned by position and orientation to each of the tail joints. From there, it is a case of linking the controllers together and constraining the joints to the controllers. Nothing fancy here, move along!

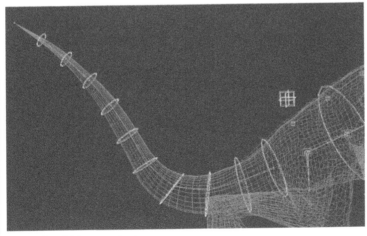

FIG 5-22 The tail rig is very easy to setup.

Alternatively, a dynamic system could be set up to drive the tail motion. In fact, a dynamic system combined with an animator-control system (FK, IK, Spline IK, or custom Spline IK) could also be an option. We cover dynamic setups in Chapter 8, and these principles can be applied to the tail rig if you so desire.

Limbs

The Belraus creature has a number of challenges we need to complete to create the animation rig. Our research and development stage has already allowed us to highlight the sort of controls needed for the limbs of Belraus, which solves the question of "what"; we just have to work out the "how."

The upper arms and legs of the creature will be IK only, and the smaller arms will be FK only. This decision caters for the animation production needed for Belraus, but your production may be completely different. In fact, a common requirement of some rigs is to have the option to switch between a FK and IK solution on the same limb. Should you need to set this up, you can rely on one of two options that can be built and set up directly from 3ds Max.

The Built-in FK/IK Switching System

The built-in FK/IK system is usually overlooked by most riggers, and rightly so. Previously, this has been an unreliable system that used to break, or just not perform as it should do. More recently, the built-in system is a lot more robust, and I have found that it can work, as long as you work with it and not against it. It requires a certain way of animating, and, if you decide to go against that, you will have an unwieldy beast. Work with the system, though, and you will have an IK/FK system you can rely on. Of course, it is not without its problems. For instance, snapping between IK and FK is just fine, but there is no blending between IK and FK over frames. This could be a deal breaker for some animators.

1. Create a two-bone joint chain in the left viewport.
2. Add an IK chain from the start joint to the end joint.
 Animation Menu > IK Solvers > HI Solver
3. Select the IK handle, and turn on Auto Key.
4. Animate the IK Solver.
5. Head over to the Motion Panel, and turn off the "Enabled" option in the IK Solver rollout.

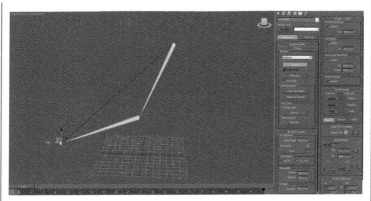

FIG 5-23 The Motion Panel contains plenty of options for your IK Solver. Be sure to check them out!

6. Now, move forward in the timeline, and animate the joints directly by rotation (FK).
7. Switch the "Enable" button back on when you want to move back to IK mode.

Just as a side note, adding a pole vector into this equation can sometimes give animators "popping" problems. If this is the case, spend some time with the animators and show them how this system works. Sometimes, it is as easy as clicking the "IK/FK Snap" button to fix the problem.

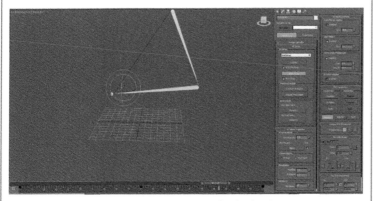

FIG 5-24 The "IK/FK Snap" button can sort out popping issues if used at the right time.

Blending Between FK and IK Solutions

This is probably the most common method of creating an IK/FK limb that is sturdy, robust, and just plain works. It requires a little bit of time to setup but rewards you with an IK/FK blending system you can trust and rely on. The blending system takes three separate joint chains: one for the FK, one

for the IK, and a final joint chain that can "blend" between the FK and IK systems.

1. Create a two-bone joint chain in the left viewport.
2. Duplicate this joint chain twice. This gives you three separate joint chains: one for the FK, one for the IK, and one used to blend between the two. Make a note of these (or color them differently) so you know which one is which.

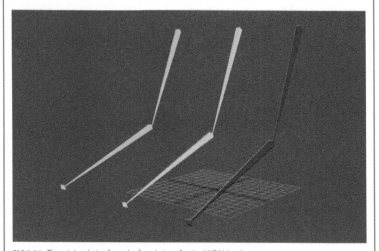

FIG 5-25 Three joint chains form the foundations for the IK/FK blending setup.

3. The FK arm is ready as we are able to rotate the joints. You could attach controllers to these FK joints if you wish.
4. The IK chain needs IK. So, create a HI Solver that runs from the first joint to the end.
 Animation Menu > IK Solvers > HI Solver
5. Your FK and IK joint chains are now setup, and you can focus your attention on the final joint chain used to blend between the FK and IK joint chains. Orientate constrain the first blend chain joint to the FK joint, then add the IK joint as another target
6. Do the same for the lower blend joint by adding an orientation constraint to it, targeting both the lower FK and IK joints.

The FK/IK blend is now complete. By rotating the FK joints or manipulating the IK handle, you see your blend joints staying in the center of these two setups. The blending from one to another can be controlled by changing the constraints weighting parameters. To allow the animator easy access, you need to add a custom attribute that controls these weighting values.

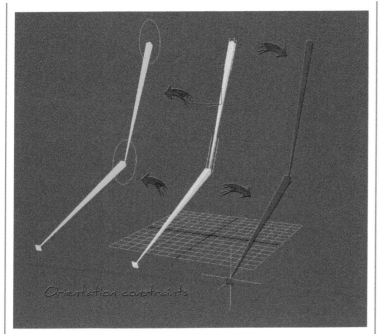

FIG 5-26 Orientation constrain the blend chain joints to the FK and IK joints.

Both sets of arms for Belraus require a twisting solution so we can combat the "candy wrapper" effect sometimes noticeable when rotating joints around their twisting axis. We can rely on a number of different methods to set these twist joints up, but I prefer to drive the rotations of those twist joints by using "Wire Parameters" tools.

Working with Wire Parameters

Wire Parameters allow one standard or custom attribute to be directly connected to another standard or custom attribute, either on the same object or on an entirely different object.

1. Create a Sphere and a Box in the perspective viewport.
2. Select the Sphere.
3. Right-click and choose "Wire Parameters…."
4. A popup menu now appears where you can choose what attribute you want to wire from the Sphere's parameters. Choose "Z Position."
 Wire Parameter Dialog > Transform > Position > Z Position

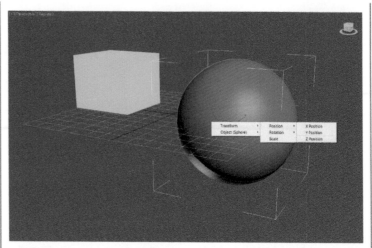

FIG 5-27 Wire Parameters dialog for the Sphere.

5. A dotted line now appears as you move the cursor around the screen. Move over to the Box and left-click.

6. Another new popup menu appears where you can choose an attribute you want to wire, or connect, from the Box. Choose "X Rotation."

 Wire Parameter Dialog > Transform > Rotation > X Rotation

7. A dialog box now displays where you are able to choose the direction of control between the two selected parameters/attributes from the Sphere and the Box. Choose the dual arrow, which allows for one attribute to affect the other. The tooltip reads "Two-way connection" if you hover the mouse over the button.

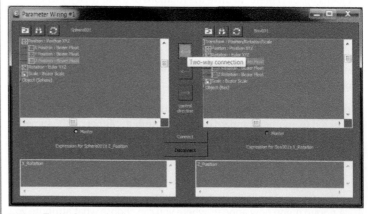

FIG 5-28 The Wire Parameters dialog box allows you to make connections one way or the other, and even both ways. Neat!

8. Click "Connect."

With this connection in place, the position Z of the Sphere affects the rotation X of the Box and vice versa. The bottom section of the Parameter Wire dialog allows you to enter some basic mathematics to affect this relationship. For instance, you could multiply or divide the X Rotation of the Box to either speed up or slow down the rotation. Experimentation is key here to find exactly what is possible when wiring parameters.

Upper Arms

Belraus requires a simple inverse kinematics (IK) chain that controls the movement for the upper arms.

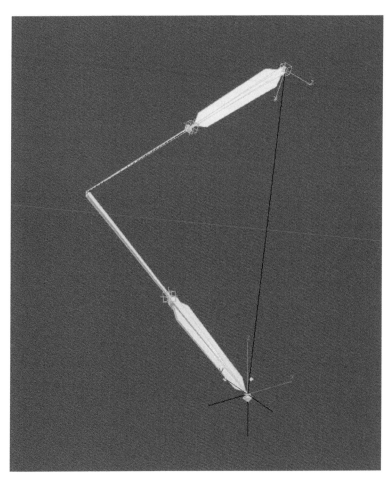

FIG 5-29 The IK chain for the upper arms of Belraus is extremely simple to setup.

This IK chain needs linked to the hand controller so it follows along with the setup correctly.

With an IK chain in place and linked correctly, we need access to the swivel angle that dictates the direction in which the joints bend. We have two main options when it comes to giving access to the swivel angle, and it is down to animator preference as to which option we will choose.

Option 1: We can give the animator direct control to the "Swivel Angle" attribute found on the IK chain via a custom attribute added to our controllers.

Swivel Angle Setup

The swivel angle on an IK chain can be directly controlled by manipulating the "Swivel Angle" parameter found in the Motion Panel. However, the animators should not have to search for this parameter, and you can give them a custom attribute on a controller that can directly manipulate that more "hidden" Swivel Angle parameter. Connecting the two could not be easier. Just wire those parameters, and you are good to go!

1. Create a two-bone joint chain in the left viewport.
2. Create an IK chain from the first joint to the end joint.
3. Create a Point Helper, and position it at the IK goal. This Point Helper is used as your main controller for both the IK and the Swivel Angle attribute.
4. Link the IK chain to the Point Helper.
5. Add a custom attribute to the Point Helper, and call it "Knee." Make sure the "Range" runs from "–100" to "100."

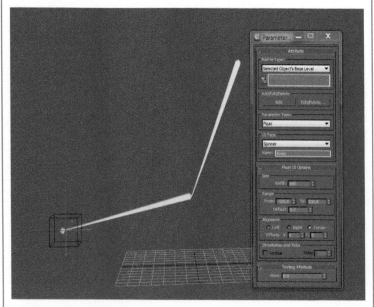

FIG 5-30 Add a custom attribute to the Point Helper so you have an attribute you can directly wire to the IK's Swivel Angle.

6. Wire the IK's Swivel Angle attribute to the Point Helper's "Knee" attribute with a "Two-way connection."

Option 2: By using an additional controller, we can assign a "pole vector" control that gives the animator direct manipulation over which angle/ direction the joints bend toward.

Pole Vector Setup

A pole vector is simply another controller that gives the animator an interface that directly accesses and manipulates the bending angle, or swivel angle of the IK chain.

1. Create a two-bone joint chain in the left viewport that has an IK chain running from the first joint to the last joint.
2. Create a Point Helper, and position it in front of the central joint.
3. Select the IK goal.
4. In the Motion Panel under the "IK Solver Properties" rollout, edit the "Pick Target" attribute by clicking the "None" button.

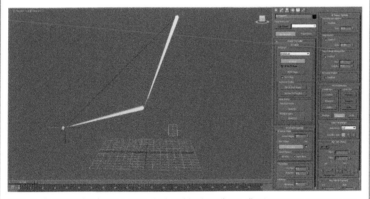

FIG 5-31 The Motion Panel gives access to the Swivel Angle attributes, allowing you to use a target as an alternative to the float controller.

5. With the "None" button clicked and toggled, select the Point Helper you just created.
6. The "None" button is now toggled off, and the name of the Point Helper is in its place. This confirms that the Point Helper now controls the Swivel Angle attribute.

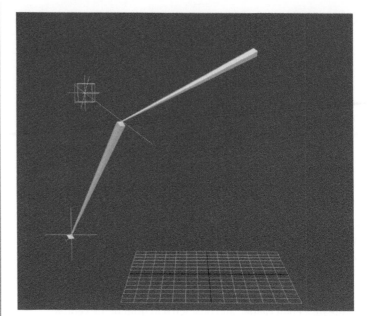

FIG 5-32 Confirm that the Point Helper now controls the Swivel Angle attribute by moving the Point Helper around.

You may notice the joints snap or twist to face the angle of your newly created pole vector controller. In fact, recreate the setup, but place the Point Helper off to the side from the bend of the joints. When you apply this Point Helper

FIG 5-33 Using a pole vector to control the Swivel Angle attribute can cause "popping" or "snapping" during initial setup.

as the target for the swivel angle, you will notice a definite "snap" as the joints realign themselves.

This is not very desirable when trying to keep the creature in its default pose. To combat this, we can set the pole vector up in a very specific way that will eliminate the snap or twist.

No-Snap/Pop Pole Vector Setup

1. Create a two-bone joint chain in the left viewport that has an IK chain running from the first joint to the last joint.
2. Create a Point Helper, and position constrain it between the first and last joints of the bone chain.
3. Add a LookAt constraint to the Point Helper that points toward the central joint (the one with the bend in it).

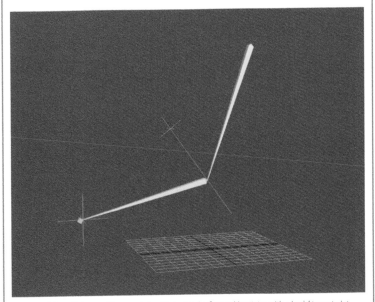

FIG 5-34 A Point Helper position constrained between the first and last joint with a LookAt constraint pointing to the central joint.

4. Create a new Point Helper, and align it to the constrained Point Helper in both position and orientation via its pivot.
5. Move this new Point Helper in its local X axis so it sits away from the bent joints (the local X axis is used as a default for the LookAt constraint).

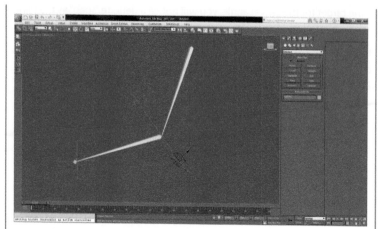

FIG 5-35 Move the aligned Point Helper in its local X axis away from the bent joints.

6. You can now delete the constrained Point Helper.
7. With only one Point Helper left, you can use that as the pole vector, so head over to the Motion Panel, and use it as the swivel angle's target.

FIG 5-36 A pole vector setup that did not pop/snap!

The next obstacle for the arm rig is to incorporate into the setup the twist joints created earlier to actually twist, as well as follow along with the arm.

As with everything, there are a number of options we can take when it comes to creating twist joints. Everything from using a Reaction to a LookAt constraint is possible; it is sort of a "take your pick" situation. If it works, it

FIG 5-37 Belraus uses Option 2, which gives the animator direct access to a pole vector control that manipulates the swivel angle.

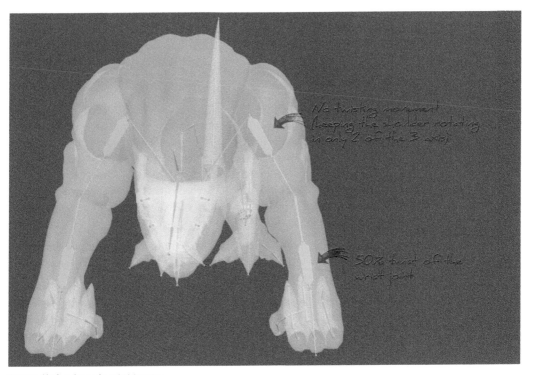

FIG 5-38 My thoughts on the twist joint setup.

works! For the Belraus creature, I opt for using Wire Parameters to simply control the X (twisting axis) rotation of the twist joints in relation to the controllers the arm has.

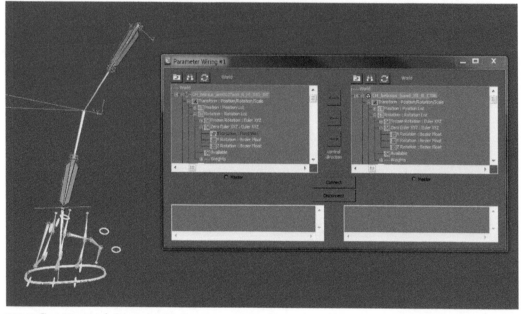

FIG 5-39 The twisting joints for Belraus rely on Wire Parameters to control the X (twisting) axis of the twist joint the creature has in place.

I would be pretty happy working with an arm setup similar to what we have already. In terms of functionality, it is all there for us to work with. With Belraus being a "realistic" creature, we do not have to worry too much about stretchy limbs; however, similar to the spine system, having stretch available on this rig can be pretty helpful. Although the spine system created earlier can be used for stretchy limbs, I prefer another method that requires us to rely on some basic mathematics.

By no means is this any kind of rocket science, and, as I am no mathematician, I find the following diagram can really help explain what is going on when we create this stretchy limb system.

Hopefully, that helps you wrap your head around how this system works. As you can see, we are once again using a positional method to simulate the stretching, rather than using scale. Again, this keeps the stretching technique consistent, as well as allows us to use this rig for a number of applications, such as a real-time game engine or crowd simulation software that may not necessarily allow for non-uniform scaling.

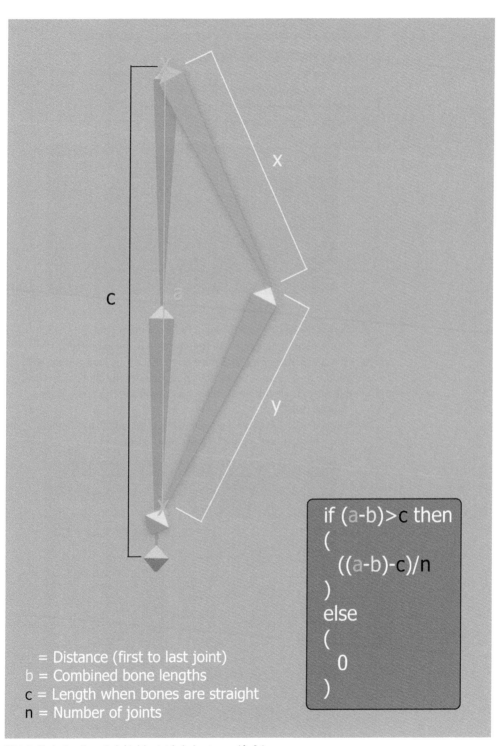

if (a-b)>c then
(
 ((a-b)-c)/n
)
else
(
 0
)

= Distance (first to last joint)
b = Combined bone lengths
c = Length when bones are straight
n = Number of joints

FIG 5-40 The basic mathematics behind the stretchy limb system used for Belraus.

Creating a Position-Based Stretchy Limb (Join Chain)

1. Create a two-bone joint chain in the left viewport.
2. Create a Point Helper, and align this to the first joint.
3. Link the first joint to the Point Helper.
4. Add an IK chain from the first to the last joint.
5. Create an "ExposeTM" node.

FIG 5-41 The ExposeTM helper.

6. Expose the length from the Point Helper to the IK goal.
7. Freeze transformations on all stretch bones in the joint chain.
8. Now add a mathematical expression to the second joint and the end joint so they move in their local X position once the joint chain is over-extended. To do this, select the second joint, and head over to the "Motion Panel."
9. Under the "Assign Controller" rollout in the "Motion Panel," find the zero X Position, and assign a "Float Script" controller to it.

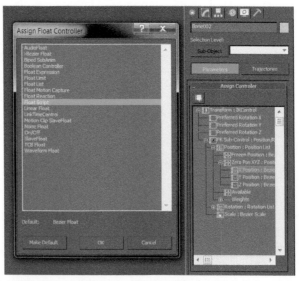

FIG 5-42 Add a Float Script controller to the zero X Position of the second joint in the bone chain.

10. In the new Script Controller window, create three variables:
 a) Constant – This is used to store the original/default length of the joints before stretching. It is worth noting that adding a zero (0) value here can make this script work if you are having problems. Adding the zero (0) value to this variable effectively eliminates it from the calculation.
 b) Distance – Here you assign the Distance parameter of the ExposeTM helper you created earlier.
 c) Straight – This is used to store the length of the joint chain when fully extended, before stretching.
11. Select the "Constant" variable, and use the "Assign Constant" button to assign the original/default length or a zero (0) value to it. Remember to "Evaluate" and then click the "OK" button to apply this value.
12. Select the "Distance" variable, and use the "Assign Track" button to assign the "Distance" attribute of the ExposeTM helper. You have to find this attribute in the dialog window that pops up.

FIG 5-43 Find the "Distance" attribute, and add that to the "Distance" variable you have setup by using the "Assign Track" button.

13. For the "Straight" variable, you need to get the distance at which you want the stretching to start. A simple way to do this is to select the ExposeTM helper and head over to the Modify Panel. Once there, pin this stack so you can continue to see it once you select something else.
14. Select the IK goal, and move it to extend the joints. Find the point at which you would like the joint chain to start stretching, and make note of the "Distance To Reference" parameter on the pinned ExposeTM stack.
15. Reposition the IK goal back to its default position.
16. Select the "Straight" variable in the Script Controller dialogue, and assign the "Distance To Reference" attribute length you just made note of as a "Constant." Remember to "Evaluate," and then click the "OK" button to assign this correctly.

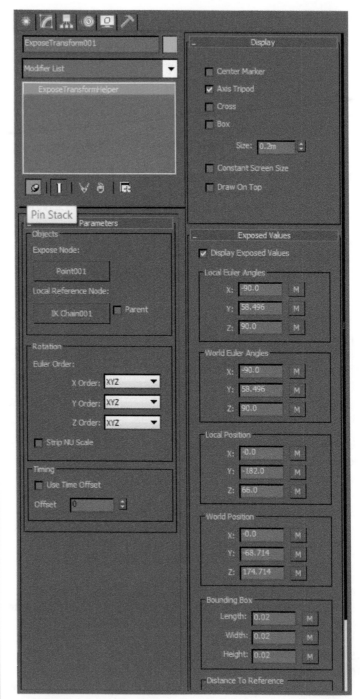

FIG 5-44 Pin the ExposeTM stack by using the "Pin Stack" button. This allows you to keep viewing this stack, even if you select something else in the scene.

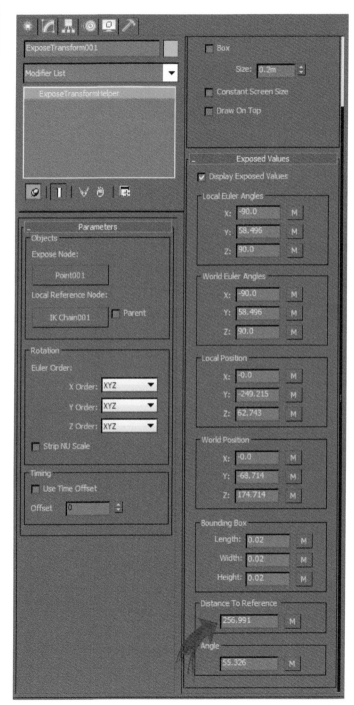

FIG 5-45 Make note of the "Distance To Reference" attribute on the pinned ExposeTM stack. This is the value at which you want the joints to start stretching.

17. Now that you have all your variables in place, create your expression in the "Expression" area. Use this expression to enable joint stretching:

```
if (Distance-Constant) > Straight then
(
    ((Distance-Constant)-Straight)/2
)
else
(
    0
)
```

18. Enter a description if you wish, and then click the "Evaluate" button.

By moving the IK goal, you notice that you have some stretching but the IK goal moves away from the end joint. To combat this, repeat steps 8–18 on the end joint. Once this has been completed, you have a stretching joint chain that behaves as expected.

FIG 5-46 Repeat these steps on the end bone so the arm stretches correctly.

With the stretching arms setup correctly on Belraus, I have to deal with the twist joints that are not in the stretching equation just yet. To get these to stretch correctly with the arm, it is a simple case of using a Point Helper that is position constrained to correctly sit in the center of each stretching bone. I can then use that as a location to constrain or link the twist joints to.

That pretty much covers it for the arm setup. It is now just a case of linking everything together correctly so the clavicle affects the arm joint.

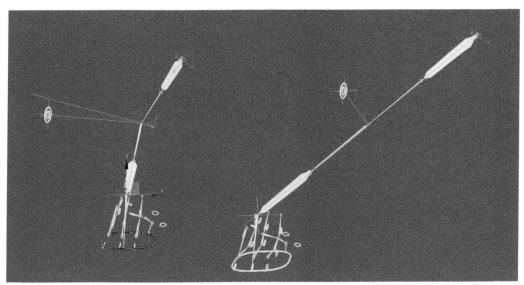

FIG 5-47 The twist joints use a Point Helper position constrained to sit in the middle of each bone. These Point Helpers act as a reference point so you can either position constrain or link the twist joints to so they follow and stretch correctly with the stretching arm solution.

Upper Arm Hands

The hands of the creature simply need to follow along with the hand control.

The fingers come along for free because of how they are linked in the hierarchy, but we, once again, can approach the control of each finger from a number of different angles.

Using inverse kinematics (IK) for this creature's hands would not be beneficial, so let us move quickly on.

We can choose to keep things nice and simple by using forward kinematics (FK) and some controllers. This method is completely valid and would provide a good interface for the animator.

Custom attributes in conjunction with the Reaction Manager to drive the joint rotation for each finger is another valid option we have.

Reaction Manager

1. Create two Point Helpers, and move them apart in the perspective viewport so they are easy to see.
2. Open the Reaction Manager.
 Animation Menu > Reaction Manager…
3. The Reaction manager rollout contains all of the Reaction Manager options available. Click the "Add Master" (the first plus symbol) button and select one of the Point Helpers.

FIG 5-48 The Reaction Manager window can be a little daunting. I am not a big fan of the UI or layout for this tool, but, hey, it gets the job done.

4. Just like the Wire Parameters tool, a pop-up appears over the selected Point Helper. Choose an attribute; I am going for the Z position.
 Reaction Manager Menu > Transform > Position > Z Position
5. You can now see that, in the Reactions list area, the Point Helper and its selected attribute have been added. Now you must add a slave, so, in the viewport, select the other Point Helper.
6. Click the "Add Selected" button in the Reaction Manager.
7. Select an attribute once more; I am going to select the Y position this time.
 Reaction Manager Menu > Transform > Position > Y Position

FIG 5-49 Adding a slave to the Reaction Manger is a lot easier using the "Add Selected" button, rather than the "Add Slave" button in my opinion.

A few things have now happened in the Reaction Manager window. First, the second Point Helper and its selected attribute have been added in the Reactions list under the first Point Helper. This shows you that the first Point Helper is the "driver," or "master" of the second Point Helper, which has become the "passenger" or "slave." In the States area of the UI, a new state has been created. It is these various states that dictate the reaction that will happen. Annoyingly, a new state is created for each slave added to the Reaction Manager, and I usually remove these computer-created states as soon as they are created. Why does 3ds Max add these states? I really have no idea, but I wish it would not!

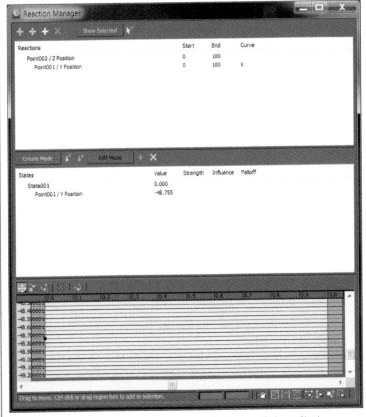

FIG 5-50 These "states" control the reaction that happens to the slaves once the "master" has been manipulated. 3ds Max automatically creates a state for each slave added to the Reaction Manager. . . It annoys me some!

8. For good measure, select the first state created (State001), and click the delete (the lower "X" icon) button to remove it.
9. You can now create your own states. Click the "Create Mode" button.

10. The button next to the "Create Mode" button is the "Create State" button. Click this to create your first and default state.

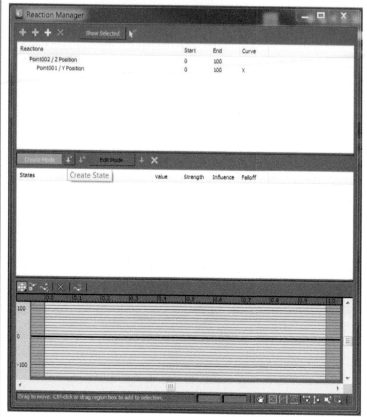

FIG 5-51 Create your own default state.

11. Move the first Point Helper (the "master") in Z and the second Point Helper (the "slave") in Y.
12. This is your second state, so click that "Create State" button again, and notice you now have two states showing in the Reaction Manager.
13. Repeat steps 11 and 12 once more so you have three states in the Reaction Manager (State002, State003, and State004).
14. End "Create Mode" by clicking the button.

You have now created some very specific movement using the Reaction Manager. This is a very powerful tool and can be used to drive a lot of user-defined movements that allow you to enhance your creature rigging. Read the help files, play with this tool, and get comfortable creating and editing various states and reactions.

FIG 5-52 Three states in the Reaction Manager window.

Of course, combining a basic FK setup with the Reaction Manager/Custom Attributes approach could be even better. The main problem found with the Reaction Manager is the fact that any slave's attribute added to the reaction is locked from user control. We can combat this a number of ways, but, when combining controls, reactions, and a skeleton, we can simply add additional Point Helpers into the mix that not only become the "slave" objects, but can also "carry" the controllers so we can have "additive" animation.

Controls and Reaction Manager

Adding controls, as well as reactions, to specific areas of your creature can really enhance the animation experience for those using the rig. The trick is all about the linking and constraining of the Point Helpers, joints/bones, and controllers.

FIG 5-53 Correct linking and constraining to enable both a reaction and controller setup with additive animation controls.

This reaction and controller setup is exactly what I have chosen for Belraus, as it is pretty darn practical for animation.

Clavicle

A lot of rigs rely on a simple FK control method, which works just fine. Many also use a single bone IK chain, which works pretty much like the FK control option, but, instead of rotating the controller, the animator can translate the controller.

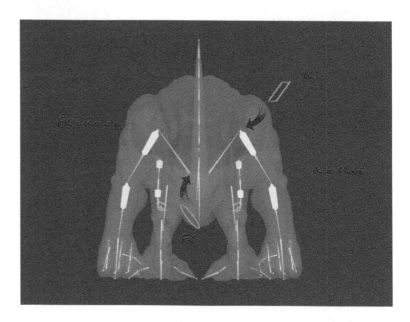

FIG 5-54 FK vs IK clavicle controls.

Both of these options are great, and I have used them a lot in the past; however, for a creature like Belraus, I like to use an auto-clavicle system.

Not only does the auto-clavicle system give the animator a little extra help with the clavicle/shoulder movement, it allows us to "fake" some muscle and skin sliding and deformation without getting into the muscle system and additional deformers.

As with everything in rigging, an auto-clavicle can be setup a number of different ways.

Reaction-Based Auto-Clavicle Setup

By finding the most extreme poses for the arm movement, you can set up a reaction-based auto-clavicle. The Reaction Manager is your friend here, and it allows you to specify exactly how much clavicle motion the creature needs for each extreme arm pose.

1. Create a two-bone joint chain in the left viewport that will represent an arm.
2. In the front viewport, create a single-bone joint chain that will represent the clavicle.
3. Link the upper bone joint of the arm to the clavicle joint.
4. Create an IK chain that runs from the top of the arm to the bottom arm end joint.

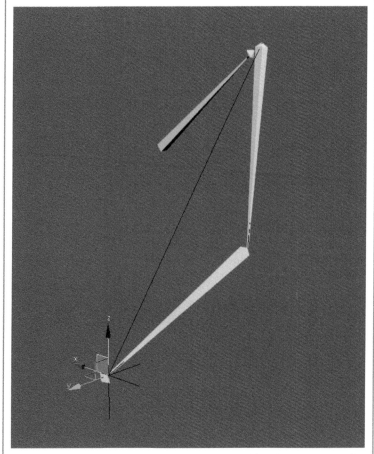

FIG 5-55 The arm and clavicle joints connected correctly, with IK applied from the top to the bottom of the arm.

5. Freeze transformations on the IK goal and the clavicle joint.
 Select Objects > Alt + Right-Click > Freeze Transform
6. Open the Reaction Manager.
 Animation Menu > Reaction Manager…
7. Add the Zero Y Position of the IK goal as a master.
8. Add the Zero Z Position of the IK goal as a master, giving two master reaction controllers for this auto-clavicle setup.

FIG 5-56 We need to have two masters for this reaction to work correctly.

9. Add the Zero Y Rotation of the clavicle joint as a slave for the Zero Y Position IK goal.
10. Add the Zero Z Rotation of the clavicle joint as a slave for the Zero Z Position IK goal.

FIG 5-57 Each master gets its own slave.

11. Remove the default states that have been added for each of the slaves.
12. Work on getting the extreme poses for the arm created with a little animation. Turn on "Auto" key, and animate the IK goal in the following keyframe positions:
 a. 0—Default (set a key in its default position).
 b. 25—Move the arm as far forward as possible.
 c. 50—Move the arm as far backwards as possible.
 d. 75—Move the arm up to its most extreme position.
 e. 100—Move the arm down to its most extreme position.

FIG 5-58 Each keyframe should contain the extreme positions used for the arm movement.

13. Turn off "Auto" key.
14. Enable "Create Mode" in the Reaction manager.
15. Set the Time Slider to frame 0 and create the first state for the Y Position master.
16. Set the Time Slider to frame 25. This should move the arm forward. Rotate the clavicle joint forward to simulate the auto-clavicle motion. Now create the second state for the Y Position master.
17. Set the Time Slider to frame 50, and rotate the clavicle backwards to simulate the backwards motion the auto-clavicle should have. Create the third state for the Y Position master.

FIG 5-59 The three states for the Y Position master of the auto-clavicle.

18. Now, focus on the Z Position master. Move the Time Slider back to 0, and create the first state for the Z Position master.
19. Set the Time Slider to frame 75, and rotate the clavicle up in Z to simulate the auto-clavicle motion for this extreme pose. Create the second state.
20. Set the Time Slider to frame 100, and rotate the clavicle down to the desired position. Create the third state for the Z Position master.

FIG 5-60 The Z Position master states are now in place.

21. Disable "Create Mode" in the Reaction Manager window.
22. Grab the IK goal, and remove the animation applied to it.

That is all there is to it. Move that IK goal around, and check the auto-clavicle motion you have just created.

FIG 5-61 The reaction-based auto-clavicle is now finished. Remember, you can go back at any time and edit the movement properties of the slave (clavicle joint) if you think it does not look right.

Using the reaction manager to control the movement of the auto-clavicle gives us direct control over how much or how little movement we want to have. It is a great system to have in place; the only real problem is that, should we wish to change that pre-defined motion, we have to go back into the Reaction Manager. Although this is not too much of a hassle, it could be a stumbling block for animators who are not comfortable with rigging setups and the Reaction Manager in particular.

IK-Based Auto-Clavicle Setup

This setup relies on an additional IK joint chain that runs from the clavicle to the end of the arm joint to find the correct rotation for the auto-clavicle. This motion is fully automated, and you have the option to give the animators a custom attribute to affect the amount of auto-clavicle movement they want to have during their animation.

1. Create a two-bone joint chain in the left viewport that will represent an arm.
2. In the front viewport, create a single-bone joint chain that will represent the clavicle.
3. Link the upper bone joint of the arm to the clavicle joint.
4. Create a Point Helper, and position it at the end of the arm joint. This will become the controller for this setup.

FIG 5-62 A Point Helper will be used to control the arm and auto-clavicle.

5. Create an IK chain that runs from the top of the arm to the bottom arm end joint.

6. Link the IK to the Point Helper.
7. Create a single-bone joint chain that runs from the clavicle joint to the end of the arm joints.

FIG 5-63 This single-bone joint chain will be the main component for the auto-clavicle.

8. Create an IK chain for this new joint chain.
9. Link the IK to the Point helper.
10. Link the clavicle joint to the single-bone joint chain just created.

The auto-clavicle setup is complete. By moving the Point Helper around, you get free movement from the clavicle joint as it follows along with the additional IK joint created because of its linking. Additionally, you could add in a few Point Helpers with some extra constraints that could allow you to control the amount of auto-clavicle movement you have. At the moment, you have 100% movement because of the way you have linked everything into one hierarchy.

I prefer the IK-based auto-clavicle setup in most cases, because the animator can control about how much the auto-clavicle has effect.

FIG 5-64 Belraus with his IK-based auto-clavicle setup. This creature has the additional controls that allow the rig user to choose how much the auto-clavicle has effect.

Lower Arms

Keeping the smaller arms super simple, they use an FK setup for everything. The twist joints behave a little differently from the bigger arms, but the principles are exactly the same, and we can use whichever method of twist joint setup we want to. We also will not be adding any stretching to these smaller, lower arms, as it should not be needed for this creature's animation.

As for the hands and fingers, well, I am opting to go with standard FK controls. It would be nice to keep the rig consistent and follow the same setup as that of the larger upper hands/fingers, but I just cannot see the need to spend time here when they will not be seen or used as much. In fact, this kind of time management is the sort of thing that happens a lot during a full production, spending time and energy on what will be seen or having more bang for the buck is always the way to go.

FIG 5-65 The smaller lower arms have simple FK controls.

Legs

The legs for a humanoid are often pretty much identical to that of his or her arms. They require a two-bone stretchy limb setup with optional twisting joints, just like what we have done with the large upper arms of Belraus.

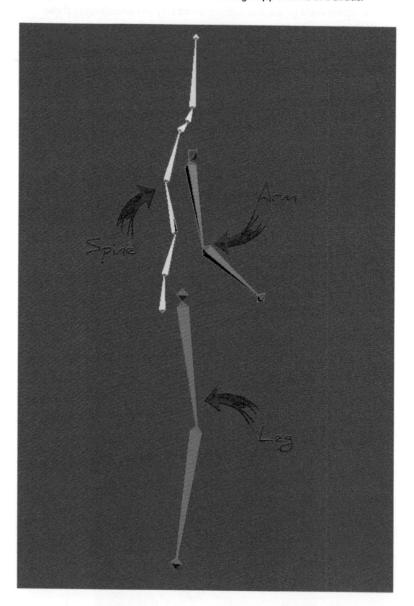

FIG 5-66 The leg rig setups for humanoid characters are often identical to that of their arms.

Quadrupeds, and indeed a lot of creatures, require a completely different approach for their leg setups. For example, a generic quadruped, such as a horse, cat, or dog, has three bones that drive leg bending.

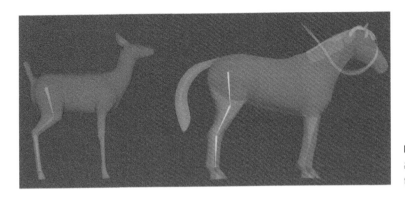

FIG 5-67 Generic quadrupeds, such as a horse, cat, or dog, have a similar three-bone chain rear leg.

To me, this is sort of a spring-type bend, instead of the hinge system we humans have. Most of the bend comes from the lower two bones, but the upper bone inherits some of this movement to help with compression and flexibility. In fact, this type of spring-type leg reminds me of the auto-clavicle solution we created for the upper arms. The lower section should have the most movement, and the upper section can grab a percentage amount of that motion. So, by using the auto-clavicle system, we can actually get some great deformation and control in there.

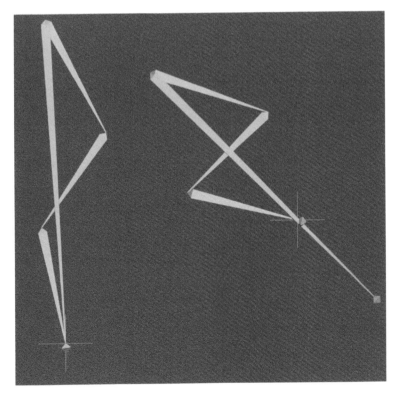

FIG 5-68 Using the auto-clavicle system for these spring-type leg setups gives us great control and allows for some pretty nice deformations too.

187

I like this sort of setup a lot; it is definitely one of my preferred methods for both quickness, ease of use, and deformation. Of course, and I know I keep saying this, there are plenty of ways to actually create a rig, and the legs are no exception. The research and development stage is really the place to experiment with various setups and come up with a solution you are comfortable creating and that the animators will enjoy using.

Belraus has a similar kind of joint placement, so my initial thoughts were that this auto-clavicle system should work just fine, and to some extent it does; however, it is not really giving me the kind of control I have come to expect from a setup like this, and that is due to the length and position of the skeleton for this creature.

FIG 5-69 The legs for Belraus are similar to that of a generic quadruped, but their length and position means that using the auto-clavicle type setup for this section of the creature will not give us the control and good deformations I am used to for this kind of setup.

Luckily, some experimentation during the research and development phase has helped me work out a solution I like for this part of the creature, and, surprisingly, it is the most basic kind of setup. A single IK chain running from the top leg joint to the bottom allows this leg to bend, stretch, and fold correctly for the movements needed for Belraus.

Single IK Spring Leg Setup

This leg setup is relatively simple to setup. It combines a single HI Solver IK chain with a correctly positioned pole vector control along with a stretchy leg that combines three joints instead of two.

1. Create a three-bone joint chain in the left viewport. (For this example, I simply grab hold of the leg skeleton for Belraus.)

FIG 5-70 Belraus has a three-bone leg joint chain that will have this technique/solution applied to it.

2. Create a Point Helper, and align it in both position and orientation to the first joint.
3. Link the first joint to this Point Helper.
4. Create an IK chain that runs from the first joint to the end joint. Animation Menu > IK Solver > HI Solver

This quick setup actually gives you a working leg rig already. Moving the IK goal compresses and extends the leg. The additional Point Helper allows you to position the starting point of the IK for additional control.

FIG 5-71 With little to no effort, we have a working leg rig solution for Belraus. Sometimes the simplest things make the most sense. (I know, it feels too easy doesn't it?)

5. Move on to the pole vector control. Create a Point Helper.
6. Position constrain the Point Helper to the first joint and last joint. Animation Menu > Constraints > Position Constraint

7. Use a LookAt constraint on the Point Helper so it points toward the first bend in the joint chain.
 Animation Menu > Constraints > LookAt Constraint

FIG 5-72 Use a LookAt constraint on the Point Helper so it points toward the first bend in the joint chain.

8. Create an additional Point Helper, and align it in both position and orientation to the first Point Helper.
9. Move the aligned Point Helper in its local X axis so it sits away from the joint chain.
10. Delete the constrained Point Helper.
11. Select the IK goal and assign the remaining Point Helper as the target for the Swivel Angle attribute.

FIG 5-73 The remaining Point Helper can now be used as the pole vector that controls the swivel angle of the IK system.

You now have a working IK leg, as well as a usable pole vector control to manipulate the swivel angle of the IK. You can finish this setup by making all of these joints stretchy.

12. Create an ExposeTM node.
13. Set the "Expose Node" as the Point Helper at the top of the leg joint chain.
14. Set the "Local Reference Node" as the IK goal.

FIG 5-74 It is important to pick the correct nodes to expose when using the ExposeTM Helper.

15. Freeze transformations on all of the leg joints.
 (Select joints) Alt + Right-Click > Freeze Transform
16. Select the second joint in the chain, and apply a "Float Script" controller to its zero X Position attribute.

FIG 5-75 Apply a "Float Script" controller to the second joint in the leg chain.

17. In the new Script Controller window, create three variables:
 a. Constant—This is used to store the original/default length of the joints before stretching. It is worth noting that adding a zero (0) value can make this script work if you are having problems. Adding the zero (0) value to this variable effectively eliminates it from the calculation.
 b. Distance—Here, you assign the Distance parameter of the ExposeTM helper you created.
 c. Straight—This is used to store the length of the joint chain when full extended, before stretching.
18. Select the "Constant" variable, and use the "Assign Constant" button to assign the original/default length or a zero (0) value to it. Remember to "Evaluate," and then hit the "OK" button to apply this value.
19. Select the "Distance" variable, and use the "Assign Track" button to assign the "Distance" attribute of the ExposeTM helper. You have to find this attribute in the dialog window that pops up.

FIG 5-76 Be careful when assigning variables their data. Get it wrong, and you could end up with some weird and wacky results.

20. For the "Straight" variable, you need to get the distance at which you want the stretching to start. Select the ExposeTM helper, and head over to the Modify Panel. Once there, pin this stack so you can continue to see this information once you select something else in the scene.
21. Select the IK goal, and move it to extend the joints. Find the point at which you would like the joint chain to start stretching, and make note of the "Distance" parameter on the pinned ExposeTM stack.
22. Reposition the IK goal back to its default position.
23. Select the "Straight" variable in the Script Controller dialog and assign the "Distance" attribute length you just made note of. Remember to "Evaluate," and then click the "OK" button to assign this correctly.
24. With your variables correctly assigned and in place, create your expression in the "Expression" area of the Script Controller window. Just like most of this stretchy setup, you use the same expression you used for the arms of the creature. However, you do have one change to

this; instead of dividing by two, you divide by three, as you have three bones in the joint chain:

```
If (Distance-Constant) > Straight then
(
    ((Distance-Constant)-Straight)/3
)
Else
(
    0
)
```

25. Enter a description if you wish, and then click the "Evaluate" button.

FIG 5-77 The Script Controller window with the correct expression to drive the leg stretching.

By moving the IK goal, you should notice some stretching; however, you need to re-do this stretching setup for the third joint and the end joint in the leg joint chain. Once you include those joints into this setup, the stretching should look great.

FIG 5-78 Stretching on a three-bone leg.

This solution did not just come out of nowhere. In fact, I thought of and tried four other methods before deciding on the single IK spring leg setup Belraus now uses.

First, I always think of a basic FK setup. For something like a leg that has to be "pinned" in position a lot of the time, FK is not generally going to work, but I like to quickly give it a thought in case it is needed in some kind of FK/IK switch setup. In this case, FK is not needed at all, so I quickly moved on.

My second thought was to use the auto-clavicle setup on the legs that usually always work for quadruped creatures and characters. I went ahead and set this all up, then did a quick animation test to see how it performed.

FIG 5-79 The auto-clavicle-type setup worked, but, disappointingly, it was not as good as I expected it to be.

It was alright, but nowhere near the sort of quality I am used to with this kind of setup. I made a note of this, and this could have been a "fall-back" plan if I could not come up with another solution in time. I mean, I did not have forever to finish this book you know.

Ok, with that in my reserve tray, I thought about using the Reaction Manager in conjunction with some FK controls. This solution is actually more than fine, but I prefer not to have too many reaction-driven setups in my rigs, both from a personal preference and a rig speed point of view. However, as this did work, I filed this in the backup-plan tray along with the auto-clavicle setup.

FIG 5-80 A reaction-based setup for the rear legs of Belraus is also a reasonable option for this creature.

Alright, I had two solutions that worked, but I still was not convinced I had exhausted all of my possibilities, and, with a little more time, I figured I could slot a few more tests into this phase of development. So, what was my next thought? An overlapping dual-IK system. Yeah, you heard right! Two IK chains that overlap one another that are then linked to the same controller. I know, insane, but hey, this was the crazy-scientist experimentation phase, so anything goes. Plus, who else is going to know about these "dark arts?" Well, obviously you do now that I have told you, but normally we can keep this tom-foolery to ourselves.

FIG 5-81 Experimentation with overlapping dual-IK system for the rear legs.

Actually, I have used this before, but only for mechanical rigs, and, if used correctly, can create some nice setups that do not take too long to do. However, for Belraus, I found that I had to add additional controllers to ensure the animator could get into all of the poses he or she would need, in turn, making the rig more complicated (from a user point of view) than it has to be. Experimentation scrapped!

At this point, I was going to choose between the auto-clavicle system and the reaction-based system and just be happy with that. Then my brain spoke to me and said, "Umm, hello? Why not try a basic IK chain from the top to the bottom of the joint chain? I know it sounds a little bit too simple, but you never know!"

I did just that, and what do you know? This is the rig I ended up with for the legs.

Feet

The feet of Belraus require what is called a "reverse foot" setup in which we place joints and/or helper objects to drive the controls of the foot.

Reverse Foot Lock Setup

1. Create a two-bone joint chain in the left viewport that will become the "leg" joints for this setup.
2. Create another two-bone joint chain in the left viewport that will become the foot and toe. Position it next to the leg.

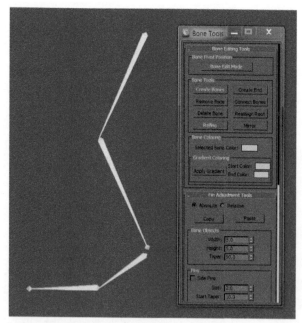

FIG 5-82 Once positioned correctly, it sort of looks like a biped leg.

3. Create an IK chain for the leg joints.
 Animation Menu > IK Solvers > HI Solver
4. Link the first joint in the foot chain to the IK goal of the leg so it follows along with it.
5. Create an IK chain for each bone in the foot: one for the ball and one for the toe.

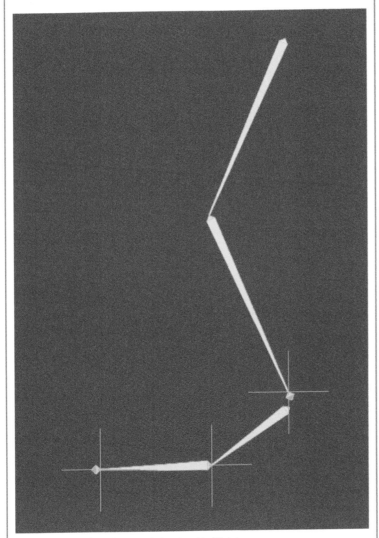

FIG 5-83 The reverse foot lock setup works by using a lot of IK chains.

6. Create another joint chain for the foot lock. This should run from the heel, to toe, to the ball, and finally to the ankle.

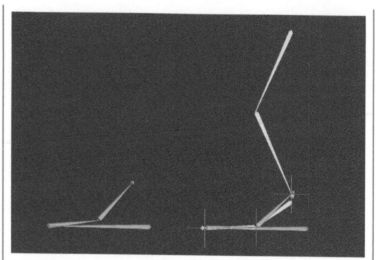

FIG 5-84 A set of reverse joints create the "lock" for this setup.

7. Link the leg IK and the ball IK to the ball lock joint.
8. Link the toe IK to the toe lock joint.

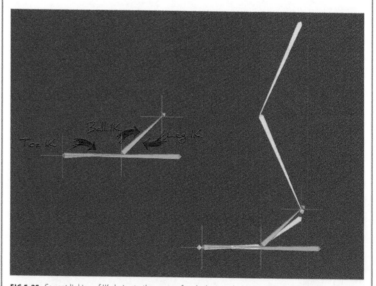

FIG 5-85 Correct linking of IK chains to the reverse foot lock gives this setup all its needed control.

To control this setup, rotate the ball lock joint for a "foot peel" action. Rotate the toe lock for "tip-toes/pivot" control, and rotate the heel for a "heel-roll/pivot" motion. Combined, these rotations can give a lot of movement for the foot rig.

This sort of setup is extremely common throughout the industry and gives a truckload of control for very little effort. However, we can expand on this setup by adding additional pivot locations, as well as including extra IK controls that can help toe "wiggling" and emulate the toes "peeling" off of the floor during animation.

The feet rig for Belraus uses these exact principles, with changes made to accommodate his bone structure and movement needs.

FIG 5-86 Belraus uses a reverse foot lock setup with additional pivot location and IK controls to allow for more movement.

These same principles can be applied to the hands and fingers of a creature or character too.

Making Sure It All Works Together

These modular components we have been creating have allowed us to compartmentalize each section and really focus on creating great animation rigs for each part of the creature. This has left our Schematic View looking

somewhat untidy. The base rig hierarchy is still there and still clean, but our newly created modular animation rig is all over the place. It is important that this animation rig is just as clean and tidy as the base rig, so it is a good idea, at this point, to take some time restructuring and refining the hierarchy of the creature.

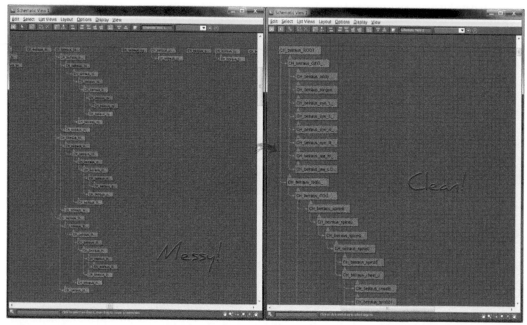

FIG 5-87 The before and after of the creature's hierarchical structure.

With the hierarchy restructured and more manageable, take a bit of time to sort out the display layers for this scene so users of the rig can navigate more easily in the viewports. Also, remember to run through each of the controllers and "lock" any unnecessary control to avoid confusion when this rig heads off to animation.

Making the Connection

Right now, the animation rig does not drive the base rig. And guess what? We need it to!

Using Position and Orientation constraints on the base rig skeletal structure, we can "connect" these rigs together. It takes some time to go through each joint, and, although a little mind-numbing, it is not difficult

and should not take up too much of your time. The hardest thing about it is keeping track of which joints you have already done and which joint you are working on next.

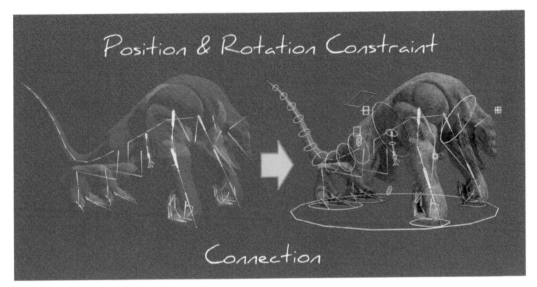

FIG 5-88 Making a connection...

Animation Test

With the messiness of the hierarchy now cleaned up and the animation rig now driving the base rig, a quick test animation should be created, and its best that we, as the rigger of this creature, do this animation test. This allows us to test our controls, see if there are any issues we may have missed, and make sure our restructuring of the hierarchy has been a success.

As we have rigged each section of the creature as its own module, should we notice any issues or problems, we can simply deal with the specific section that is not behaving as suspected.

Once all issues and errors have been corrected, we not only have a rig that we can send through to the rest of the production, but we also have a quick animation test that can help show the rest of the team what the rig is capable of.

Great job!

FIG 5-89 Take your rig for a spin, and create some of your own animations. The animations you create should fit with the style of the creature, but I like to push it just a little and take the creature out of its comfort zone. This not only shows some potential rig problems, but it is kind of funny too.

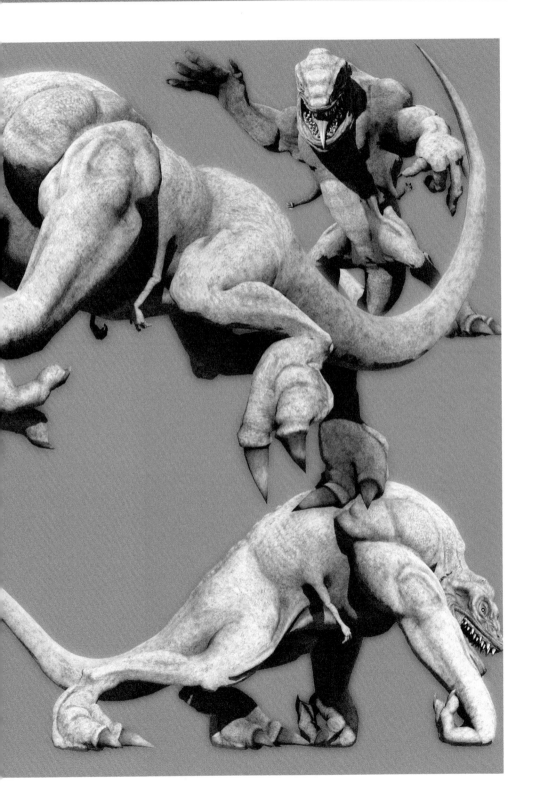

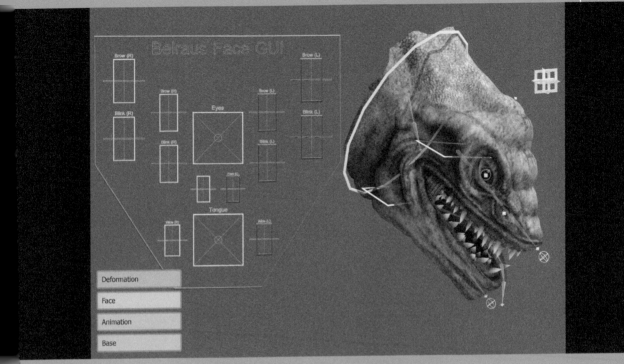

Face Rig

"God hath given you one face, and you make yourselves another."

William Shakespeare

The primary goal of any face rig is to allow the creation a believable acting performance.

Facial animation is considered one of the most important aspects of creature and character animation, if not the most important. Expressions, emotions, feelings, thoughts, and lip-syncing are all factors that can and are acted through the face of a character. In fact, the face of a character or creature is capable of creating so many different states of emotion that it is a language anyone can understand, a worldwide, multinational, multicultural, barrier-breaking, unspoken language if you will.

Face rigging is an incredibly huge topic with a near endless amount of factors that contribute to the success or failure of the facial acting performances of our creatures and characters. Not only are we combatting the creation of implementing a setup capable of realistically recreating amazing facial expressions, we also have to consider and tend to the needs of our animators who are giving movement, acting, and emotion to this digital, lifeless creature.

The human face has around 52 muscles, not including any individual distinctions regarding things like posterior and inferior, longitudinal and transverses, and major and minor. About 19 of these muscles play a major role in facial movement. Muscles tense/contract and relax in such a way that they create our facial expressions that relay mood and speech. In addition, we have creases/wrinkles, eyelids, eyeballs, teeth, tongues, and hair, all combined together to create one of the most complex communications systems in the world. Yep, even more complicated than your smart phone. This system is so complicated that it is impossible for us to create a face rig that is 100% anatomically correct.

This complexity can be a little overwhelming, but, by using some relatively clever thinking, we can simplify this stuff, making everything more manageable, while still fooling our audience into suspending its disbelief in our creature's performance.

Our challenge when creating a believable and intuitive face rig is to allow subtle and believable facial movement despite the limitations of our tools. This, we can still do.

The Aims of Any Face Rig

As the first line in this chapter states, "The primary goal of any face rig is to allow the creation a believable acting performance." The audience has to connect and feel the emotions of the creature as it articulates, gestures, and expresses itself as it reacts to various situations.

To achieve this goal, we have to create a setup that is easy to use, is of substantial quality for its use, and is able to reach every pose possible.

Style Thoughts

The style of your character or creature greatly affects both the technical and artistic direction you choose when creating your face rig. Do you need to think about making the face squash and stretch more than usual? Does this setup require sticky lips? Understanding exactly what style your creature is can help you answer these kinds of questions and allow you to create a solid list of inputs, parameters, and features the rig will need.

There are at least three broad areas in which your character or creature fits into.

1. **Photorealism**
 Yeah, you already guessed it. Photorealism tries to mimic real life as closely as possible. TV and film VFX work is where you can see most of this work, and video games have been trying to emulate realism for a long time now, in some instances, getting incredibly close.

FIG 6-1 Photorealism, it is real... But not real, all at the same time!

2. **Hyper-Realism**

 Hyper-realism is both realistic and fantastical at the same time. Most creature-based TV and VFX work sits firmly in this category, where real elements (plates/live-action footage) are composited with creatures that, although look realistic, still come from someone's imagination. This is definitely the category that best suits Belraus.

FIG 6-2 Hyper-realism combines realistic elements with fantastical settings, creatures, and characters. Belraus is a hyper-realistic creature.

3. **Stylistic**

 Abstract images to cartoon, these stylistic visuals can often be found in everything from video games, to music videos, to children's television.

FIG 6-3 Cartoons and more abstract visuals can be described as stylized or stylistic.

If one of these three options does not fit your creature entirely, you are probably looking at mixed attributes from these options.

Face Rig Systems

Our face rigs can be created by three different methods. Our first option is to use joints and bones to drive the surface deformations, allowing the character or creature to emote. Second, we have the options of using morph targets (or blendshapes, depending on what you are used to calling them) to blend between various deformation shapes. Third, and finally, we can use a mixture of joint/bones and morph targets/blendshapes to create a hybrid facial rig system.

FIG 6-4 Joints/bones, morph targets/blendshapes, or a mixture of the two?

208

There are pros and cons for each option, and limitations in the output may shut down the choices. We can take a look at the three different options in more detail, but first let us create a character head so we have something to work with.

Meet Quoobe

Reader, meet Quoobe (pronounced "cube"). Quoobe, meet the reader.

FIG 6-5 It is Quoobe!

Quoobe is the super basic, ultra-stylised character we use to demonstrate a few face rigging techniques so we can better understand what is going on.

Creating Quoobe

Modeling Quoobe is super simple and introduces you to the simple geometry you have to work with.

1. Create a Box at the world center ([0,0,0,]) with eight segments for the Length, Width, and Height parameters. You can make this box as big or as small as you wish (I am keeping this guy at 0.25m squared).
2. Turn this Box into and Editable Poly.
 Right-Click > Convert To: > Convert to Editable Poly
3. In a front viewport, use the Polygon sub-selection (hotkey "4"), and select a place for the mouth and eyes area of the character.

FIG 6-6 Use the Polygon sub-selection option to select the mouth and eye area of Quoobe.

4. Extrude this selection in-over, twice (I am using an extrusion iteration of -0.025m).
5. Scale the still selected polygon sub-selection so it is around 50% smaller, then exit the sub-selection.

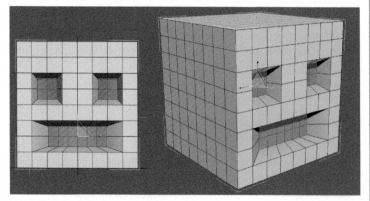

FIG 6-7 Scale the selection by around -50%.

6. Create a sphere, and place it in one of the eye sockets.
7. Duplicate the sphere, and place the duplicate in the other eye socket.

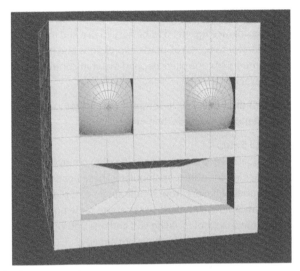

FIG 6-8 Quoobe got some eyes!

8. Optionally, you could box model (I use this term lightly here) some eyebrows and teeth for the character if you wish.
9. Finally, use the Material Editor (hotkey "m") to color the character as you wish.

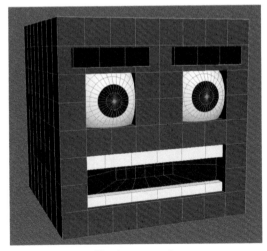

FIG 6-9 The relatively painless creation of Quoobe is now complete.

His expressionless simplicity empowers us to build a rig quickly so we can experiment and have fun without worrying about too many complexities. Having a character like this is a great learning tool, and it is a great starting point for more complex setups.

Face Rig Controls

The control setups for face rigs need to be easy to use and intuitive, as well as to enable the animator to access all of the expressions and poses they need. The sorts and numbers of controllers depend on what control/manipulation you give over the facial rig.

There are plenty of different ways to setup controllers for a face rig, two of which are more standard methods than others.

1. **Control Board Setup**

 The "Control Board" style setup relies on floating controllers that represent areas of the face we are able to manipulate. These floating controllers come in a number of flavors, from simple single-axis sliders to multiple-axis sliders that can drive multiple poses at the same time. This is an incredibly common sort of facial rig GUI and one you will come into contact with at some point if you have not already.

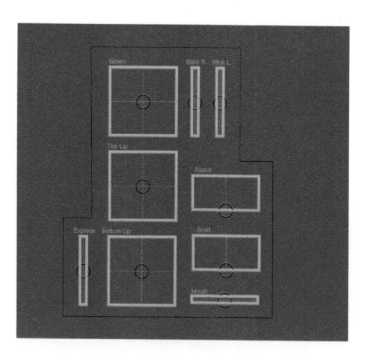

FIG 6-10 "Control Board" style setups are commonplace when animating the faces of creatures and characters.

Creating a Control Board

The creation of a Control Board facial GUI system is relatively simple. Although any object could be used for the controllers (I like to keep things simple and use only Splines to define the Control Board shapes). This is in keeping with the industry in general.

1. In the top viewport, create a Rectangle at the default position (world space [0,0,0,]).
 Create Panel > Shapes > Splines > Rectangle
2. Create a Circle that sits inside of the Rectangle.
3. Link the Circle to the Rectangle.

FIG 6-11 The basis of a multi-axis Control Board controller.

4. Freeze transformations on the Rectangle and Circle.
 (Select Objects) Alt + Right-Click > Freeze Transform
5. Select the Circle, and head over to the Motion Panel. In the "Assign Controller" section, expand the "Zero Pos XYZ" controller so each axis is exposed. Select the "X" axis and assign a "Float Limit" controller.

FIG 6-12 Assign a "Float Limit" controller to the Zero Position X axis of the Circle controller.

6. In the new popup window, adjust the limit value so the Circle can only move a certain amount in the X axis and does not go fully outside of the Rectangle (I use the Rectangle as a "bounding box" for the Circle controller). This value changes depending on the size of your Rectangle.

213

7. With the limit value set, leave the "Smoothing Buffer" value as "0.0," and close the floating window. Repeat the Float Limit controller steps for the Y axis.

FIG 6-13 Do not allow the Circle to go outside of the Rectangle, which has become the controllers "bounding box." Some overlapping is totally fine, however.

8. You need to stop any movement on the Z axis now. You could use a float limit, but it is simpler to head over to the "Hierarchy Panel" and into the "Link Info" area. From there, simply use the "Locks" rollout and lock the "Move" Z axis.

This completes one controller for the Control Board setup. This can be duplicated for other controllers or recreated as an actual rectangle (rather than square) for a single-axis controller. Additionally, you can group multiple controllers inside another, much larger rectangle, and you could even add text to each of these controller objects so the animator knows exactly what these controllers do.

FIG 6-14 A completed Control Board for a face rig. This can be as simple or as complex as needed for the character or creature you are working on.

If you are feeling really creative, you could use the Line tool to draw specific areas of the creature's face so the controllers are more distinguishable. You could even do some basic deformations on some of the lines by using a "Linked XForm" Modifier.

FIG 6-15 Go crazy and "draw-out" some of the facial features using the Line tool. Make things even more interesting by getting the "Linked XForm" modifier involved for some basic deformations on the controllers.

2. **On-Face Controls**
 This type of control setup sees the controllers sitting in front of specific facial regions that indicate what that controller will manipulate. Extremely

FIG 6-16 "On-Face" style control setups are also extremely common in animation productions.

215

similar to the Control Board style setup, the only real difference is that these controllers cover the character or creatures face but their intentions are the same. This kind of control-type setup is also an extremely common sort of facial rig GUI.

FIG 6-17 You could even use a Control Board style controller for your On-Face controls.

Of course, these two methods can be combined, both animatable by the user with the Control Board system driving the On-Face system.

FIG 6-18 The Control Board system drives the On-Face controllers in a combined setup. However, both sets of controllers are available for animation input from the user.

There are plenty of alternative face GUI methods too, from using a single controller or object filled with custom attributes that drive the facial deformations to clickable "geometric controllers" that are a duplication of the facial geometry giving direct interactions with various elements and sections of the creature's face.

FIG 6-19 There are plenty of other options to choose from when creating your facial GUI. What you choose is entirely up to you and the needs of your production.

Which method of facial GUI you choose is up to you, or your production. Each and every one of these methods can be combined, although it would take a lot of time (that you probably do not have) to setup correctly.

Joint/Bone-Driven Facial Rig System

Joint/bone-based face rig systems rely on the same principles as our base rig. Our geometry is bound to the face bones, which act as influences for the surface deformation. When the joints/bones are moved, any weighted geometry is also influenced and moves with it.

In fact, this is pretty much the same as using joints/bones for the rest of the creature or character you are in the process of rigging. Add some bones, link them in a hierarchy, skin them to the face, and create some controls.

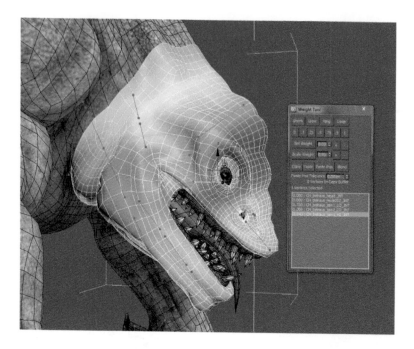

FIG 6-20 Joint/bone-based facial rigging works on the same principles for rigging a character's or creature's body with joints/bones.

So, the only thing we are able to edit at this point is the placement of the bones that will affect the facial deformations. We can have joints that mimic the facial muscles of the character, and, by turning off the "Freeze Length" attribute of the joints, we can get some fantastic deformations just by using the Skin modifier.

FIG 6-21 Mimic the facial muscles and turn off the "Freeze Length" attribute for some great facial deformation results. Be warned, though, it uses scaling so will not be accessible to all outputs, such as some real-time engines.

Using that method is great, but, if you need to output to something like a real-time engine that does not support non-uniform scaling, you are going to run into some problems, as turning off that "Freeze Length" attribute gives that joint non-uniform scaling.

As we are trying to cater for everything here, we can use single joints/bones positioned in certain areas skinned to the face. This does not mimic the muscularity of the facial features, but can give good results.

FIG 6-22 A diagram of joint positions for the Quoobe face rig.

Joint/Bone-Based Quoobe Face Rig

Creating a joint/bone-based face rig requires techniques taken from body rigging. There are a lot of bones that you can place in the face rig, and, from there, you have to enhance the facial setup with additional controls so the face rig is easy to use and intuitive. After all, you do not want the animators to have to manipulate each and every joint.

With Quoobes being such a simple character, you will keep the setup relatively simple, just remember that you can continue to add additional controls and bones to setups that require something a little more complex to work correctly.

1. Create a diagram of where you need the joints positioned; this will act as good reference before jumping into the 3D.
2. In the left viewport, create a single-bone joint chain for both the head and the jaw.

FIG 6-23 The head and jaw joints are the first things we need to create.

3. Find the center of one of the eyeballs, and create a joint. From there, point forward out of the eye.

FIG 6-24 Eyes have joints too... At least in my 3D world they do.

4. Duplicate the eye joints, and position them on the other side of the character.
5. Link the eyes and jaw to the head joint.
6. Using the diagram you created in step 1, create Point Helpers for each of these positions.

FIG 6-25 Using the diagram we created in the first step as a guide for placing and positioning Point Helpers.

7. Using the Point Helpers as guides, align joints to each of them. It is also worth noting that you could just use the Point Helpers as "influence objects" instead of bones. So this step is up to you (I prefer to create bones to control most skinning deformations).

FIG 6-26 Point Helpers define where the deformations will take place from. We can use these as "influence objects," but I prefer adding joints to these to control the skinning deformations of the face.

8. With the joints in position, link them to the Point Helpers.
9. Link the Point Helpers to the head joint.
10. Skin the joints to the geometry using the same techniques covered in the Base Rig. This step could take you some time.

FIG 6-27 Linking and skinning, two words only used in a rigger's vocabulary.

Now that the joints have been skinned to the geometry, you can manipulate the Point Helpers and joints to deform the face. You may need to tweak the skin weighting to get things looking right, but, for the most part, it should be there. You can now start thinking about animator control.

11. Create controllers for your face rig. This is specifically up to you and your production as to how you go about doing this. Have fun, experiment, fail, and then succeed.

FIG 6-28 Create you control system for your face rig.

12. Link your control system however you wish! Wire Parameters, Reaction Manager, Controllers… anything and everything goes to drive those bones correctly.

Anything goes here. Re-link things, add in driven controllers, do whatever it takes to make your facial rig intuitive and easy to use for your animators.

As you can see from the joint/bone-based setup we have just created, there is a fair amount of control from this sort of system. Difficulty arises when this face rig is pushed to an extreme pose. Because we are relying solely on skin deformations, there will be a point at which the manipulation of the controls overwhelms the skinning information and the face will look twisted, pinched, and broken. We can try to limit controllers, and for the most part this should work fine, but make sure that your face rig can hit all the required facial poses needed for your animators to work with.

Morph Target/Blendshape-Driven Facial Rig System

A morph target is an edited/deformed/manipulated version of a shape that allows the base, or unedited shape, to blend to; in other words: a sculpted mesh that is used as a deformation goal for the base mesh. Because each movement/shape is hand-sculpted, the artist is given a great deal of flexibility when trying to achieve an anatomically correct specific pose.

FIG 6-29 Each morph target is hand-sculpted by an artist to get the best possible pose. This can be anything from subtle movements to broad facial changes.

This technique for geometry deformation is often referred to as "Morph Target," "Blend Shape," "Per-Vertex," or "Shape Interpolation" animation.

223

Creating a Morph Target

The actual creation of a morph target is incredibly simple. Although, sculpting great morph target shapes is a way more complicated.

1. Create a sphere.
2. Convert the sphere to an Editable Poly.
 (Select Object) Right Click > Convert To: > Convert to Editable Poly
3. Duplicate the sphere, and move it to the side so you can see it easily.
4. Jump into a sub-selection mode on the duplicated sphere, and start editing into a new shape (the shape choice does not really matter at the moment, so it is entirely up to you).

FIG 6-30 The original sphere and its edited duplicate sphere as the target shape.

5. Select the original, unedited sphere.
6. Add a "Morpher" modifier.
7. In the "Channel List" rollout, right-click the first "- empty -" box and click "Pick from Scene."

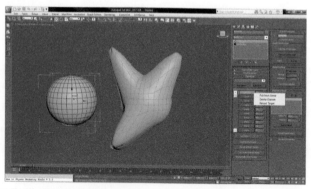

FIG 6-31 The "Channel List" rollout gives you access to each channel of the Morpher modifier, allowing you to choose the target shape for each available morph channel.

8. Select the edited sphere shape (this is the target shape you want the original sphere to morph into).

The morph target is now complete. By editing the value of the spinner (found next to the selected morph target in the "Channel List" rollout), you can morph the original sphere shape into the new target shape you created.

If you are unfamiliar with morph targets, check the help files and try this modifier out a little more. Play with the settings and options, and experiment.

Geometry is simply a large array of vectors, or, in simpler terms, a list of points/series of vertices in 3D space. Morph targets affect the position of these vertices by dialing or blending in the target shape based on a percentile weight assigned to it—0–1 or 0–100%, depending on how you want to look at it. Actually, morph targets can be overloaded and underloaded, with values of less than 0 and more than 100%.

FIG 6-32 Overloading and under-loading a morph target can give both positive and negative deformation results.

Overloading and Underloading a Morph Target

It is possible to overload and underload morph targets in 3ds Max. By doing so, it is possible to save yourself some work and get desirable results without even trying. Of course, the flip side of this is that you get some crazy and distorted results that you really do not want. The only way you are going to know is if you check it out though.

Find the "Use Limits" toggle button in the "Global Parameters" rollout of the Morpher modifier and turn the limits off to try out overloading and underloading your morph targets.

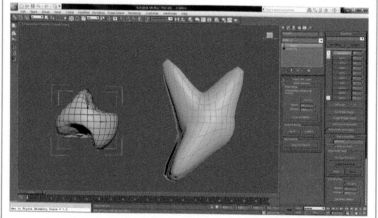

FIG 6-33 Overloading and underloading morph targets can give good or bad results. The best thing to do is check. Do not leave it to chance.

Unless limited by our output, such as a real-time engine, we can use as many morph targets/blend shapes as we want to get the very best results. This deformer is extremely powerful and calculates relatively quickly. A morph target blends between its original shape and the target linearly and uses the shortest distance between the two to get there.

Morph Targets Are "Additive"

It is an important point to note that, when working with morph targets, you have to keep in mind their additive nature.

In simple terms, this means that each morph target will add its shape to the next and so on. Or, in more visual and mathematical terms, you could use Fig 6-34 to help understand this.

This can be a little confusing at first, but, once you get the idea, it makes a lot of sense and you can use this to your advantage.

FIG 6-34 Morph targets are additive in nature. A morph target is "added" to the base shape, a second morph target will "add" itself to this shape, a third will "add" itself to this shape again, and so on.

Morph targets are a fantastic deformer to utilize; however, their power is also one of their biggest problems. As a target shape is dialed into the Morpher modifier, each point takes the shortest route from its original position to the new position linearly. Rarely do organic creatures move without some form of arc (think back to our animation principles here). Because of this, it is often the case with morph targets that we have to add additional in-between morph targets to simulate arcing movement.

We get this sort of arcing movement for free when using a joint-based system, but with morph targets we have extra work to do. With that said, let us take a look at creating some morph target face shapes for our friend Quoobe.

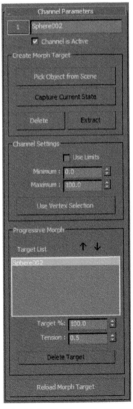

FIG 6-35 Use the "Progressive Morph" found in the "Channel Parameters" of the "Morpher" modifier to simulate "in-between" morph targets and arcing movements.

Creating Face Shapes for Quoobe

Generally, the base geometry for a character or creature should be modeled in a "default" pose. Not only does this make more sense when trying to model morph targets, but it allows real-time engines to have zero morph inputs when in the character's default/relaxed pose. In other words, it just makes sense. Unfortunately, Quoobe has been modeled with an "open" mouth shape. You should correct this now to make things a little easier when it comes to modeling the rest of the morph target shapes.

1. Duplicate the Quoobe geometry.
2. Edit the original geometry to create a closed mouth shape. This becomes your base geometry for the face rig as it is the "default" pose for Quoobe.

FIG 6-36 The closed mouth geometry is now the "base" model for Quoobe. The duplicated open-mouth pose will be our first morph target.

3. Add a "Morpher" modifier to the base geometry.
4. Add the open-mouth pose as the first morph target in the "Channel List" rollout of the Morpher modifier, and test it out.
5. With the mouth of Quoobe now able to go from closed to open, you can think about an eye blink. Duplicate the base geometry (closed-mouth version), and delete any additional modifiers that may be present on this duplication, such as the Morpher modifier.
6. Create a closed-eye morph target by grabbing the vertices around the eyes and manipulating them to a closed position of your choice.

FIG 6-37 Quoobe with closed eyes.

7. When you are happy with the closed-eye model, add it to the Morpher on the base geometry as the second morph target.

You now have a face rig for Quoobe that can open and close the mouth and eyes. It may be very basic, but it forms the start and foundations of a much more complex face rig you can expand on.

Nice work! Quoobe now has some sort of face rig. Apart from some animator controls, he is also missing something… Yep! Quoobe is incapable of any asymmetrical facial movement. He cannot smile on one side only. He cannot even wink.

FIG 6-38 Are you winking at me? Errr, no, I guess not since you cannot wink!

To get some asymmetry into our character's face, we could just go ahead and create shapes for each side of the face. For instance, a left side wink and a right side wink. This is a great way to do things, but, if this guy was any more complicated, creating morph targets for each side would take a long time (of course, if your character's or creature's base geometry is asymmetrical, you do not have much choice). You may be thinking, "Ok, so let us just create one side and we will just mirror the geometry for the opposite side." This is clever thinking, but, just to throw a brick wall in front of this idea, I have to tell you—YOU CANNOT MIRROR MORPH TARGETS. Yeah, I capitalized that just so it is burnt into your retina and you remember for next time.

FIG 6-39 YOU CANNOT MIRROR MORPH TARGETS!

Morph targets cannot be mirrored. Each vertex has its own unique ID number, a number randomly assigned by 3ds Max as you created it. By mirroring geometry, these numbers get moved, flipped, changed, or reassigned (depending on what you are doing). It is a nightmare!

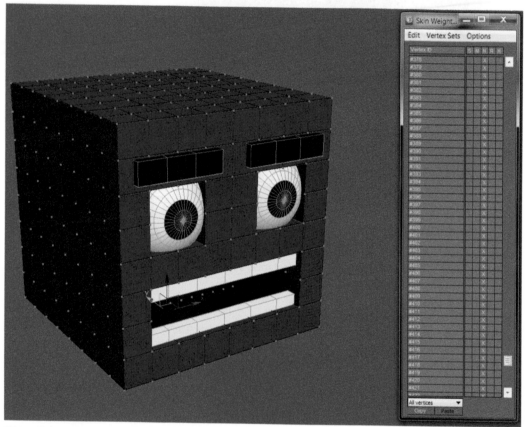

FIG 6-40 Each vertex on your geometry has its own unique ID number randomly assigned by 3ds Max as it was created. Mirror geometry moves, flips, changes, or reassigns these ID numbers.

Luckily, there are a number of tricks and hacks to allow us to duplicate the changes made on one side to the other. The best options are usually to script up something; this could be anything from reordering vertex numbers to creating your own mirror-script that keeps vertex numbering in-tact for morph targets. Alternative methods, and one's that are built into 3ds Max, are also available. Using the "Skin Wrap" modifier can work well for instance, or creating symmetrical shapes and then choosing which vertices are affected is another option.

As we already have symmetrical morph targets for Quoobe, we can go ahead and create asymmetrical shapes so we have more control over his face setup.

Creating Asymmetrical Morph Targets from Symmetrical Shapes

1. Create symmetrical morph targets for your character if you have not already done so (I am just using the morph targets we have already setup for Quoobe as a starting point).

FIG 6-41 The shapes we have already created for Quoobe are a good starting point.

2. Duplicate the base geometry.
3. Delete any modifiers that may be present on the duplicated mesh.
4. On the duplicate geometry, enter the vertex sub-object level and select just the left or the right side of the character.

FIG 6-42 On the duplicate geometry, select just one side of the character by dropping into the vertex sub-object level.

5. Keep that sub-object vertex selection, and apply a "Morpher" modifier.
6. In the "Channel List" rollout, add one of the symmetrical morph targets.
7. Ramp the morph target up to 100%. Notice that only the side you have selected in your sub-object level has been affected.

FIG 6-43 Look at that! An asymmetrical shape created from a symmetrical morph target.

8. With that shape still dialed in to 100%, right-click in the modifier window area and "Collapse All." By doing this, you have removed the Morpher modifier and the geometry is back to a standard "Editable Poly." This shape can now become a morph target for your character.

FIG 6-44 By collapsing the modifiers, we get a clean Editable Poly mesh for us to use as a morph target for the rig.

Simply repeat these steps for the other side, and, once you are finished, you can delete the symmetrical morph target as it will no longer be needed for the rig. Neat!

Hybrid Joint/Bone and Morph Target/ Blendshape-Driven Facial Rig System

There are debates about which is a better system: is it joint-based setups or morph target-based rigs. Like many Creature TDs, my preferred method for setting up face rigs for creatures and characters is to use a hybrid method that combines both joints and morphs. By using a mixture of the joint/bone-based and morph target/blendshape-based systems, we get the best of both worlds and can rely on one or the other, which enables us to get the best possible poses for the face rig.

FIG 6-45 A combination of both joint-based and morph-based facial rigging is my preferred method for the basis of a face rig. It gives the best of both worlds in which we can use the power of both joints and morphs to work together, creating a less-restrictive and more expressive facial rig for our characters and creatures.

Should you be using this method, there are two specific areas in which joints are usually preferred over morph targets. The first is the jaw bone of the character or creature. Because the jaw rotates in an arc and moves a lot of the face around with it, using a bone/joint for this movement is the logical thing to do.

FIG 6-46 I advise using a joint/bone for the jaw.

233

The second area for the use of bones is the eyes. This allows us to mark the center of the eyeballs with a joint, and those joints can have LookAt constraints applied to them so we can give our character something to "look at"—like an eye direction controller.

FIG 6-47 Using joints for the eyes is also a good idea. This allows us to use a LookAt constraint on the joint so we can dictate where the eyeball should look.

Of course, there are no rules that MUST be followed for this method, so, if you want to use morph targets for these movements instead of joints, then please do.

Additional Deformers and Systems

After choosing your face rig method, we can still look into improving the movement and believability of the face rig by creating additional deformers and systems driven by the facial controllers. Yeah, even after we have given the animator more than enough control, we can still give them more and more; it is a never-ending cycle to aim for that non-attainable goal of a perfect setup.

Using anything from extra bones, to corrective shapes, FFD modifiers, animated materials, and driven shader networks, whatever works to get the best visual appearance should be considered.

FIG 6-48 Additional deformers and systems can really make our creature's body and facial deformations more believable and more aesthetically pleasing.

In fact, these additional deformers and systems should not be confined to just the face rigs of our creatures and character. They can and, if possible, should be used for the bodies of these digital thespians.

We take a deeper look at these additional deformers and systems in Chapter 8, where we can start applying these to our creature rigs.

Expression Creation

When first starting out with facial rigging, a common mistake, but an extremely logical one, is to create expressions for the animators to use. We have already started "expression creation" with our Quoobe rig, and, on first thoughts, it seems like a perfectly good idea; after all, we can quickly work out expressions off the top of our heads:

- Happy
- Sad
- Angry
- Worried

- Scared
- Shocked
- Bored
- Sleepy
- Tired

The list goes on!

When animating a character or creature with just expression-based controls, the animation can often look "floaty" or "bouncy" as we try to blend from one expression to another. For some secondary or tertiary characters, this may be a completely valid way of creating a face rig, and, if it works for its purpose, then it will be quick and easy to setup. However, for more primary characters, this just really is not going to cut it.

FIG 6-49 Expression-based face rigs can be fine for more secondary or tertiary character and creatures, but it is generally not good for primary or more expressive characters.

These expression-based systems also leave us with the problem of symmetry, and symmetry is kind of an undesirable feature to have in our creatures, although we did manage to fix this with our Quoobe character.

So, how can we combat this? Well, if we think about it, the creation of each and every one of those expressions comes from muscles expanding and contracting in harmony. This is something we can use, and, although this is a complex and difficult subject, we are lucky enough that Dr. Paul Ekman, a professor of psychology at the Univeristy of Califorina, San Francisco, has already taken the time, studied, and documented the human face, face muscles, and its emotions.

Facial Action Coding System (FACS)

Unmasking the Face: A Guide to Recognizing Emotions from Facial Expressions, written by Paul Ekman and Wallace V. Friesen, documents the face, its emotions, what they look like, and all of their complexities. From this research came "FACS," the "Facial Action Coding System." FACS is a research tool that allows us to analyse and measure any facial expression a human can make. It is an anatomically based system for exhaustively describing all observable facial movement, and, honestly, this manual is not easy reading. There are lessons for detecting, performing, and categorizing facial movements that really allow us to master facial movements in humans.

Now, in our profession, we do not necessarily have to be experts in facial appearances, movement, and expressions, but we do have to have a very good understanding of how we can simulate those movements to allow the animator to create realistic and believable expressions.

FACS measurement units are Action Units (AUs). These combine muscles in the face and are descriptive only, providing no implications about the meaning of the behavior. This is perfect for us, as we do not necessarily know what the character or creature will be emoting. We just know it has to be able to emote that way. Luckily for us, the FACS Action Units are freely available. There are 44 different units, and they are arbitrarily numbered from 0 to 65, and revisions to these have taken place since the first documentations were written. We can combine these Action Units to give us different expressions; for instance, Action Unit(AU) 1 + Action Unit(AU) 7. Many of these Action Units are symmetrical and have corresponding left and right versions, and we have the task of breaking these units down into individual left/right shapes.

Oh, and Action Unit (AU) 0 is not listed here but would be classed as the "neutral" facial expression that the character or creature has.

AU	Name	Facial Muscles	Example
1	Inner Brow Raiser	Frontalis, pars medialis	 FIG 6-50
2	Outer Brow Raiser	Frontalis, pars lateralis	 FIG 6-51

(Continued)

AU	Name	Facial Muscles	Example
4	Brow Lowerer	Corrugator supercilii, Depressor supercilli	FIG 6-52
5	Upper Lid Raiser	Levator palpebrae superioris	FIG 6-53
6	Cheek Raiser	Orbicularis oculi, pars orbitalis	FIG 6-54
7	Lid Tightener	Orbicularis oculi, pars palpebralis	FIG 6-55
9	Nose Wrinkler	Levator labii superioris alaquae nasi	FIG 6-56
10	Upper Lip Raiser	Levator labii superioris	FIG 6-57

AU	Name	Facial Muscles	Example
11	Nasolabial Deepener	Zygomaticus minor	\nFIG 6-58
12	Lip Corner Puller	Zygomaticus major	\nFIG 6-59
13	Cheek Puffer	Levator anguli oris (a.k.a. Caninus)	\nFIG 6-60
14	Dimpler	Buccinator	\nFIG 6-61
15	Lip Corner Depressor	Depressor anguli oris (a.k.a. Triangularis)	\nFIG 6-62
16	Lower Lip Depressor	Depressor labii inferioris	\nFIG 6-63

(Continued)

AU	Name	Facial Muscles	Example
17	Chin Raiser	Mentalis	FIG 6-64
18	Lip Puckerer	Incisivii labii superioris and Incisivii labii inferioris	FIG 6-65
20	Lip Stretcher	Risorius w/platysma	FIG 6-66
22	Lip Funneler	Orbicularis oris	FIG 6-67
23	Lip Tightener	Orbicularis oris	FIG 6-68
24	Lip Pressor	Orbicularis oris	FIG 6-69

AU	Name	Facial Muscles	Example
25	Lips Part	Depressor labii inferioris or relaxation of Mentalis, or Orbicularis oris	 FIG 6-70
26	Jaw Drop	Masseter, relaxed Temporalis and internal Pterygoid	 FIG 6-71
27	Mouth Stretch	Pterygoids, Digastric	 FIG 6-72
28	Lip Suck	Orbicularis oris	 FIG 6-73
41	Lid Droop	Relaxation of Levator palpebrae superioris	 FIG 6-74
42	Slit	Orbicularis oculi	 FIG 6-75

(Continued)

AU	Name	Facial Muscles	Example
43	Eyes Closed	Relaxation of Levator palpebrae superioris; Orbicularis oculi, pars palpebralis	FIG 6-76
44	Squint	Orbicularis oculi, pars palpebralis	FIG 6-77
45	Blink	Relaxation of Levator palpebrae superioris; Orbicularis oculi, pars palpebralis	FIG 6-78
46	Wink	Relaxation of Levator palpebrae superioris; Orbicularis oculi, pars palpebralis	FIG 6-79
51	Head Turn Left	Skeletal	FIG 6-80

AU	Name	Facial Muscles	Example
52	Head Turn Right	Skeletal	 FIG 6-81
53	Head Up	Skeletal	 FIG 6-82
54	Head Down	Skeletal	 FIG 6-83

(Continued)

AU	Name	Facial Muscles	Example
55	Head Tilt Left	Skeletal	FIG 6-84
56	Head Tilt Right	Skeletal	FIG 6-85
57	Head Forward	Skeletal	FIG 6-86

AU	Name	Facial Muscles	Example
58	Head Back	Skeletal	FIG 6-87
61	Eyes Turn Left	-	FIG 6-88
62	Eyes Turn Right	-	FIG 6-89
63	Eyes Up	-	FIG 6-90
64	Eyes Down	-	FIG 6-91

Although it is not necessary to memorize all of these Action Units, knowing what they are can help us communicate in the language of expression. There are times, when trying to describe a very precise expression, we can use Action Units to help explain and make sure everything is clear for everyone involved.

Anatomy and Biomechanics

The anatomical and biomechanical movements of the face are explained by the FACS Action Units better than what I could come up with on my own. For most facial rigs, we can and will rely heavily on this documented research to help achieve believable performances from our rigs.

Using this information, along with general anatomy research, can help recreate a realistic face rig that can shock and awe our audience. Luckily, as we are in the realm of 3D in which nothing is really real, we can take some liberties on this research and add or simplify things to make our face rigs more manageable, and more fun to use.

Placement of the jaw joint is important to our characters and creatures, and, where possible, we should follow anatomical study as closely as we can. This ensures both a good range of motion and realistic mesh deformations.

FIG 6-92 Positioning of the jaw joint is important to the range of motion and realistic geometric deformations for our creatures and characters.

We use joints for the eyes in our Quoobe rig, and, although not anatomically correct (as we do not have joints in our eyes), it gives us the correct control and manipulation of that geometry.

Using a single joint for the head/skull of our creatures and characters keeps our work close to anatomical correctness; it also gives believable biomechanical movement too. However, we could go ahead and have multiple joints for the head/skull. These additional joints would allow use to twist, twirl, rotate, skew, and stretch the head/skull area of our character. Sure, that would be crazy, but, should we be creating a stylised character that needs to fit into a cartoony universe, this would be a perfect addition.

Anatomy and biomechanics should form the base foundations of our research, but, by adapting this information, we can cater for a wide range of styles and needs for our productions.

Creature Adaptation

When we try to convert anatomy, biomechanics, and FACS Action Units across to creatures, it can be a little daunting and may seem overcomplicated at first. By adapting this information to suit our needs, rather than directly converting things, it can make this process a little easier and a lot more straightforward.

By first assessing and listing the sorts of movements and poses our creature will need, we get a clearer picture of both what is needed for the rig and what sort of control scheme is most suitable for our animators.

Belraus is a big brute of a creature, and, although the possibilities of speech from a creature like this are limited, we still need to keep in mind the Facial Action Coding System (FACS) so we can give the animators enough control over specific sections of the face. Let us start to dissect the face of Belraus so we know what sort of system we will apply to this creature's facial rig.

- **The Head/Skull**
 Logically, the best place to start with any character's or creature's facial rig is the head/skull. This makes up the main mass, or bulk of the facial area, and, as a consequence, everything has to follow along with it.

 The head of Belraus needs to be pretty rigid with the only movement coming from the pivot location of the skull (which we already have in place from the body rigging). Because of this, using only one joint for the head is more than sufficient as we do not have the need for any cartoony twisting, turning, or other deformations.

Skull
- Head up
- Head down
- Head left
- Head right
- Head twist left
- Head twist right
- Head position

Jaw
- Upper jaw open
- Lower jaw open
- Upper jaw bend
- Lower jaw bend
- Dislocate lower jaw
- Dislocate upper jaw
- Upper jaw slide
- Lower jaw slide

Eyes
- Eyes up
- Eyes down
- Eyes left
- Eyes right
- Eyes close
- Eyes wide
- Eyes wink

Brow
- Brow up
- Brow down

Tongue
- Tongue up
- Tongue down
- Tongue left
- Tongue right

FIG 6-93 Create a list of movements and poses our creature will need. This gives us a clearer picture of what is needed for the rig (the internal structure) and the control scheme that would be suitable for our animators.

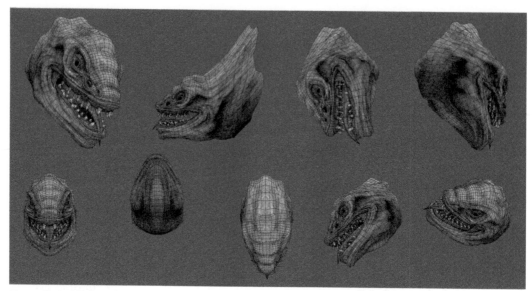

FIG 6-94 The head/skull area of most creatures and characters make up the main mass, or bulk of the facial rig.

- **The Jaw**
 A human jaw bone consists of one main joint that pivots just below the bottom of the ear lobe.

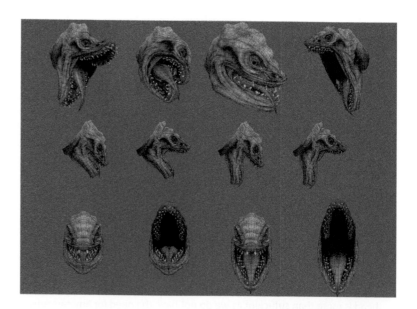

FIG 6-95 The jaw is usually the area of the face that has the most movement because of the opening and closing of the mouth.

Should we be rigging a more humanoid character, this would be the perfect location to place our jaw joint. Belraus does not have any ears, and, if we tried to use a similar jaw pivot position for a creature like this,

FIG 6-96 A human jaw rotates just below the bottom of the ear lobe if we look at it from a side-view.

the visual appearance when the mouth is opened and closed would look incorrect and unrealistic. Two properties we are not trying to match.

Because of the shape and structure of his jaw, having the pivot point positioned lower would allow for better movement and more believable deformations. I also really want to give the animator the freedom to dislocate the jaw of this creature. This will enable some great poses and simulates the sort of dislocated-jaw system that snakes do. And who is to say Belraus can't have that sort of jaw? After all, he is a hyper-real creature! For me, the simplest way to allow for jaw dislocation in our creatures is by having both a lower and an upper jaw bone.

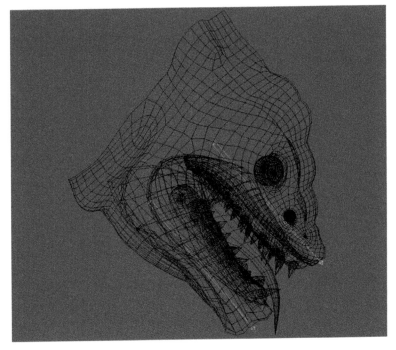

FIG 6-97 By having both a lower and upper jaw joint, we can dislocate the jaw easily and give the animators a lot of control options.

This setup should work well for what I am trying to achieve with this creature. Additionally, I could include multiple-joints on these jaw bones so some muzzle and jaw bending is available. Obviously, this is just a cool "extra" feature to have, and it is not required for the specific movements I need for Belraus. It is definitely something to think about.

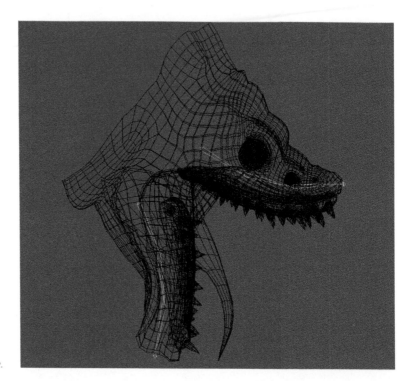

FIG 6-98 Each jaw bone could have multiple joints, which would give additional "bending" controls to the muzzle and jaw areas of the creature.

- **The Teeth**

 Belraus has some big teeth! Sure, he has a big mouth and jaw too, but his teeth are really massive. In usual situations like this, it is a good idea to give the animation some control over the position and scale of the teeth. This kind of setup can be something as simple as a Point Helper, custom controller or a simple attribute. As the teeth make up such a large section of Belraus's jaw and facial structure, I will not be giving the animator any additional control for these, as I will spend that time making sure the teeth move and deform correctly with the muzzle and additional jaw joints.

 Should the teeth of your creature be super-ridiculous huge-tastic, you should also think about some automation of both the teeth positioning and scaling. With the jaw opening and closing, automation of the position and scale of the teeth could be very desirable, specifically when fully closing the mouth. It is a good way to stop any geometry penetration that could be an issue with large teeth geometry.

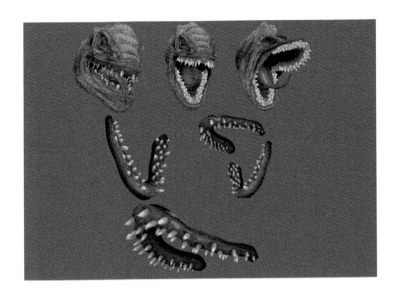

FIG 6-99 Teeth – Not only are they good for chewing, they gives us something else to think about when rigging a creature's head.

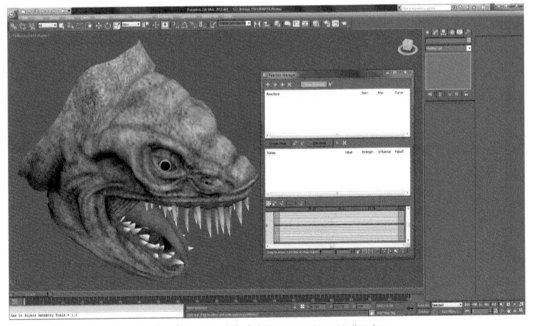

FIG 6-100 Automating the position and scaling of the teeth can help eliminate any geometry penetration when closing the mouth. Using the Reaction Manager for these kinds of circumstances is probably the most intuitive way to set this up.

Automating the position and scale of the teeth could be done a number of different ways, as with everything. I find that using the Reaction Manager for this kind of setup is one of the most intuitive ways.

251

- **The Tongue**

Belraus has a "standard" tongue. Although it is rather large, there is nothing special or particularly unique about it. Having said that, I have yet to see a "standard" tongue rig on any creature or character.

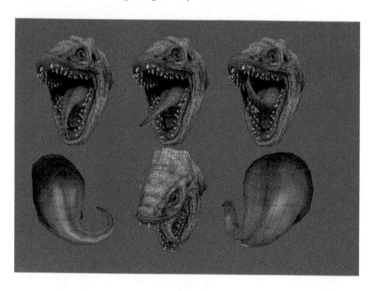

FIG 6-101 The tongue... good for giving things a licking!

A simple FK system could be enough. We could add custom attributes to a controller as additional control for this, or we could even a spline IK system, should you want some kind of additional controls.

Keep in mind that the tongue can twist, turn, and curl, so some additional joints may be needed if you want to have this sort of control.

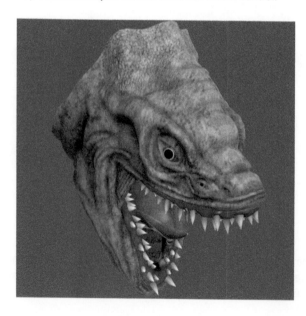

FIG 6-102 Remember what sort of movements the tongue needs for your creature. A "standard" tongue is a relatively simple setup, but remember that the tongue can twist, turn, and curl, so adding additional joints could be a winner. If your creature needs something a little more complex, a spline IK system could be what you need.

- **The Eyes**

The eyes of a person, animal, fish, character, or creatures are often referred to as the "windows to its soul." It is incredible that, just by looking into the eyes of a character, it is possible to read so many emotions. Of course, having the rest of the face there to give us indicators of the emotions felt by the character are helpful, but phrases like "the eyes just look dead" are commonplace when speaking about digital characters, showing how affective the eyes are at showing emotion and feeling.

FIG 6-103 You can tell a lot just by looking into the eyes of a character or creature.

Of course, there are many factors that contribute to the "deadness" in some CG eyes. The materials used, the textures applied, and the animations all affect how the eyes are perceived, just as with the rest of a digital character. The rig is often forgotten about; after all, the eye just rolls around and looks at things, right? Well, yes and no. Sure, the eye does have to "roll" and "look" directly at things in the scene. Things like how the eyes roll affects the geometry surrounding it. The eyelids sliding and how they close, as well as the dilation of the pupils, are other more secondary actions that need looking into (pun intended) from a rigging point of view (yeah, that's another one).

Belraus is no different; he needs to look around, which we can simulate easily by a single joint with its pivot in the center of the eyeball. Surrounding geometry needs to be affected by the eye movement, and we could use simple skin weighting, additional joints, or morph targets to simulate this. The closing of the eyelids can be achieved by using more joints or morph targets and finally the pupil dilation. We can edit the tiling size of the texture to simulate this movement; we just need to give the animator a way to access it.

FIG 6-104 The eye rig for Belraus can include a custom "control board" setup for the main control, additional controllers to drive morph targets for the closing of the eyes, and simple skin weighting to affect the surrounding geometry as the eyes move around.

· **Expressions**

FIG 6-105 Expressions convey thought and emotion to the audience.

As we already discussed, Belraus is not a talkative creature in that he is incapable of speech. We have also looked into the fact that using only

"expressions" for our face rig is not the best way to go for a main character or creature because of the various limitations and lower-quality output of this technique when compared to a setup that relies on the FACS. Because of this, Belraus will have to use an adapted, but relatively limited, version of the FACS, which should allow for the kinds of facial expression that may be needed. I still would not recommend any kind of speech with this creature, but the possibility is there should we wish to implement it.

The Setup

Should you be setting up this creature for some kind of real-time system, you need to be aware of the limitations you may be "faced" with (I know, I know, another pun!). Your options, at this point, could be limited to just using bones/joints, or a finite number of morph targets. If this is the case, then please tailor this setup section to fit your needs, as a lot of what we are going into may not work for you. However, the techniques discussed previously will work just fine; this next section uses those techniques but adds to and expands on them, which is more suited for a TV or feature film environment. Of course, as time goes on and technologies get better and better, this may not even be an issue, but I am guessing some of these following additions will be.

FIG 6-106 Working with a real-time system can be somewhat limiting when we are setting up our creature rigs and, specifically, our face rigs. Remember to adapt the techniques discussed here so they can fit within your own production environment.

With that said, let us get to it!

Working with morph targets increases the size of a 3ds Max file, as well as adds to the calculations that have to take place; these factors can slow down the scene file. Although the face and facial rig does not need to be separate from the body of the creature, it can help with keeping the scene as fast as possible. Less geometry (by cutting off the head from the body) means less morph target data, and it can also help for more complex setups. At the moment, the head of Belraus is attached to his body, and the smart thing to do at this point would be to disconnect the head of the creature so we can work on this as a separate entity. However, for the sake of clarity, I am simply duplicating the geometry and hiding the geometric faces that make up the

body, leaving just the head to focus on. Of course this is going to slow down this scene and increase the file size, but, for our learning journey, I think it is the best thing for now.

So, with the additional face/head geometry created from the duplicate original geometry, we can look into making a note of the head joint's pivot location, as this affects everything in the face rig we are going to create. I usually mark this pivot location by either duplicating the head joint or by using a Point Helper, which is aligned in both position and rotation to the existing head joint. This is an important step, because all movement for the head of the creature emanates from this location.

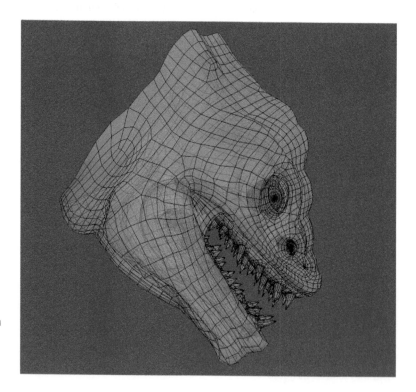

FIG 6-107 Our new duplicated creature with just head geometry displayed that I will be working with for the creature's facial setup. Note that I have marked the head's pivot location with a Point Helper.

With this scene now saved, I can really start to work on the head rig.

The first thing to do is add in any additional joints that will be used to drive the main sections of our facial rig. For me, this includes the jaw bones and the eye bones.

Starting with a single jaw bone for both the upper and lower jaw, these mark the locations for where the main deformation will happen for the jaw. I am running additional joints down each of these jaw bones for extra jaw and muzzle deformations.

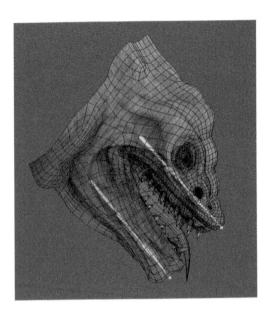

FIG 6-108 Additional joints have been added to the Belraus jaw bones so we have extra control over the deformations of both the upper and lower jaw sections.

These additional bones need to be added to the base skeleton (linked to the head bone) and skinned correctly. It is worth noting that I am only adding those additional jaw joints into the base skeleton, as they are the only joints I am interested in skinning to the head. The original jaw joints are for rigging purposes only. Simply duplicate these bones again for the face rig and link them to the Point Helper that marks the location for the head joint pivot.

With the jaw joints skinned and in place, we move onto the creature's eyes. Each eye needs its own joint that it can either be linked or skinned to. These joints are usually linked directly to the head joint of a creature; however, in the case of Belraus, where there are additional joints for muzzle deformation,

FIG 6-109 Usually, the eye joints of a creature can be linked directly to the head joint. In Belraus' case, the eye joints need linked to the muzzle joints so they move along correctly when the jaw and muzzle are deformed.

257

I need to work out which muzzle joint each eye needs linked to so it moves along correctly as the jaw and muzzle deform. Not too difficult, but, if the linking is not correct, things are not going to look great.

The joints for the face rig are now in place, and we can start to work on the morph targets that will give us additional control.

Duplicate the head geometry, remove the skinning, and slide it over to the side so we can see what we are working on more clearly. It is also a good idea to duplicate the eyes and teeth (or any other head/face geometry your creature has) so we have reference of them while we create our facial morph targets. Make another duplicate of this duplicate and slide it over once more so we have three separate creature geometries in the scene.

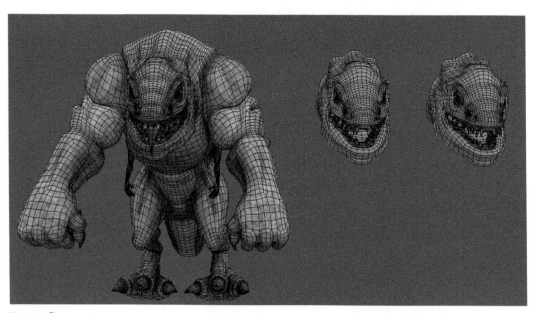

FIG 6-110 Three separate creature geometries are needed to start our morph target face rig.

What we have done here is started a multi-layered facial rig, just like we did with the body rig. The body rig for Belraus has a "base rig," "animation rig," "face rig" (which we are working on), and "deformation rig" (which we will cover in Chapter 7). These "layers" of the rig keep things modular. With the face rig, we can do the same by using a "driven rig," "driver rig," and multiple "input rigs."

Trying to explain this in words is somewhat difficult, so, to make things easier for you to understand and for me to tell you about it, take a look at this diagram and table:

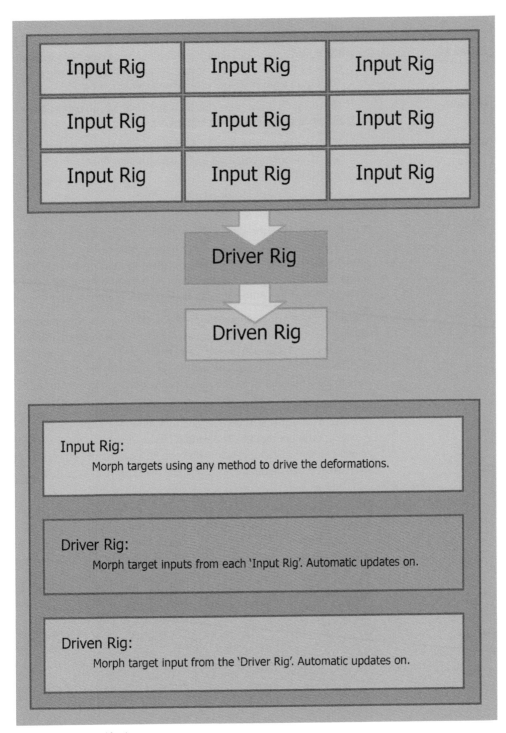

FIG 6-111 A multi-layered facial rig.

SECTION	DESCRIPTION
1) Driven Rig	The driven rig includes skinning information from the main skeletal structure for the creature. All other deformation inputs are driven 100% from a morph target connected to the driver rig.
2) Driver Rig	The driver rig acts as a conduit for many other morph targets. These morph targets are all driven from multiple input rigs.
3) Input Rigs	There can be multiple input rigs. These rigs can be either joint-based setups, deformer-based setups, or actual morph targets that feed directly into the driver rig.

The "driven rig" includes only the most basic of joint skinning setups and usually only contains the eyes and main head joint (I have added the jaw/muzzle joints to this for Belraus to keep things a little easier to work through). Although it has a "Morpher" modifier applied to this section, there is only one morph target that is active. This morph target is the "driver rig," which is always set to 100% with the "Automatically reload targets" option set to "on."

The "driver rig" has no skinning information, and only a "Morpher" modifier is applied to it. This Morpher modifier has multiple morph targets that come from the "input rigs." This section of the rig also has direct input from the animation controls we will setup in just a bit. Just like the driven rig Morpher modifier, we have to make sure the "Automatically reload targets" option is set to "on."

The final section or piece of this puzzle is the "input rigs." There can be as many of these pieces as you like, and they form the basis of the facial movements for our creature. These input rigs are driven by joints or deformers to make either facial shapes (eyes blink, mouth smile, mouth frown, etc.) or movement-based deformations (jaw open, jaw close, head squash, etc.).

We are simply expanding on the techniques used previously in this chapter but separating out various sections. The driven rig takes most of its information from the driver rig. The driver rig sits as a "hub" for most facial

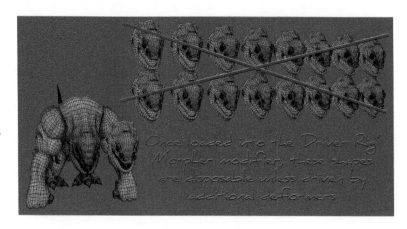

FIG 6-112 By using a multi-layered face rig approach, we compartmentalize sections of the rig, which allows us to change, edit, or even throw away facial shapes we do not like, want, or need without the fear of breaking another part of the rig.

inputs, and the input rigs become the various shapes or states for our face rigs—the morph targets if you will. These input rigs can be changed, edited, or thrown away with little to no effects shown on the driver or driven rig. This is the main reason for splitting out the face rig into these separate, compartmentalized sections.

I like to color these various sections of the face rig so they are visually easier to distinguish. Generally, the "driven rig" stays the color of the original creature as, after all, this is what the user will see when animating. I color the "driver rig" bright red, and the "input rigs" bright green.

I can now go ahead and add a "Morpher" modifier to the original geometry, which is now the "Driven" geometry of this setup. Add the "Driver" geometry as the only morph target that should be set to 100%, and make sure the "Automatically reload targets" is set to "on." From this point on, any changes to the "Driver" geometry are reflected in the "Driven" geometry of the face rig.

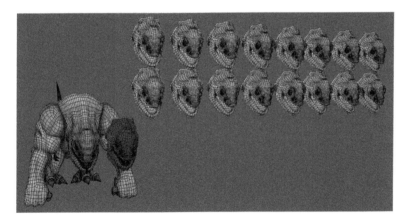

FIG 6-113 I color the "Driver" geometry red and the "Input" geometry in green so I can visually see which geometry is driving the "Driven" and the "Driver" geometries. This color-coded geometry may seem trivial, but, when you start pushing your face rigs into hundreds of morph targets (input rigs), it can really help out.

Add the Input geometry as a morph target for the "driver" (red) rig geometry. Again, make sure the morph target value is set to 100% and "Automatically reload targets" is checked "on." With this all set correctly, you should notice that any manipulations you do to the "input rig" filter down to the "driver rig" and then to the "driven rig." This flow of information allows us to have input rigs that indirectly update the base geometry (driven rig), meaning we can test out shapes quickly and easily without disrupting our main setup.

Input rigs can use a mixture of joints, deformers, or the simple push and pull of vertices to create the shapes needed for a complex facial rig. Hopefully, you should now be able to see the benefit of splitting out the face rig into these three stages. Of course, now is the hard part… We have to create all of the face shapes, movements, and deformations needed to finish the face rig for our creature.

The face rig for Belraus, or indeed any creature, can be as simple or as complex as you need. With Belraus being an example rig, his facial setup will be kept simple, but extremely functional, by using the following face shape table as a guide.

Belraus Face Shapes (Input Rigs)			
Blink (Left Low)	Blink (Left High)	Blink (Right Low)	Blink (Right High)
Brow Up (Left Low)	Brow Down (Left Low)	Brow Up (Right Low)	Brow Down (Right Low)
Brow Up (Left High)	Brow Down (Left High)	Brow Up (Right High)	Brow Down (Right High)
Nose Flare (Left)	Nose Flare (Right)	Mouth Wide (Left)	Mouth Wide (Right)

Additional input rigs can be added at any time, and more complex setups, like sticky-lips, or FACS-based facial shapes can be applied to this rig easily and at any point.

FIG 6-114 Creating great face shapes can take a long time. Time to knuckle down!

Animation Input

As we discussed previously in this chapter, the sort of control scheme you want for your creature can be down to personal preference, animator influence, or the needs of the production. It is important to note that the controls we create for the face rig need to drive the "driven rig" (eyes/jaw), the "driver rig" (morph target percentages), and the "input rigs" (all other face shapes and movements). Again, this can be a little confusing, but remember that we can pretty much use anything we need to drive these shapes and deformations.

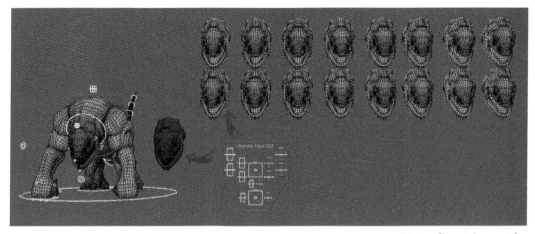

FIG 6-115 The controls we create for the animator input to our facial rig need to directly control the input rigs, as well as the driver rig.

Belraus is using both on-face controls (for the jaw) and a Control Board for the other face shapes, including the rotation of the eyes. There is nothing special in here, just some Reaction Manager inputs driving things forward.

Should you be including some additional rigging magic to your face rig, you may want to have control in addition to a Reaction-driven node; in fact, you may want to have one controller affecting another controller as well. This could be something like one controller moving along with another, or at least partially with it. We kind of have this sort of setup on the spinal system of Belraus, where by, if we move the chest controller, the smaller arms come along for free. However, we are unable to have any control over that position, as we are using a Position constraint that locks out any positional input from us, the user. To combat this, we can use 3ds Max's built-in "Animation Controllers".

Animation Controllers (Motion Panel)

Animation controllers allow you to have control over an object, even while it is influenced by another. This is especially useful when it comes to facial rigging setups, and, as the implementation of this is pretty simple, it is a good technique to have in our box of tricks.

1. Create three Point Helpers, and position them in a line.
2. Select the central Point Helper, and head over to the "Motion" Panel.
3. Expand the "Assign Controller" section if it is not already.
4. Select the "Position" transform, which should be assigned its default controller of "Position XYZ."

FIG 6-116 The Motion Panel gives us access to the Animation controllers for each object in the scene.

5. Use the "Assign Controller" button to replace the "Position XYZ" controller with a "Position List" controller. This "Position List" controller allows us to create a list of position-based controllers for this Point Helper.

6. Expand the Position controller, and you notice you now have a "Position XYZ" controller and an "Available" controller. This "Available" controller allows you to add additional controllers to the Position List, which can give you different outcomes.

7. Select the "Position XYZ" controller, and assign a new "Position Constraint" controller in its place.

8. Add the other two Point Helpers as the Position Targets for the position Constraint.

9. The central Point Helper now moves along with both of the other Point Helpers in the scene. However, you are unable to have direct control over the central Point Helper, because it has a constraint applied to it. To fix this, select the "Available" option in the Position List controller and apply a "Position XYZ" controller.

FIG 6-117 A Position List controller allows us to "stack" position controllers together to give various outcomes. Here we are adding a "Position Constraint" controller to the stack.

10. In the "Position List" section, set the "Position XYZ" as active by selecting it and using the "Set Active" button.

FIG 6-118 Be sure to set the "Position XYZ" controller as the active controller or you still will not be able to move the constrained Point Helper.

You should now be able to move the central Point Helper around, even though it is still affected by the other two Point Helpers via a constraint. Changing the weighting of the Position Constraint controller can give different affects, and you can utilize these powerful Animation controllers to your advantage.

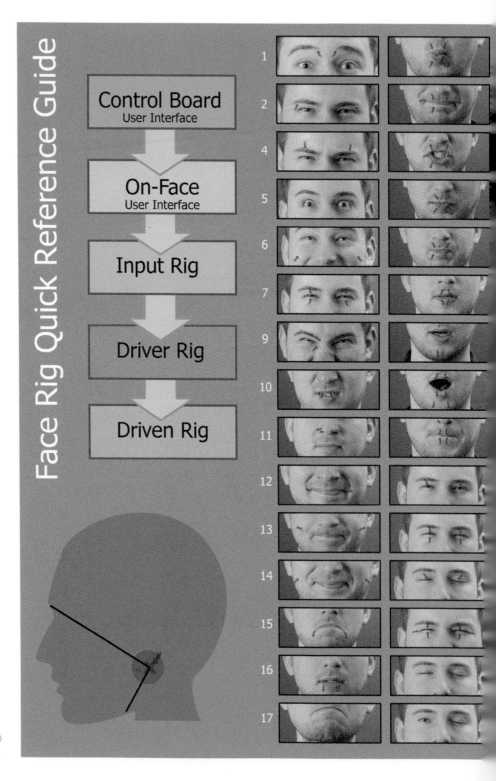

FIG 6-119 Facial Setup Quick Reference Guide.

AU	Description
1	Inner Brow Raiser
2	Outer Brow Raiser
4	Brow Lowerer
5	Upper Lid Raiser
6	Cheek Raiser
7	Lid Tightener
9	Nose Wrinkler
10	Upper Lip Raiser
11	Nasolabial Deepener
12	Lip Corner Puller
13	Cheek Puffer
14	Dimpler
15	Lip Corner Depressor
16	Lower Lip Depressor
17	Chin Raiser
18	Lip Puckerer
20	Lip Stretcher
22	Lip Funneler
23	Lip Tightener
24	Lip Pressor
25	Lips Part
26	Jaw Drop
27	Mouth Stretch
28	Lip Suck
41	Lid Droop
42	Slit
43	Eyes Closed
44	Squint
45	Blink
46	Wink
51	Head Turn Left
52	Head Turn Right
53	Head Up
54	Head Down
55	Head Tilt Left
56	Head Tilt Right
57	Head Forward
58	Head Back
61	Eyes Turn Left
62	Eyes Turn Right
63	Eyes Up
64	Eyes Down

Rig Attach

When your facial rig is ready, you need to attach it to the body of the creature. A simple position and rotation constraint should be more than sufficient to get the face rig and body rig working together.

Additional Facial Rig Systems

Of course, joints/bones and morph targets are not the be all and end all of facial rigging systems. They do, however, form the basis, or the foundation, of most face rigs I have seen out there in production.

Additional deformers, such as FFD/lattice modifiers, non-linear deformers, lines/curves, and a whole variety of other methods, can help enhance and drive your facial setup.

Other additions to these systems include muscle systems, that is muscular geometry/shapes that expand and contract simulating the movement of real facial muscles, in turn, influencing the surrounding geometry. Muscle systems can become overly complex, but, if they fit the purpose and give the desired result, then it is worth researching and implementing this kind of setup in your facial rig.

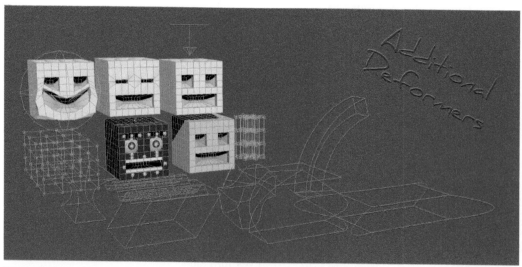

FIG 6-120 Additional deformers can and should (if possible) be used in conjunction with joints/bones and morph targets to enhance and drive your facial rig.

All of these additions can be used in conjunction with joints and morph targets. As long as the desired output can handle this kind of data and you have the time to implement all of these features, then go for it!

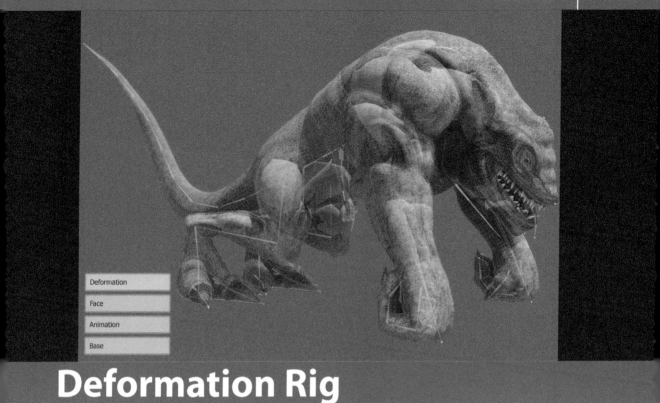

Deformation

Face

Animation

Base

Deformation Rig

"And although our bodies are bounded with skin, and we can differentiate between outside and inside, they cannot exist except in a certain kind of natural environment."

Alan Watts

We, as an audience of film, TV, video games, magazines, and all other forms of media, are demanding. Not only are we demanding, but we are even more demanding than we previously were. Every second we are exposed to these mediums, we demand more and more from them: better audio, better visuals, better story, better characters, better everything.

From a Creature TD's perspective, it is our job to bring realism and believability to our creatures and characters. This not only involves creating complex, but intuitive and easy to use, rigging solutions, as well as flesh-surface deformations that mimic reality as closely as possible.

We have a number of tasks to complete for our deformation rig to look and feel as it should. From the complex interactions between bone, muscle, and skin, to muscle-to-muscle collisions and even a creature's breathing, all of these have to be taken into consideration when trying to create a believable creature.

Throughout this chapter, we look over a number of deformation solutions that complete and refine our creature's basic skinning, as well as pushes beyond that to create additional flesh-surface deformation enhancements, taking our creature to the next level.

Advanced Skinning

During our base rig, we spent some time creating the basic skinning for our creature. What we created is more than fine for animation and development purposes, but this sort of flesh-surface deformation does not stand up when sent out to our audience. We have to work on making this skinning less of a "work in progress" skin to a finished skin with deformations that are more refined, more realistic, and more believable.

Grab the geometry of your creature and head on over to the Skin modifier. Take another look over the skinning you already have. Is there anything else you can improve on by using the Weight Tool and the Weight Table? If there is, then do not just sit there looking at it! Edit those vertices that could be better. This could take some time, but, as always, it is worth doing well so the final results look great.

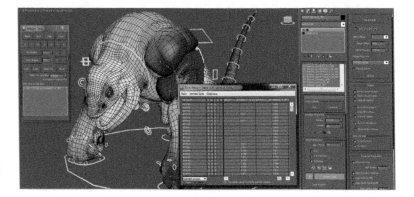

FIG 7-1 Once again, we revisit the Weight Tool and the Weight Table to make sure our vertex weighting is as good as we can possibly make it.

With some time spent editing the vertices of our creature (again), we start the process of "painting weights."

Painting weights is the process of digitally painting weight distribution on our geometry using the "Paint Weights" tool and all relative options. The "Paint Weights" tool can be found in the main "Parameters" section of the Skin modifier, right under the "Weight Tool" spanner icon. By turning the Paint Weights tool on, it allows us to click and drag the cursor over vertices in the viewport to brush on skin weighting for the selected bone. The button next to the Paint Weights tool is the Painter Options ('...'). These options allow us to control the brush envelope, use pressure sensitivity, change the visual appearance of the brush, and enter mirror painting mode.

FIG 7-2 Painter Options allow us to change a number of attributes for the brush we are painting the skin weights with.

In addition to these options, the "Paint Blend Weights" button found under the Paint Weights and Painter Options buttons allows us to toggle whether or not the brush blends weights together or adds weights. Both adding and blending weights are affected by the "Bone Affect Limit" and not watching this can get us into a load of trouble, quickly!

FIG 7-3 Painting skin weights is a tricky business and can get us into trouble pretty quickly if we are not careful.

There is no easy solution to painting skin weights. Skin weighting is a true art form. It forms the basis of most flesh-surface deformations, and, done badly, it can really affect the overall look of a character or creature as it moves. Many people dislike painting weights, or skinning in general, and I can sort of

understand why. It can take a long time, and you can end up going in circles trying to correct a bad deformation that you seem to just keep pushing from one place to another. However, I find it kind of relaxing. It is one of those times I can really shut off and focus just on the skin weighting. OK, I am usually listening to music, a podcast, or watching a movie at the same time, but, for me, it is a chance to really focus on something that can make or break the creature.

We could refine the skin infinitely, but it is worth noting that skinning alone will not get you truly believable flesh-surface deformations. But, if you are working with a real-time engine, or even crowd-simulation software, your only option may be that you have to use only the Skin modifier.

Corrective Shapes

Bad deformations happen. Relying on skinning alone can (and often is) a fine way of doing things, but removing all incorrect deformations by just using the Skin modifier is pretty much impossible. Corrective shapes are one of the ways we combat these deformation issues. What are they? Well, corrective shapes are just that—shapes that correct things, such as bad deformations.

FIG 7-4 Corrective shapes can remove bad deformations from a rigged model.

Because of their versatility, the practical implementations of using corrective shapes are vast, and they are often found not only in the body, but also the face of our creatures and characters. There are also a number of different ways a corrective shape can be applied to our creature. Two of the most common techniques include driven morph targets and pose space deformations (PSD).

1. **Driven Morph Target Corrective Shapes**
 This technique simply refers to using a morph target, of which the shape corrects a deformation driven by another input, such as a controller, joint, deformer, or other morph target. Because we drive a morph target channel, we can only use a single axis or single movement for this method. This means that things like shoulders require a number of corrective shapes, all driven by different rotations of the joints (or FK controller).

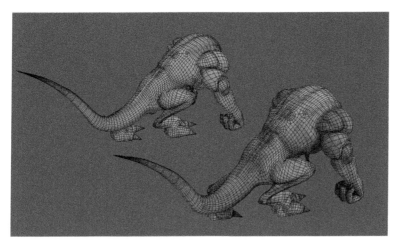

FIG 7-5 Simply create a morph target that corrects a bad deformation for this method.

2. **Pose Space Deformation (PSD)**
 Pose space deformation is another shape interpolation technique. Similar to a driven morph target, this solution interpolates a driven shape according to a set of targets at a particular driver value. The advantage of PSDs is that we can use multiple drivers, such as the full rotation of a joint, and multiple shapes while keeping the same performance associated with more traditional shape interpolation techniques.

FIG 7-6 PSDs allow us to use multiple shapes with multiple drivers while keeping the same fast performance as using just a single morph target.

3ds Max already has its own kind of pose space deformation straight out of the box, in the form of what is called "Skin Morph." This is a big advantage to us, as we only have to work out how to use this tool and then we can start using pose space deformations with little to no trouble. We take a look at the Skin Morph tool in just a bit, but, for now, we have even more options to look at.

Right at the bottom of the Skin modifier options is the "Gizmos" rollout. The controls in this section allow you to deform the mesh according to the angle

of the joint. This is incredibly similar to the Skin Morph modifier but allows us to have this kind of pose space deformer control at the Skin modifier level.

FIG 7-7 The Gizmos rollout in the Skin modifier gives us access to three deformers that can help improve our skin weighting deformations.

There are three deformers available in the Gizmo rollout section of the Skin modifier:

1. **Joint Angle**
 The Joint Angle deformer uses a lattice that can deform the vertices on the parent and child bones.
2. **Bulge Angle**
 The Bulge Angle deformer uses a lattice that only works on vertices associated with the parent bone.
3. **Morph Angle**
 The Morph Angle deformer works on vertices of both the parent and child bones, but does not use a lattice. This behaves most like the Skin Morph modifier, which we cover in Chapter 8.

The Skin Modifier Gizmo Tool

This tool is relatively easy to work with. It is worth taking a look at even if you cannot use it in your productions final output. You never know when

it could come in handy later. This tutorial focuses on using the Morph Angle Deformer (as I find it to be the most useful of the three options we have available).

1. Select the skinned geometry of your creature (I am using a simple cylinder with two joints to illustrate this example).

FIG 7-8 I am using a simple cylinder with two joints to illustrate how to work with the Morph Angle Deformer. You can use your creature's geometry if you wish.

2. Make sure the creature is in its default pose.
3. Turn on "Edit Envelopes."
4. In the "Bones List" under the "Parameters" rollout, select the bone you wish to affect with the Morph Angle Deformer (the bone that will transform to drive the deformation). This bone has to have a parent or the deformer will not work.
5. Select the vertices you would like to affect with this deformer.
6. Expand the "Gizmos" rollout.
7. Use the drop-down menu to select the "Morph Angle Deformer" option.

FIG 7-9 Make sure the creature is in its default pose, select the joint you want to affect the Morph Angle Deformer in the Bones List, and select all of the vertices you want affected by this deformer as well.

8. Use the plus "+" button to add a Morph Angle Deformer to the geometry.

There will now be a new rollout in the Skin modifier named "Deformer Parameters." This is where you can change and edit the deformer properties.

The "Base Morph" has already been created, which is the morph target that the geometry will morph back into when it is at its default position. You now need to transform the joint into a new position where you want to fix the deformations.

9. Transform the joint to the position you want to affect the geometry deformation with the Morph Angle Deformer.

You can now edit the geometry manually to fix the deformation issues you have. There are two options to choose from when doing this.

The first is to add an "Edit Poly" modifier to the geometry of our creature and edit directly on there. This enables you to use the "Add from stack" button in

FIG 7-10 A new rollout is created once the Morph Angle Deformer has been applied. This new rollout gives us direct access to the attributes of the deformer.

the "Deformer Parameters" options. It is worth noting that you have to turn off the "Edit Poly" modifier once this has been added to the Morph Angle Deformer, as keeping it turned on doubles the effect of the deformation.

FIG 7-11 We can use an "Edit Poly" modifier on top of the Skin modifier so we can directly edit the geometry and fix the deformations. To apply this to the Morph Angle Deformer, we use the "Add from stack" button. However, it is a good idea to switch off the Edit Poly modifier once applied to the deformer or we will see an additive, doubled-effect.

Your second option is to duplicate the geometry and create the deformation edits on the duplicate. This allows you to work in a more traditional morph target technique, and you can use the "Add from node" button to affect the Morph Angle Deformer once you are finished.

FIG 7-12 An alternative method is to use a duplicated mesh. We can edit and apply this duplicate to the Morph Angle Deformer by using the "Add from node" button. This technique resembles the steps used when creating standard Morph Targets in 3ds Max.

Muscle Systems

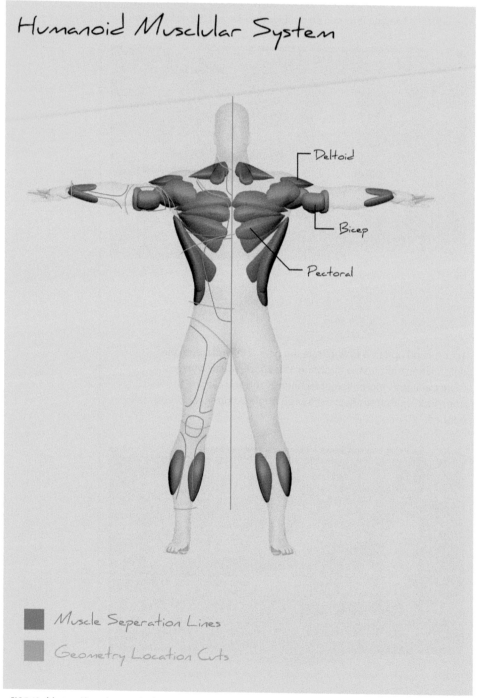

Humanoid Musclular System

Deltoid

Bicep

Pectoral

Muscle Seperation Lines

Geometry Location Cuts

FIG 7-13 A humanoid muscle system in place.

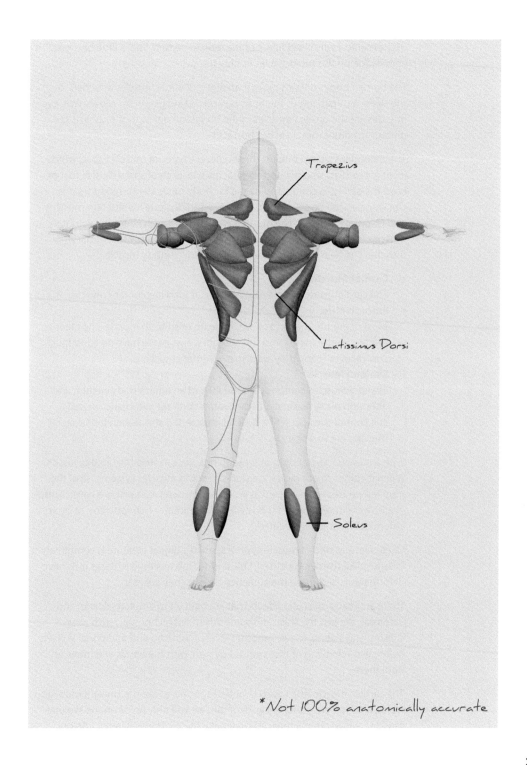

Trapezius

Latissimus Dorsi

Soleus

*Not 100% anatomically accurate

When it comes to the muscle systems in our digital creatures, we are more interested in the visual look and appeal of the finished creature than we are of the medical why's and how's of the muscle system. Still, a little background knowledge on the subject does not hurt, so…

The human body contains more than 650 individual muscles attached to the skeleton, enabling us the pushing and pulling power for movement. Eye muscles are the busiest muscles in the body, and our largest muscle is the gluteus maximus muscle in our buttocks.

The muscular system contains three different types of muscle tissue, which includes cardiac, smooth, and skeletal muscle. Each of these muscle tissues have the ability to contract, allowing for body movements and functions. Our muscles can be split into two types, which include involuntary muscles and voluntary muscles. The muscles we control ourselves are the voluntary muscles, and the muscles we have no control over are the involuntary muscles. The heart is a good example of an involuntary muscle.

- **Cardiac Muscle**
 The cardiac muscle is the heart muscle. It is an involuntary muscle.
- **Smooth Muscle**
 Most of our internal organs are made up of smooth muscle. The bladder, arteries, and veins fall into this category, and, as we have no conscious control over them, they are also involuntary muscles.
- **Skeletal Muscle**
 Skeletal muscles comprise around 40% of an adult's body weight, and, although many skeletal muscle contractions are automatic, we can still control the action of a skeletal muscle. It is this reason that skeletal muscles are voluntary muscles.

With a basic understanding of these things, we can stop the biology lesson. When it comes to our digital creatures needing muscles systems, all of the muscles we create are classed as voluntary muscles, because we have control over the creature, whether this is via direct animator manipulation or by an automated process we created.

Of course, any kind of muscle system seen in a digital creature is completely fake, just like the creature itself. Still, it is our job to simulate these muscular deformations and make the audience believe they are real.

There are many muscular effects that are difficult to emulate: flexion and extension are just the start, and some advanced techniques, such as skin sticking and sliding, require another level of thinking and additional skillsets. Before even thinking of that stuff, let us start with the basics and move on from there.

The cardiac muscle (the heart) is kind of specific, as are the smooth muscles (veins, arteries, etc.), and, because of this, we will only focus on the skeletal muscles, which are the muscles that make the most visual impact on our skinned creatures.

FIG 7-14 Skeletal muscles generally make the most visually impactful deformations to our skinned creatures.

These skeletal muscles work in pairs: one muscle moves the bones in one direction, and the other moves it back. I know I keep saying this, but, as with everything in 3D, there are a number of tricks and techniques we can use to create and replicate pretty much anything and everything. Again, muscles are the same as everything else, there are a lot of options, and it is up to us to use the best solution for our project and creatures.

Sadly, at the time of writing this, 3ds Max does not have a built-in muscle system that can rival what its competition already has. Both Maya and Houdini ship with great muscle systems already there for us to use, something that 3ds Max is really missing out on. That is not to say that we are at a complete loss, though. There are a few techniques that come to mind when thinking about muscle systems in 3ds Max.

1. **CAT Muscle System**
 The built in CAT system has its own muscle system that is quick and easy to setup. Additionally, this muscle system is not limited to just CAT rigs. It can also be used with Biped or even a custom rig.

2. **Additional Driven Joints**
 Should a muscle system not be available, the use of additional automatically-driven joints is an option to simulate a basic muscle system. For instance, a bulging bicep can be achieved by adding an additional joint that moves (to simulate a bulge) when the arm is flexed. We could even add springs to this joint to simulate some kind of muscle jiggle.

FIG 7-15 The built-in CAT system comes complete with its own muscle system to use.

FIG 7-16 Driven joints can be used to simulate muscles. We can even add springs to these joints to simulate jiggle.

3. **Geometric Shape-Based Muscle Systems**

 It can be somewhat labor intensive, but modeling the muscle system for our creature and using that geometry as extra skinning deformation data can create some interesting muscle effects.

FIG 7-17 Using geometry shapes like muscles can be used as additional skinning information.

4. **Joint-Based Muscle Systems**

We have the option of using joints that have the ability to squash and stretch to simulate muscles stretching and contracting. These joint-based muscles can also be modeled to replicate each muscle as needed.

FIG 7-18 Joints can be used to simulate muscle stretching and contracting.

5. **Pose Space Deformation (PSD)**

We just covered pose space deformation (PSD) in the last section for corrective shapes (Chapter 7 - Page 269), but they can also be used to simulate some muscular movements in our creatures. Yeah, that includes using the Skin modifier Gizmo tools, or the Skin Morph modifier itself (covered in Chapter 7!).

FIG 7-19 Pose space deformations can also be used to simulate muscular movements, as well as to correct bad deformations.

6. **Third-Party Plugin Muscle Systems**

There are plenty of third-party plugin muscle systems out there that are available for an additional fee. These solutions often offer additional

options and generally give more control over the muscle system, which gives a more realistic output.

FIG 7-20 Third-party plugin muscle systems offer additional control for additional costs.

Third-party muscle system plugins definitely give us the most believable muscle movement, but, if we do not want that extra cost and hassle of learning a new plugin, using the built-in methods get us 75% there. So, let us create a joint-based muscle to see how quickly and relatively easy this is.

Creating a Muscle in 3ds Max

Creating a muscle in 3ds Max is relatively simple, although this technique will not work for any output that does not support non-uniform scaling.

1. Create two Point Helpers, and space them apart in the scene.
2. Create a single bone joint chain that runs from the first Point Helper to the last.
 Animation Menu > Bone Tools…

FIG 7-21 A single bone joint chain that runs from the first Point Helper to the second.

3. Position constrain each joint to its respective Point Helper.
 Animation Menu > Constraints > Position Constraint
4. LookAt constrain the first joint so it points toward the second (end) Point Helper.
 Animation Menu > Constraints > LookAt Constraint

5. Select the first joint in the bone chain, and, under "Object Properties" in the "Bone Tools" rollout, turn off the "Freeze Length" option and change the "Stretch" option to "Squash."

FIG 7-22 Turn off the "Freeze Length" option, and change the "Stretch" mode to "Squash."

These joint-based muscle systems can be edited so they represent the look of actual muscles too. Simply by adding an "Edit Poly" modifier on top of each of the muscle's modifier stacks, we can edit the geometry as needed.

Ok, now that we have a muscle, it is simply a case of recreating as many of those muscles as we need, then placing and connecting them as needed. This is where our anatomy studies come into play once more. Keeping as close to real-life as possible is definitely the best bet for connecting any kind of muscular structure we have created.

Of course, even being extremely conscious of connecting the muscles correctly, things sometimes do not work as expected. In these kinds of

FIG 7-23 There are times that correctly linked muscles may not work as expected. In these situations, use whatever you need to get the job done. This could be anything from the reaction manager to a driven expression.

285

situations, using a reaction, script, or expression is totally feasible. Whatever works to get the job done!

Even with muscles added to the creature, there is still room for improvements. This technique, however, can form the basis of a solid muscle system that can be expanded and enhanced.

At this point, we have a muscle system that works, and everything moves along correctly with our rig; we now have the task of connecting these muscles to our creature's geometry!

Muscle System Skin Deformations

This is definitely more difficult than it sounds. Simply getting the geometry to deform with our muscle system is as easy as adding those muscles to the skin modifier and adding weight influences to the mesh; however, if we want to take this further, it becomes a whole new ball game.

Taking these muscle system skin deformations to the next level requires us to think of skin sliding, skin sticking, creases, folds, wrinkles, and other nuances that are not catered to by adding additional influences to the standard Skin modifier.

Now, there are third-party plugins that can really help, but, in keeping with using 3ds Max only, as the rest of the book has, we need to come up with a solution already available to us. First, though, let us think about what CG, animation, and VFX studios are doing to combat this part of the flesh-surface deformation process. Even if it is just you working on your own production, it is worth taking cues from the larger CG, animation, and VFX studios when it comes to technology advanced in all areas of computer graphics. Sure, as a single person or small team, you may not be able to implement all of the

FIG 7-24 Keeping up to date with what is happening at the larger CG, animation, and VFX studios keeps your skills and productions as far ahead of the game as you can possibly be. You do not want to get stuck behind the times, no matter how cool it is.

solutions they have, but it can be a good indicator, or at least a basic guide, to how you should think about things in your own productions.

First, third-party plugins are being utilized; however, we have already established that we will not be going down this route during this book. Studios definitely use what is already available in the applications as standard. For instance, the Morph Angle Deformer and Skin Morph modifier allow us to "fake" a lot of things when it comes to the deformations of our creature geometry. As this is relatively simple to implement and gives great results, it would be silly of us not to use these built-in tools to their full advantage.

FIG 7-25 We can rely on some of the built-in tools in 3ds Max, such as the Morph Angle Deformer and Skin Morph modifier, to simulate some muscle system skin deformations.

So, what else? Well, most studios are coming up with their own kinds of systems. These often involve tailoring cloth simulation algorithms to create a kind of global skin simulation driven by the underlying muscles and skeletal system. This is advanced stuff, and, as you can probably already tell, it is significantly past the boundaries of this book. In fact, we have not even touched on cloth simulation just yet, so, for now, we just have to make a mental note that this kind of thing is happening and is a way for us to enhance our creature's surface deformations.

FIG 7-26 Cloth simulation algorithms can be used to create a kind of global skin simulation driven by the underlying muscles and skeletal systems. This sort of thing is pretty advanced and definitely pushes the believability of a creature's skin.

287

Pose Space Deformation (PSD)

One enhancement and something we have briefly talked about, but not really looked into, is pose space deformation (PSD), or the built-in Skin Morph modifier. Combined with a muscle system, such as the joint-based system we just implemented, this technique can create amazing deformations that increase the creature's believability and "wow" factor.

It is worth noting that a PSD can be added at multiple points throughout a production. I prefer to add these after the muscle system is in place. This allows me to use pose space deformations to not only clean up any badly deforming geometry from both the rig and the muscle system, but also enhance the muscle system, by adding extra movements and bulges, as well as stretching or stress marks on the skin.

Skin Morph Modifier

Once again, I am working with a cylinder that has two joints already skinned to it. Feel free to use your own creatures for this stuff, but, for the purposes of clarity, I will stick with the amazing cylinder primitive.

1. Select the geometry.
2. Add the "Skin Morph" modifier from the modifier list.
3. The "Parameters" section of this rollout allows you to choose which bone affects the Skin Morph (I am using Bone002, as this is the bone that has animation attached to it).

FIG 7-27 Choose the bone you want as the "driver" for this deformation.

4. The bone has now been added to the Parameters section, and you can now rotate the joint into place where you want the Skin Morph to affect the deformations.

5. Once in position, select the bone in the Parameters rollout, and, under the "Local Properties" rollout, click the "Create Morph" button.

FIG 7-28 Manipulate the joint into the position you want the Skin Morph modifier to affect the geometry, and click the "Create Morph" button found on the "Local Properties" rollout.

6. "Morph 0" has now been added to the Parameters section under the bone. The next stage is to model the deformation you want to happen at this point, and, for this, you have two options available.

 a. Edit the mesh directly.

 To edit the mesh directly, click the "Edit" button under the "Local Properties" rollout of the Skin Morph modifier, and then directly edit the geometry into the deformation pose you want. When you are finished, simply click the "Edit" button again and you are done.

FIG 7-29 By choosing to edit the mesh directly, we can work on refining the creature's model without the need for additional targets to blend to.

 b. Use an external mesh (think of a morph target).

 Using an external mesh requires pretty much the same steps as using a standard morph target. Duplicate the mesh and collapse it so it is editable. Make your geometry adjustments, and, when you

are happy with the changes, click the "-none-" button, which can be found in the "External Mesh" section of the "Local Properties" rollout.

FIG 7-30 Using an external mesh as the target for the Skin Morph deformation works similarly to standard morph target creation.

There are many other options in the Skin Morph modifier that need tested, changed, and tweaked to ensure the deformations are working correctly. Be sure to check out the help files and work with this modifier to get the best rewards from it.

FIG 7-31 There are many settings and options in the Skin Morph modifier we have not even looked at. It is a good idea to sit down with the help manual and work out what all of these options can do and how they can enhance your Skin Morph deformations.

A Skeleton with No Control

All of these techniques are, of course, applied to the "deformation rig" component of the creature. This deformation rig is first taken from the "base rig" and resaved as a new deformation rig file. At no point should the animation rig have any of these techniques applied to it. Applying more advanced deformation techniques to the animation rig will simply slow down the deformation calculations, in turn, slowing down the animation team and their workflow.

Animation should be passed to the creature's base skeletal structure, and that should then drive the deformation rig we have been working on. This deformation rig is a rig that no animator should really need to see until the final output is delivered.

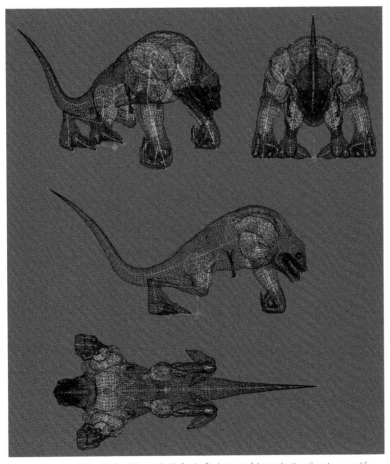

FIG 7-32 The deformation rig should be used only for the final output of the production; there is no need for any of this information to be transferred to the animation rig.

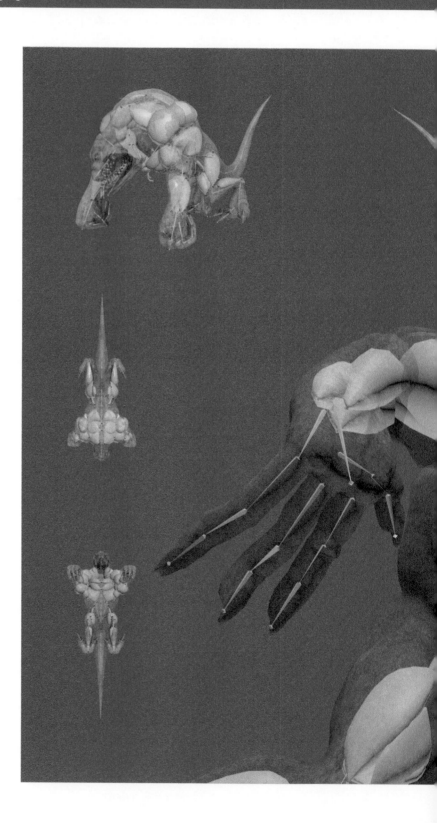

FIG 7-33

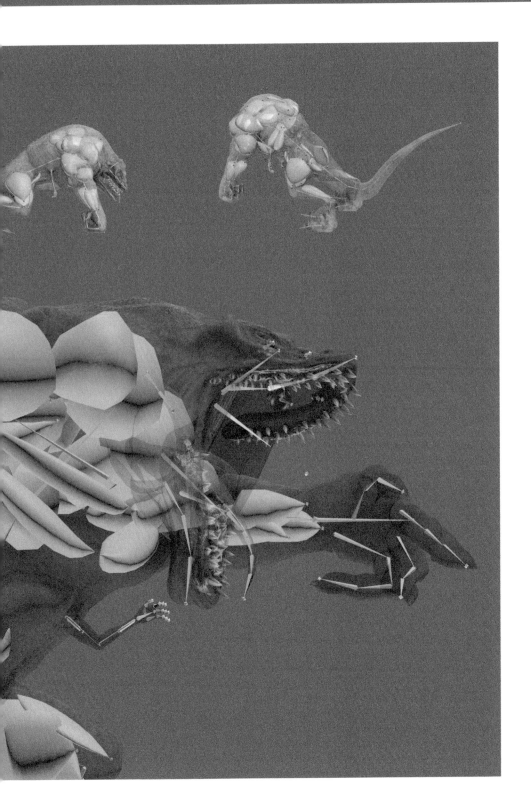

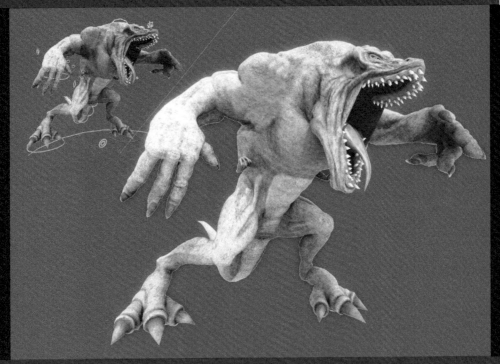

Finaling

"When you're finished changing, you're finished."

Benjamin Franklin

"Art is never finished, only abandoned."

Leonardo da Vinci

These two quotes work well together. I have never felt as though a rig of mine has ever been "finished." In fact, I could continue to change, tweak, edit, and enhance any number of my rigs' components for an eternity. I am never satisfied. However, there comes a time that we have to "abandon" our work.

In a production environment this "abandoning" of our creations is usually due to a looming deadline, the needs of another department, or some other task that is more pressing. For personal projects, it usually comes down to a self-imposed deadline, lack of time, boredom, or frustration. Whatever the excuse for this "abandonment," it is annoying to say the least, and the two quotes from Benjamin Franklin and Leonardo da Vinci complement each other well.

Alas, the time has come for us to finish with the rigging of our creature and move on to the final stages of its development, the "finaling."

Finaling is another one of those extremely big topics, and there are jobs out there for talented people who do just that — they add the final finesse to characters, creatures, and digital assets. These Finaling/Finishing Technical Directors complete the digital creature creation puzzle by adding the bells and whistles needed to really make the creature's shine and realize it's true potential. Albeit, these roles are usually reserved for film and TV, but I am sure we will be seeing this role move into video game production in the future. Well, if not this role, something similar I am guessing.

We are going to take a look at some aspects of creature finaling for production. Like I said, this is another huge topic, and it is out of the scope of this book to cover all the ins and outs of it. What we can do is look over some of the more common topics and techniques that will not only help you when finaling your own creatures and characters, but should also be pretty useful for rigging and production work in general.

Finaling for Real-Time Engines or Crowd Simulation

The finaling steps needed for real-time and crowd-simulation engines can differ vastly depending on the tools you are using. As a general rule, finaling for these systems comes down to removing all unnecessary data, as well as ensuring that the asset can be exported into a recognizable and usable format.

FIG 8-1 The approach to finaling for real-time and crowd-simulation engines can be vastly different, and it depends on the tools and programs you are working with.

Thoughts and decisions also need made on how animation data will be handled; animation exporting/importing, animation blend trees, and a number of other animation and rig related subjects all need consideration, planning, and implementation. There can be a lot of things to think about for this stage of the process, and every project can be different, so it is up to you to learn and find solutions for the tools you have to work with.

Geometry Cache

Caching geometry is a way of storing modifier and sub-object animation data to a disk file that records on the changes in vertex positions. This data can then be used to give objects animation instead of the traditional method of using keyframes. It is kind of like a super clever morph target that uses a data file as its target rather than another object in the scene.

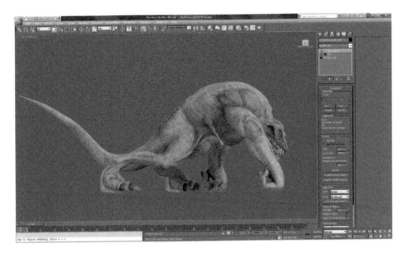

FIG 8-2 Caching geometry allows us to store changes in vertex positions to a data file that can later be used as a kind of animation data.

The primary benefit of using a geometry cache is that it allows us to remove all of the rig and modifier components of our creatures. In turn, this speeds up the animation playback and viewports so it is easier for us to work in the scene, can eliminate dropped frames of animation when trying to view real-time, and can help prevent crashes if 3ds Max gets overloaded. Other benefits include the ability to apply that same cached geometry animation to a number of objects, of which we can vary the start time and strength settings so they do not all move identically. Additionally, any simulated geometric movements, such as cloth or dynamics, can be cached, speeding up everything as we no longer need to keep evaluating the simulation in the 3D scene.

FIG 8-3 Using cached geometry has many advantages, the most notable is the speed by which it can increase our animation playback in the viewports of 3ds Max.

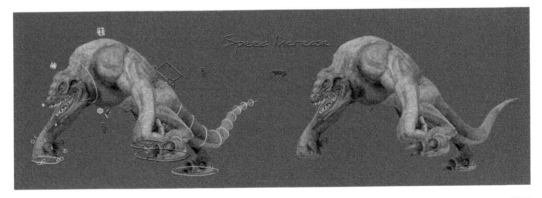

As you can tell, caching geometry can really help speed up workflows and increase productivity. Of course, the only time we can really do this is once the creature (or object) and animation has been locked down and will not change further. Hence, why we have kept this section until the "Finaling" process.

3ds Max has a built-in modifier that can cache geometry called the "Point Cache" modifier. This modifier is available in local and world-space versions, the difference being that the world-space version uses world-space coordinates instead of local-space coordinates. So, if your geometry relies on world-space modifiers, such as PatchDeform (WSM) or PathDeform (WSM), then you have to use the world-space Point Cache (WSM) modifier for it to work correctly. In all other circumstances, I suggest using the standard "Point Cache" modifier.

FIG 8-4 The Point Cache modifier comes in two flavors: local-space and world-space. Which you choose depends on what modifiers you have been using to deform the geometry.

Let us give this thing a test!

Using the Point Cache Modifier

You can apply the Point Cache modifier to your creature for a more in-depth analysis of the Point Cache modifier tool. However, to keep things clear and simple, use the cylinder with two joints and Morph Angle Deformer applied to it for this demonstration.

FIG 8-5 This demonstration uses the cylinder with two joints and a Morph Angle Deformer already applied to it.

1. Select the geometry you wish to apply the geometry caching to.
2. Apply the "Point Cache" modifier to the selected geometry.

FIG 8-6 Use the local-space Point Cache modifier found in the larger list of modifiers, as opposed to the world-space Point Cache (WSM) modifier closer to the top of the modifier list.

3. Check that the start and end frames match up with the "Start Frame" and "End Frame" parameters in the Point Cache modifier rollout.

4. Click the "Record" button.

FIG 8-7 Check the Start Frame and End Frame parameters, and then click the "Record" button to save out a geometry cache data file.

5. A new window appears that will allow you to save either an XML file or PC2 file. Stick with XML for now, and rename the file to whatever you wish.
6. Click the "Save" button.

 The Point Cache modifier has now exported a file that contains all of the vertex animation data for the selected geometry. Look at how you can bring that data back into the scene.

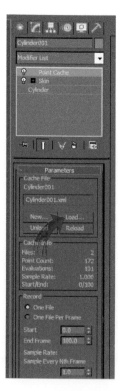

FIG 8-8 With the geometry cache data already saved, we can now bring this information back into a scene with just geometry.

7. Set the object back to its default pose.
8. Collapse the entire modifier list so you are left with just the geometry and no animation or movement.
9. Remove any rigging in the scene so it is just the geometry.
10. Select the geometry, and add a Point Cache modifier to it.

FIG 8-9 Collapse the geometry back to its original pose, and remove any rigging components from the scene, as they are no longer needed.

11. Click the "Load…" button on the Point Cache modifier rollout.
12. Navigate to your saved geometry cache data, and click the "Open" button to load it back into the scene.

You can now scrub through the timeline, and your saved Point Cache data file will have been read and transferred to the object in your scene.

FIG 8-10 We should now have a clean scene file with just the geometry in there. This geometry still has animation, as it is referencing the geometry cache data file we saved earlier. Should you be doing this on a deformer-heavy creature rig, you should notice a big leap in viewport and animation performance speed once the rig is removed and the Point Cache modifier is enabled.

There are obviously a few more options in the Point Cache modifier we have not discussed, and I suggest that you familiarize yourself with them so you can utilize the full potential of this pretty powerful and very helpful modifier. The ability to have access to a number of parameters that can edit the animation at this point is pretty fantastic, especially if you need to offset animation or change the weighting of the animation.

FIG 8-11 The additional parameters in the Point Cache modifier allow us to edit the animation even at this stage.

Oh, and just before I forget: As this modifier relies on an external file to read the animation data, should you move the data file or change the pathing of the data file, this modifier will no longer work. You have to reload the data file into the Point Cache modifier, should you need to change the data files location.

FIG 8-12 Remember that the Point Cache modifier needs to reference your geometry cache data file. Moving this data file or changing the pathing of this data file requires you to reload the data so the Point Cache modifier can find it again.

Cleaning and Correcting

With the geometry cache in place, our scenes should run quicker and smoother than before. This is a great point for us to take one final look at the creature and make sure the deformations are behaving and working as they should.

FIG 8-13 Arrgh! I missed a bit!

If you have missed any problematic deformation areas or the creature has been positioned in an extreme pose that breaks even our deformation rig, we have a final chance to go in to clean and correct the geometry.

This may not be a problem and everything may look fantastic already. If so, then great news, there is nothing else for us to do. However, if you are in a situation in which you need to spend a little time fixing up the final deformations, you can use as many tricks or techniques as you need on the already cached geometry.

Just remember, when you have finished up with these corrections, to resave a new geometry cache file using the Point Cache modifier.

Cloth, Hair, and Fur

The addition of cloth, hair, and fur can dramatically add an extra level of realism and believability to our creatures. With this added realism comes additional difficulties and specialist skills, from actually creating the cloth, hair, and fur, to making sure they behave as expected, to making sure the renders of these elements blend seamlessly into a realistic and believable image. These are all pretty advanced topics, and a lot of the larger CG, animation, and VFX studios employ specialists in these roles.

Cloth TDs (or similar roles) work specifically with any kind of cloth simulations. This could be from characters garments, to a flag, to even the flesh-surface

deformations of our creatures. Grooming TDs (or similar roles) work with the hair and fur of any object in the scene, ranging from characters hair, to the fur of a mammoth, to even the grass in the environment.

FIG 8-14 Cloth, hair, and fur simulations require a specialist skillset that can take years to master. This is not the image of a master.

Because of the difficulty in creating these kinds of simulations, there are many tools, attributes, and parameters available. These options help create complex toolsets to work with so the final results are indistinguishable from the real thing. The complexity of these toolsets means that, to master them, it takes time and dedication, just like rigging, animation, rendering, or any other specialism in computer graphics.

Although we do not necessarily need to be a master of these kinds of simulations, a good understanding of the basics and the toolsets can help not only create our own simulations, but enable us to speak and understand more clearly with others who specialize in these roles.

- **Cloth**

FIG 8-15 Cloth has a range of uses, from a tablecloth to a flag, and even as an option for our creature's skin.

Clothing, flags, sails, tablecloths, and even flesh-surface deformations: cloth simulation has a range of uses that can enhance the visual appeal

and believability of our scenes and creatures. As with any kind of simulation in 3D space, it requires a certain way of working to get the best results.

Creating Cloth Simulation

1. Create a sphere and a plane.
2. Place the plane above the sphere. This will be the cloth geometry.
3. Make sure the plane has enough length and width segments (I am going with 50 height segments and 50 width segments).

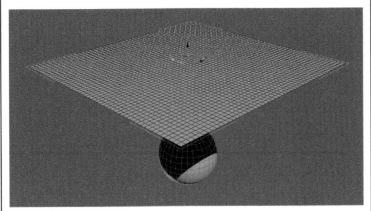

FIG 8-16 Place a sphere under a plane that will become our cloth for this demonstration.

4. Add the "Cloth" modifier to the plane.
5. In the cloth modifier object rollout, select "Object Properties." This new popup rollout gives us the parameters for editing all cloth-related objects in the scene.

FIG 8-17 Add a "Cloth" modifier to the plane, and use the "Add Objects…" button to add additional objects, such as the sphere, to the cloth simulation.

6. Use the "Add Objects…" button to add in the sphere to this cloth sim.
7. Set the sphere as the "collision object," and leave the settings as they are.
8. Set the plane to be cloth, and, for now, just use a preset.

FIG 8-18 The sphere needs to be the collision object, and the plane needs to be set as a cloth preset for this simulation to work.

9. At this point, you can do a quick simulation test by clicking the "Simulate Local" button. Check it out! You have cloth. Not great cloth, but you have it none the less!

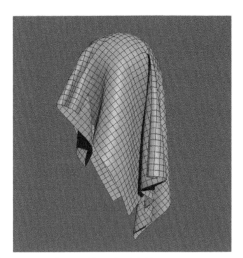

FIG 8-19 And after a short time there was 3D simulated cloth!

Go ahead and do more tests, play with all of the settings, and see what you can come up with. Keep in mind that, if you get some settings you like and they work well, you can save them as a preset and use them later.

- **Hair and Fur**

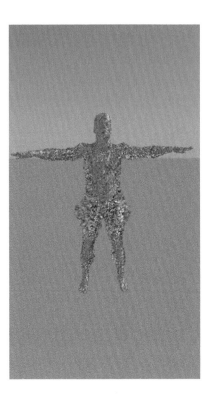

FIG 8-20 Shimmer-man! A new superhero, covered in random stuff. Using the Hair and Fur modifier, of course.

The creation of hair and fur for our characters and creatures is a difficult task. Using geometry planes with an alpha texture is one way video games have achieved hair and fur for a long time, but films have been using different techniques that are more believable but impossible to calculate in a real-time engine. We can, however, work in such a way that we can utilize the high-end film-based techniques to work with our real-time engines and vice versa.

Creating Hair and Fur

1. Start by creating a sphere, and convert this to an editable poly.
2. Add the "Hair and Fur (WSM)" modifier in the modify panel. This will create some default hair placed all over the sphere.

FIG 8-21 Add the Hair and Fur (WSM) modifier to the sphere to create some default hair.

3. In the "selection" rollout, click the "polygon" button. This allows you to choose the polygons on the sphere that you want to be affected by the Hair and Fur modifier. So, go ahead and pick the polygons you want, then click the "Update Selection" button in the same rollout.

FIG 8-22 The Hair and Fur modifier allows us to choose what sections of the object the hair and fur is applied to.

4. This is a great point to open the "Tools" rollout and click the "Load" button under the "Presets" section. Basically, this is where you can load in pre-configured hair setups. A few are already included with 3ds Max, and the "Save" button next to the "Load" button allows you to save your own presets once you have a style that works. Go ahead and choose a style that you like the look of for your creature right now!

Awesome! You have now applied hair and fur to a sphere. There are a lot of options on this modifier, and you should spend some time right now just playing with all of the settings and hitting the render button to see what they do and how they affect the rendered results.

Styling Hair and Fur for Later Use

1. Once you are comfortable and happy using this modifier, reset your scene and create a brand new sphere.Then apply the "Hair and Fur (WSM)" modifier once more.
2. Stop everything, and go grab a beverage and a snack. No, really! What you need to do is manipulate the modifier so you get a hair style you want for your creature. This is no easy feat, and it is going to require some time and patience. So, under the "Styling" rollout, click the "Style Hair" button, and get to work on that hair style.

FIG 8-23 The "Styling" rollout of the Hair and Fur (WSM) modifier contains all of the styling tools that enable us to be the next Vidal Sassoon!

Much, much later…

3. OK, while you have been working on your hair style, I have been creating mine too, and this is what I have come up with:

FIG 8-24 My sphere now has a classy hair style. OK, it may not be classy, or have any style, but it is some hair that I have messed around with for a while.

4. With a "happy hair style," you can now save this as a preset so you can apply this to your creature. Use the "Save" preset button, and name your hair preset. That is about it. You can now load this preset whenever you need it.

 Oh, and if you are interested (and maybe need to delete a preset you created at some point), head over to this folder:

 C:\Program Files\Autodesk\3ds Max 2012\hair\presets

 This is where you can find all of the presets available. Oh, if your installation location was changed from the original location, the above folder may be located somewhere else. Do not worry, it is there, you just need to find it!

Using Film Methods to Apply Real-Time Appropriate Hair and Fur

It is worth noting that, although this method could work in a real-time engine, it is probably not advised as the increase in polygons is going to be pretty dramatic. Still, it is worth taking a look over, and it also opens some additional uses for this modifier that you may not have thought of just yet.

1. Once again, start by creating a sphere and covert the sphere to an editable poly.
2. Add the "Hair and Fur (WSM)" modifier to create some default hair that will be placed all over the sphere.

3. Use the "polygon" button in the "Selection" rollout to choose the polygons on the sphere you want to be affected by the hair and fur modifier. Remember to click the "Update Selection" button to re-apply the hair onto the selected polygons.

4. You now need to create another object that will be used in place of the built-in hair strands. This can be any kind of geometry object, from a sphere to a box or even a modeled flower (for clarity and simplicity, I am using a tall box with multiple height segments).

FIG 8-25 The "Hair and Fur (WSM)" modifier can be utilized a number of ways. The box is used as the "hair" or "fur" of the sphere. This does not have to be a primitive object and could be modeled grass or even flowers, if we were creating a garden.

5. With your hair object created, select the sphere once again.
6. Expand the "Tools" rollout on the "Hair and Fur (WSM)" modifier.
7. Find the "Instance Node:" section. Click the "None" button, and select the newly created "hair" object in the scene.

FIG 8-26 The sphere now has instances of the modeled hair object in place of the default Hair and Fur (WSM) modifier's hair guides.

You should now see the sphere's hair has been replaced by instances of the hair object you created. If the hair is looking a little too sparse, just increate the "Hair Count" found in the "General Parameters" of the "Hair and Fur (WSM)" modifier.

We are definitely just shaving away at the surface of possibilities for the uses and creation of hair and fur for our creatures (come one, you cannot be sick of these puns just yet, right?!). By spending some additional time with this modifier, you are able to find various options for hair growth, editing of the guide hairs, styling of the hair, and many others that can dramatically enhance the look of the hair and fur we can create.

FIG 8-27 We are just shaving away the surface of possibilities for the uses of the "Hair and Fur (WSM)" modifier (pun totally intended as always!).

Dynamics and Particles

Usually left up to an FX TD or a similar role, dynamics and particles form a very big part of what we see in most VFX movies. As with most elements of computer graphics, dynamics and particles form another specialist area that,

although we do not need to be a master of, it certainly helps if we have at least a general understanding of it. In fact, there may be times you will be asked to work on the character effects (CFX) or extra effects (EFX) work of your creature. This could be as simple as placing a locator or emitter for the FX TDs, or it could be as complex as coming up with a base solution that can be expanded on.

- **Dynamics**

 In earlier versions of 3ds Max, prior to their 2012 release, dynamics would have been handled by a system called Reactor. Reactor was a stable, but sometimes clunky, solution for the implementation of dynamics within our productions. 3ds Max 2012 has completely stripped this solution and replaced it with MassFX. This MassFX tool relies on Nvidia's PhysX technology, and I find it a lot simpler to work with and a much more stable solution.

 MassFX is not perfect, though. In fact, it is far from it and has removed a lot of the functionality that Reactor had. For instance, MassFX only has Rigid Bodies, whereas Reactor provided us with both Rigid and Soft Bodies. However, as MassFX is so simple to work with, we can quickly create dynamically driven elements in our scenes with little to no effort. Of course, these quick dynamic setups are not going to shock or amaze anyone, but it is a start if anything.

Creating Rigid Body Dynamics with MassFX

1. Create a box, the size of which does not matter too much.
2. Move the box above the ground plane.

FIG 8-28 We are going to make this box dynamic!

3. On the main toolbar at the top of the screen, right-click in an empty area and select the "MassFX Toolbar." This will open a new floating window with the MassFX tools easily accessible.

FIG 8-29 The MassFX toolbar is hidden by default, but easy enough to access when you know where to look for it!

4. With the box selected, convert it to a Dynamic Rigid Body by using the "Set Selected as Dynamic Rigid Body" button.

FIG 8-30 Setting an object as a Dynamic Rigid Body is as easy as a single button press.

5. In the "Physical Material" rollout of the "MassFX Rigid Body" modifier that has now been applied to the box, select one of the presets available (I am going with "Cardboard" for now).
6. Click the "Start Simulation" button of the MassFX toolbar, and check out what happens. You should now have some dynamic geometry that has the attributes of cardboard.

Not difficult at all right? Sure, it is not much, but it definitely gets you started with some basic dynamics. To expand on this basic tutorial, take a look at the "Advanced" rollout in the MassFX Rigid Body modifier.

FIG 8-31 Choose from one of the built-in presets for this dynamics test.

FIG 8-32 The Start Simulation button will show the affects the dynamically driven objects you have in the scene.

Changing things like the "Initial Spin Speed" of the object can have dramatically different effects even though you have not had to work too hard to change the properties of the dynamics.

Should you wish to convert your dynamically driven object into keyframes, you can either use the "Bake" button found on the "Rigid Body Properties" modifier or go ahead and select the objects, turn on the "Auto Key" button, and click the "Start Simulation" button in the MassFX toolbar. This records the movement of the dynamic objects and gives you a key on each frame. From there, you can remove the MassFX Rigid Body modifier and retain the animation of the objects.

- **Particles**

 There is no getting away from it, particle effects are used everywhere. From environments that are on fire, to sparks coming out of a generator, or to even out creatures foot splashes in a puddle, these are all particle effects, and a particle system creates, animates, and destroys objects according to a set of rules we set for them. There are two main kinds of particle systems: non-event-driven particle systems and event-driven particle systems. For us as Creature TDs, however, getting into that kind

FIG 8-33 Particle View gives us ultimate control of the particles in 3ds Max, but it can become somewhat complicated for new users.

of gritty how-to details may not be needed. In fact, most of the time, the basic particle emitters do the job we need just fine. Only in more special circumstances will we need a more in-depth knowledge of these things. Sure, this knowledge cannot hurt, so if you are inspired to do so, looking deeper into particle systems could be a good idea.

So, these "basic" particle systems can be found in our create menu.

> Create Tab > Geometry > Particle Systems

We are not going to look at any of these specifically, but this is where you can find them.

Particles are designed to save us time, even though learning the tools could take time to master. Particles can be used in conjunction with "Deflectors" for control and "Forces" for flow. For the ultimate level of particle control in 3ds Max, we can use a built-in tool called "Particle View."

> Create Tab > Geometry > Particle Systems > PF Source > Particle View (Hotkey '6')

Lighting and Rendering

FIG 8-34 3ds Max gives us the option to quickly render our creations, but, with a little push we can make these renders look more appealing.

The lighting and rendering of any project is another stupendously huge topic, and there are Lighting TDs and Rendering TDs employed at some studios to deal with these areas specifically. However, we have been creating some pretty nice creature rigs with some good deformations, as well as cloth, hair, and fur. So, should we not at least attempt to light and render these creations a little better than what the default 3ds Max settings give us? I think so! And, as 3ds Max has a pretty neat renderer named Mental Ray already built-in for us to use, we should utilize it.

Rendering Basics with Mental Ray

Be sure to have at least something in your scene for this demonstration, or we will be lighting and rendering nothing and that would be a big waste of our time.

1. Make sure that your units are setup correctly to work with Mental Ray and your production needs. Mental Ray is an advanced rendering engine that approximates physical lighting conditions (photons/light

rays, etc.), and, as such, it expects things to be the same size in 3ds Max as they are in the real world.

FIG 8-35 Hey, look at that! Unit setup has cropped back up. It must be kind of important, eh?

2. You now need to start lighting the scene, and, for this, you need some daylight.

 Create Tab > Systems > Standard > Daylight

3. A popup appears asking if you would like to use the Logarithmic Exposure Control. At this point, it does not really matter if you choose yes or no. It is totally up to you.

FIG 8-36 The daylight system will be the light for our scene.

4. Once the daylight system has been created, head over to the modify panel. Under the "Daylight Parameters" rollout change the "Sunlight" option to "Mr Sun" and the "Skylight" option to "Mr Sky."

5. A dialog will pop up. Just click the "Yes" button.

FIG 8-37 We are using Mental Ray, so we will use the Mr Sun and Mr Sky settings.

6. Now get ready to render this thing. So, open the Render Setup dialog.
 Rendering > Render Setup... (F10)
7. At the bottom of the new rollout, change the Preset option to "mental.
 ray.daylighting."

FIG 8-38 Set the rendering presets to "mental.ray.daylighting," and 3ds Max will sort out the rest of the options.

8. You can now close down this dialog and quickly check that the Gamma and LUT settings are set to 2.2.

 Customize > Preferences > Gamma and LUT

FIG 8-39 It is important that the Gamma is set to 2.2 to get the best results.

That is pretty much it! Click the render button, and you are good to go. Should you want to change the light color, it is a simple case of re-positioning that main daylight icon (not the navigation compass, of course).

There are plenty of other methods, tricks, and techniques that work equally well and even much better than this, but I find that, as a fast solution, these settings work well for pushing our basic default renders up to the next level without too much time or hassle.

FIG 8-40 From a default render to this basic Mental Ray render, the differences improve our renders enough to warrant the small amount of work it takes to get them to that point.

Without a doubt, we are not even close to finishing up all of the topics we have taken a brief look at. Compositing, rendering layers, motion capture, performance capture, the list keeps going on, and, although I would love to discuss all of these exciting areas of computer graphics, there has to be a line drawn or this would possibly be the biggest and heaviest book of all time. Hopefully, this section has introduced you to some principles and techniques that expanded your understanding of what can be done to really help create the believability and magic in our creatures.

FIG 8-41 The line has been drawn!

Streamlining and Automation

"The first rule of any technology used in a business is that automation applied to an efficient operation will magnify the efficiency. The second is that automation applied to an inefficient operation will magnify the inefficiency."

Bill Gates

Throughout this book, we have worked with what 3ds Max has to give us straight from the box. We have not added anything, expanded on anything, or created anything as we have been working on our creature rig. Deliberately, we have touched no scripting, and we have only briefly looked over expressions. What this has done is forced us to conform to the 3ds Max toolset. We have used the tools already provided and worked around any problems, nuances, or complications this may have caused. We have learned some tricks to help us work with 3ds Max's base toolset at a more proficient level, and this has possibly thrown up a few hurdles we have had to walk around or climb over to get the job done. A smart Creature TD will know that walking around or climbing over a hurdle is the hard way to do things. Why not build some stairs or knock down that wall? Well, this is where scripting can really help.

This chapter focuses on streamlining some of the manual operations we have done during the creature rigging process. We are also going to take a theoretical look at automating some of our creature pipeline and how we can even help others in the production. But, before we jump in with two feet, after each and every rig that we create, it is important to analyze exactly what we have created.

> What did we learn that was new?
> Did we write it down?
> What could have been easier?
> What took up the most time?
> What did not go so well?
> Would we change something next time? If so, what?

All of these questions should be answered; ideally, we should be able to come up with a possible solution… at least something to try out next time.

How Can We Streamline Our Rigging Approach?

There are many ways in which we can streamline our approach to rigging.

- Repetitive operations or actions that we do over and over should be simplified and automated if possible.
- We do not need to reinvent the wheel every time. If there is a tool or script already freely available, we should make use of it.
- Sections of our rig can be split up into modules that can be scripted so they are quicker to build next time.
- Libraries of scripts and rig parts can be utilized to help facilitate the rigging process.

This list is just a quick compilationof techniques I have come up with off the top of my head, but there is no doubt that this could be tweaked, changed, and expanded on with a little more thinking.

No rig is perfect, and, likewise, no rigging pipeline is perfect. We can always change, expand, improve, and streamline our creature setup pipelines, making them better and better. In fact, as new tricks and techniques appear, these streamlined approaches (even in larger animation and VFX studios) keep changing and evolving.

An important part of streamlining our rigging approach is the ability to script. Scripting gives us the ability to create tools, pipelines, and workflows that really help in a number of ways, including speeding up our workflows and taking away some of the more monotonous tasks we have to deal with but would rather not.

Scripting is a big topic, and it is important enough that we cannot really skip it. So, take a look at 3ds Max's built-in, native scripting language—MAXScript.

What Is MAXScript?

MAXScript is one of the many scripting languages available. However, this language is exclusive to, and only works within, the 3ds Max application.

By delving into the world of scripting, you are starting to dig a little deeper into how your application works and the inner-workings of computers in general. Once you are comfortable with scripting, the opportunities for you to create, innovate, and expand your chosen application, or indeed your computer, become immense.

As MAXScript is only available within 3ds Max, we are limiting the scope of what we can do by learning this language. For instance, if we were to study Python, we would be able to create scripts, tools, and utilities that function outside of the 3ds Max application. However, covering Python in-depth, or even MAXScript for that matter, would take a full book, of which many have already been written. So, for the purposes of this creature rigging book, we cover more of an introduction to scripting, and, as MAXScript is already built-in and freely accessible in 3ds Max, it is a good place to start. Plus, scripting skills are transferrable. Sure, each scripting language is different, but the basic principles are all the same.

Programming and Scripting… The Same Thing?

FIG 9-1 Binary is "machine language."

Yes! Well, nearly, but not quite. They are both very similar, and the great thing is that, once you learn one scripting language, you will have a good idea of what other scripts are doing in different languages. This is all made possible, because the foundations of scripting and programming are pretty much the same, no matter which language you choose to study first.

The primary difference between a "programming language" (C, C++, VB, etc.) and a "scripting language" (MAXScript, MEL, Python, etc.) is that code writing in a programming language needs compiled before it is run. Once it is compiled, it can be run any number of times.

Scripting languages, conversely, are interpreted at run-time. This means that every time you want to run the program, a separate program needs to read the code, interpret the code, and then follow the instructions in the code. Compiled code has already been interpreted into machine language, so it typically executes faster, because the conversion into machine language has already been done.

Markup languages (HTML, XML, etc.) are somewhat different from the others. A markup language is simply a set of tags that are used to "mark up" text documents so sections of text can be logically arranged and labeled. These documents can be viewed as plain text or, more commonly, are viewed through a browser. The browser parses the document, looking for markup tags, then arranges the text and/or formats it according to the values in the tags.

Right now, this may still seem a little confusing, but they are important concepts to grasp. Read through them again, do some research, and, if in doubt, ask someone or the Internet.

My Thoughts on Scripting

Scripting can be difficult to wrap your head around, there is no doubt about it, but the more you do the better you become. Practice really does make perfect in this case.

FIG 9-2 Practice makes perfect when it comes to scripting. Using the help files and getting guidance from other, more experienced scripters is also a good way to come to grips with things.

Book tutorials, Internet tutorials, and scripting guides always seem to cover the same thing in the beginning. Often, the "Hello World" example pops up, closely followed by some other tutorial that prints out something

else. The "Hello World" example I totally get and understand. With the following examples, I tend to lose track, my attention moves elsewhere, and, ultimately, I give up following the tutorials. I have often pondered why this happens to me, when this must obviously be the most logical way of learning this stuff.

FIG 9-3 "Hello World" is the most common first example of scripting.

I still do not have an answer as to why I find these self-help scripting guides so difficult to follow, but I did manage to come up with a solution that seemed to get me over those first initial hurdles that kept holding me back. What is this solution? Well, I built interfaces first, before learning how to make them do things.

FIG 9-4 Start with creating the interface, then worry about how everything works.

It may not be logical, and, sure, I may have had to change the interfaces after I started to understand how things worked, but the visual output rather than some printed text, really helped me learn what I was trying to create.

With that said, let me try and explain some scripting concepts to you, and we can work on our own "Hello World" example and jump straight into user interfaces. From there, we work out how to get those interfaces to do something practical.

Scripting Basics

First, the things that make you a good Creature TD also apply to your ability to program and script. A good programmer has all of the following qualities (this is not an extensive list of course):

- Problem solving
- Logical thinking

- Openness to feedback
- Continued learning
- Patience

Learning a scripting language is exactly that: you are learning a new language. Similar to if you were learning French, German, Italian, Spanish, or any other language, there are a lot of barriers to work through to eventually understand everything, and this takes time and dedication.

FIG 9-5 Learning a scripting language is no different to learning a new people language.

These "computer" languages have a few things in common and some basics we need to understand. Take a quick look over some of them.

1. **Top Down**

```
40      button buildProp_BTN ">>> BUILD <<<" pos:[5,185] width:325
41
42      on baseProp_BTN pressed do
43      (
44          if baseProp_ETXT.text != "" then
45          (
46              local creatureName = baseProp_ETXT.text
47              baseProp_ETXT.readOnly = true
48              creatureBox.sj_createCreatureBase_FN(creatureName)
49          )
50          else
51          (
52              messageBox "Please enter a name and try again!" title:"Error..."
53          )
54      )
55      on basePropRemove_BTN pressed do
56      (
57          if isValidNode world_CTRL then
58          (
59              delete world_CTRL
60              delete layout_CTRL
61              baseProp_ETXT.readOnly = false
62          )
63          else
64          (
65              messageBox "There is no base built in this scene!" title:"Error..."
66          )
67      )
68
69      on layoutProp_BTN pressed do
70      (
71          creatureBox.sj_propLayout_FN()
72          layoutProp_BTN.enabled = false
```

FIG 9-6 In a top-down language, the computer reads the script from the top to the bottom.

In a top-down approach the computer works through a script from the top to the bottom, just like when reading (at least in English). This approach is exactly how MAXScript works.

2. **Syntax**

FIG 9-7 Syntax refers to the ordering and structuring of words so they are read and understood by the computer.

Syntax (from Ancient Greek—"arrangement," "together," "an ordering") is the study of the principles and rules for constructing sentences in languages. So, in programming terms, it is how we construct our scripts.

3. **Variables**

FIG 9-8 Variables are a container for storing data and information.

Variables are simply a facility for storing data.
"The keys are in my left side jacket pocket." That "left side jacket pocket" becomes a variable name, an identifier for where something is stored.
"The fruit is in the basket." That "basket" becomes a variable name. This identifier contains "fruit."

- **Global**

FIG 9-9 A chair in your home could be classed as a "global" variable, as you are able to move that chair from one room to another, making it accessible globally.

Global variables are variables that can be accessed from anywhere in the computer program. So, declaring a variable as global in one script means that another script can also access it. Take, for instance, your home. A chair could be a global variable as it can be accessed and placed from anywhere—you just have to retrieve it.

- **Local**

FIG 9-10 A shower is only available in the bathroom, not anywhere else. This could class the shower as a "local" variable.

Local variables live within a script or section of a script and cannot be accessed from the outside.

Back to our home example: a shower is available in the bathroom only, not anywhere else globally in the house. So, this makes the shower a "local" variable.

4. **Variable Types**

String = "The cat sat on the mat!" -- Alphabetical
Integer = 19846738291029834763 -- Whole numbers
Float = 4738392648.948746488 -- Decimal numbers

FIG 9-11 Strings (alphabetical), integers (whole numbers), and floats (decimal numbers) are the most common variable types.

OK, so our examples talk about a chair and a shower as variable types. In scripting, we do not have access to such items (although we could call our variables that if we wish). However, we do have access to a number of variable types. Within MAXScript, we have a number of different variable types we can use. Let us talk about the three most commonly used.

- **String**
 A string variable refers to the alphabet.

> "John"
> "Kawabunga"
> "Awesome Cool Beans"

- **Integer**
 An integer refers to a whole number.

> 1
> 25689
> 325684541542

- **Float**
 A float refers to a floating-point number, or a number containing a decimal.

> 0.25
> 25658.3256
> 23.0

5. **Arrays (Multiple Variables)**
 An array is simply multiple variables in the same "container." We access each of the variables inside the array by a number. Think of it like a postal office. Say there are five boxes to put mail into. The first box is labeled "1,"

the second box "2," the third "3," and so on. So, if we want something from a specific box, we would say something like, "I need something (a variable) from box 3."

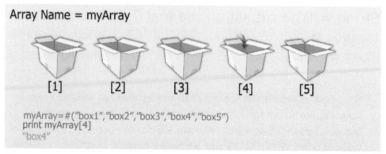

Array Name = myArray

[1] [2] [3] [4] [5]

myArray=#("box1","box2","box3","box4","box5")
print myArray[4]
"box4"

FIG 9-12 Arrays are simply multiple variables grouped together and labeled 1, 2, 3, 4, 5, and so on. Call a specific component from an array by typing the array name and then the number in brackets ("[number goes here]").

6. **Functions**

Functions are simply a set of commands stored in memory. When that function is called, or accessed, the computer recalls those commands and executes, or does them. Think of going to the store for groceries. "Go for groceries" is the function, variables in this function could be the store and the actual groceries.

```
1   -- Create a function and name it.
2   -- Put something into the function by using the 'equals' symbol ("=")
3   function goForGroceries =
4   (
5       -- Store groceries as variables
6       local milk = "milk"
7       local eggs = "eggs"
8       local bread = "bread"
9
10      -- Print the grocery list, putting each item on a new line
11      print "Grocery List: \n" + milk + "\n" + eggs + "\n" + bread
12  )
13
14  -- Call the function and remember to add in the open and close brackets
15  goForGroceries()
```

FIG 9-13 Functions are a set of commands we can call on when needed.

7. Loops

Loops are what we make the computer do when reading our scripts if we want it to do something more than once. As the computer reads from top to bottom, we can tell it to read and do a certain section of the script a number of times.

```
1   -- Start the loop by telling Max that for each item we
2   -- have selected, do what's inside of the brackets
3   for eachItem in selection do
4   (
5       -- For each item selected print the name for each item
6       print eachItem.name
7   )
8   -- This script simply 'loops' around for however many
9   -- objects we have selected in the scene
```

FIG 9-14 Loops tell the computer to re-read lines of script a certain amount of times before continuing further down the script.

8. Comments

Comments are lines of code the computer ignores when reading the script. By using comments, we can leave ourselves, or others, notes within the script. These notes can simply separate sections of the script or have explanations on how to work with the script or any nuances or issues that we have to still iron out. I advise using comments a lot, I certainly do. From version information, bug information, update logs, general notes, and script separation, they are very handy to have around, and the best thing is we can type those lines out in plain English so everyone can understand.

There are two ways to invoke a comment within MAXScript. The first is used for comments that only take up a single line, and this can be invoked by using two minus symbols at the beginning of the line "-- COMMENT GOES HERE." The second option is better for multi-line comments, this kind of comment is created by using a "/*" at the beginning of the comment and a "*/" at the end of a comment. This will all make a lot more sense after looking at the diagram below and when we start using comments in our scripting examples.

FIG 9-15 Comments allow us to leave notes and information in the script that the computer will ignore. This is helpful for both ourselves and others who may have to work with the scripts we have created.

9. **Headers**

The top lines of a script file are usually filled with comments that explain a number of things about the script itself. This can include the script author's name and contact information, the uses for the script, any known issues, problems, or bugs, and even an update log. This kind of thing is optional, but it is something I recommend you do for each and every script you write. These "Headers" to a script file not only help us, but others in the production that may have to access, change, edit, or use your created scripts.

FIG 9-16 Script headers can contain a lot of valuable information that can help decipher what a script actually does and how it should be used without having to execute the code and figure it out ourselves.

Pseudo Code

Pseudo code is an artificial and informal language that helps programmers and scripters develop algorithms... Arrrgh! What?

OK, step back for a second! Pseudo code simply lets us write out a script in plain English (or whichever language you prefer), in the form of statements we can convert into real programming statements later. There are no formatting rules to think about, and it can be as simple as:

1. When a button is pressed.
2. Create a cube.
3. Play a sound.
4. Display the message – "I made a cube!"

Or even something more practical, such as:

1. If a user picks a number that is greater than or equal to fifty.
2. Print "YAY."
3. Else.
4. Print "Nay."

Remember that pseudo code is your friend. Once you start understanding how MAXScript works, you should always start by planning out your scripts. It helps even for the smallest scripts, and, when you start creating multi-file scripts, the benefits are definitely worth the small amount of time it takes to write pseudo code.

FIG 9-17 Pseudo code can be a simplified version of real scripting/programming and can often help us understand what we want our scripts to do before actually writing them out correctly.

An Introduction to MAXScript Tools

OK, enough with all of this paperwork and theory stuff. Take a look at the scripting tools available to in 3ds Max

- **Command Line (Mini Listener)**
 Found at the bottom left corner of Max's standard interface is the command line... or mini-listener.

FIG 9-18 The 3ds Max mini-listener.

`MAXScript Mini Listener`

The pink area is the "macrorecorder" section where, if enabled, 3ds Max prints back commands as you do things in the interface.

The white area is the scripter window. Here you can type short scripts, and it is also the place that Max will show you errors.

- **Listener**

 The listener window is the "big brother of the mini-listener. It includes the same sections but much bigger so it is easier to read. It also has more options available, such as the MacroRecorder and the Debugger.

 You can access the listener by hitting F11 (default) in the viewport or by using the menu:

MAXScript > MAXScript Listener…

FIG 9-19 The listener is the big brother of the mini-listener.

Both the mini-listener and the listener can be used to make basic scripts that can be dragged to your interface to create MacroScripts.

- **Macros**
 In the listener window, we have access to the MacroRecorder. This makes Max print back "all" of the things it is doing and can be handy to find commands at times.
- **Script Files**
 To create an actual script file, go to the listener and click:

File > New Script… (Ctrl+N)

A MAXScript window opens with a number of options from syntax highlighting to line numbering. This is the preferred place to work for more complex scripts. In fact, it is where you will spend most of your time, as it allows you to test scripts without any feedback from 3ds Max convoluting the view.

FIG 9-20 A script file window looks a little different from the listener and mini-listener windows.

- **Objects**

 You may have noticed that, as we used the MacroRecorded and selected things in our scene, 3ds Max put a dollar ($) sign in front of all the objects. Why? Well, this is the way that Max distinguishes that it is an actual object present in the scene. So, if we need to script something that is name specific for something in the scene, we need to use the $ symbol before the name of an item.

- **Wildcard**

 A wildcard is a character used to substitute for any other character or characters found in a string. It is pretty handy if you do not know the name of an item or need to substitute a string in a script. The wildcard for 3ds Max is "*."

- **Help!**

 When in doubt, ask! Asking for help is the best way to learn, and the MAXScript built-in help files are a good place to start. If you are scripting daily, it is a place you will visit a lot.

FIG 9-21 The MAXScript help files are a great place to start if you need some guidance.

When in a MAXScript window, simply hit the F1 (default) key. Alternatively, use the menu.

Help > MAXScript Help…

How Can We Streamline the Production for Others?

Once you are able to script for yourself, scripting for others is a natural progression. The main limiting factor, at this point, is finding and understanding various roles in the production pipeline. It is important to have a basic grasp of what everyone you work with is doing. You do not necessarily need to be an expert in all areas of production, but having a more in-depth understanding of a few can certainly help. It helps if you are interested in the subject matter of course, but asking those who work with you in your production is the best way of understanding what is missing from the basic tools we all have when we get 3ds Max.

Once you have enough experience and understanding of other roles, you can start to help troubleshoot and build toolsets for others.

FIG 9-22 Earn "awesome points" from your peers by building scripts and tools for them.

Let Us Make Something!

I think we have spoken long enough about scripting, and it is time to do something a little more practical and start creating something from the scripting knowledge we have. So, let us get right into the most basic of basic examples, the famous "Hello World" example!

Hello World MAXScript Example

This is by far the most famous scripting or programming example ever created. Honestly, it is not as much of a scripting example, but more of a "here you go, start using the tools" example. So, without further ado:

1. In the pink section of the MAXScript mini-listener, type:
 print "Hello World"
2. Hit the "Enter" key.

FIG 9-23 "Hello World!" How are you today?

It really does not get any easier than this "Hello World" example, and it should be a manageable first step into scripting.

Scripting, and a lot of what we do inside of a 3D program, is going to require some mathematics. We can actually get the MAXScript listeners to help us with math too.

Mathematics in MAXScript

1. Open the MAXScript listener.
 MAXScript > MAXScript Listener… (Shortcut key F11)
2. Clear any text that may be visible in the pink or white sections of the listener.
3. Type your mathematic equations into the white area and hit the "Enter" key.

 Examples:
 1 + 1
 1 + 2 + 3

These "Hello World" and the mathematics example are incredibly simple examples of how we can use both the mini-listener and the main listener in 3ds Max.

How about creating something? Remove any text that you have in the listener window, and in the pink section type:

```
Sphere()
```

Now hit the "Enter" key.

FIG 9-25 We just created a sphere by using MAXScript, rather than the 3ds Max interface.

We just created a sphere, and we created the sphere by calling the "Sphere()" function using only MAXScript and not the 3ds Max user interface. You will also notice that 3ds Max has printed some text to show us what it has done in the scene:

```
$Sphere:Sphere001 @ [0.000000,0.000000,0.000000]
```

This is a simple readout to interpret from the listener. Let us break it down:

- The dollar ($) symbol shows this is an actual object in the scene.
- The object is a sphere, indicated by the "$Sphere" text.
- The name of the sphere is "Sphere001."

```
$Sphere:Sphere001 @ [0.000000,0.000000,0.000000]
This is useless information...OK
```

FIG 9-26 The print out in the MAXScript listener can often contain useful information. At other times, the information will be useless.

- The "at" (@) symbol tells us that it has placed the object: at" the following coordinates in the scene.
- In our case, the coordinates are world position [0,0,0]. X = 0 units, Y = 0 units, and Z = 0 units, putting our object right in the center of the scene.

These three examples obviously do not even scratch the surface of the capabilities of MAXScript, but hopefully they introduce you to MAXScript. Learning this stuff really just takes time, patience, and practice. Let us expand on that sphere creation example and create a user interface with a button that creates that same sphere.

A Button for a Sphere

Using a "New Script" window, type the following text, and, when you are finished, save the script and hit Ctrl+e to execute and run it.

This is our first real script. Although it is not very complicated, do not be alarmed if some of this looks a little strange at first. We will go through this line by line so it makes more sense.

```
rollout sphereButtonInterface "Sphere"
(
    button aButton "Press Me"
    on aButton pressed do
    (
        Sphere()
    )
)
createDialog sphereButtonInterface
```

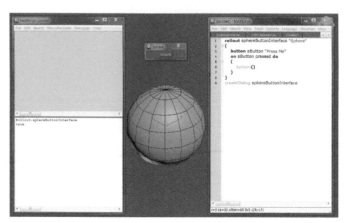

FIG 9-27 This short, nine-lined script creates a window with a button. When this button is clicked, it creates a sphere in the viewport.

Line 1 tells 3ds Max that you are creating a new "window," or rollout in this case. It also gives the computer a unique name for this window that you can reference later, this unique name being "sphereButton." The last part of this line is the name (or title if you will) you want to display in the window to the user (this part is always in quotation marks).

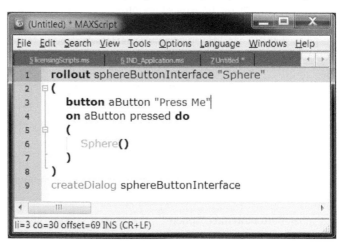

FIG 9-28 Line 1 tells 3ds Max to create a rollout with a unique name and a title.

Line 2 is an open bracket and tells you that whatever sits inside of this section is part of the interface you are creating in the rollout.
Line 3 creates the button in the interface. "button" is the command to create a button, "aButton" is the unique name you are giving to this interface element, and "Press Me" is the text that displayed on the button for the user to see.

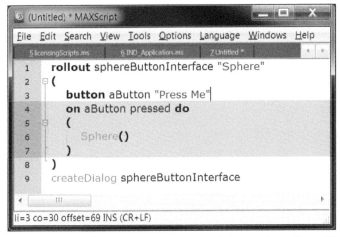

FIG 9-29 Line 3 creates a button in the interface.

Line 4 tells you that, once the button is pressed, it is going to do something. Notice that it is pretty simple to read in plain English. What I mean is, when aButton (the unique name you gave to the interface button) is pressed to do something, that something comes up in a moment.

Line 5 is another open bracket. This open bracket tells 3ds Max that, when the button is pressed, do whatever is inside of this bracket.

Line 6 is the command to make a sphere. So, the computer reads, when the button is pressed, do whatever is in-between the brackets. In this case, it is to create a sphere.

Line 7 is the closing bracket for the button. This means that anything after this point has nothing to do with the function that the interface button has.

FIG 9-30 Lines 4, 5, 6, and 7 form the components needed to get that button to do something useful.

Line 8 is another closing bracket. This bracket closes out the interface and is associated with that first open bracket you created at line 2.

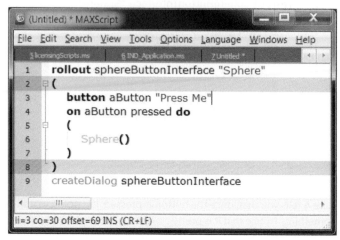

FIG 9-31 Lines 2 and 8 are open and close brackets for the interface. This tells the computer that anything sitting inside these brackets should be part of the user interface. If we did not have the button in there, this interface would look something like this image.

Line 9 uses the "createDialog" command. This command tells 3ds Max to build an interface (or dialog) that you specify next as the unique identifier for the interface. In this case, it is "sphereButtonInterface" that you created in line 1.

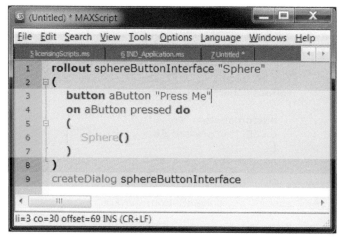

FIG 9-32 The final interface with each line section marked for clarity.

Hopefully this acts as a very brief introduction to how we can make more complex and interesting MAXScripts.

With that said, we can start thinking about creating a real script, something a little more taxing and that really starts to push us in the world of tool creation in which we can make utilities that are beneficial for the pipeline. There is just a little planning we have to cover before we can jump in feet-first.

Visual MAXScript

Building interfaces in MAXScript can be a time consuming task. It can also be a little daunting to those new to scripting in general. In the previous example, we created an interface for our sphere button "manually." What I mean is that we scripted every single line of not only the function that the script has, but also the interface the user has access to. This is my preferred way of creating scripted interfaces. It can take a bit of time and some trial and error to get things exactly how I want them, but this works better for me. Not only does the interface look how I want, but the scripted code I have to manipulate is written by me, for me, I guess it just makes things easier to read and edit as I am so used to how I work with scripts

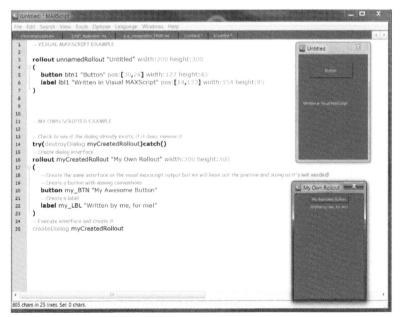

FIG 9-33 Script written by me, for me!

Built into 3ds Max is the Visual MAXScript editor.

MAXScript > Visual MAXScript Editor…

This editor is a form-based editor that allows us to layout and edit MAXScript rollouts (interfaces) visually, without having to rely on scripting. Interfaces can be created from scratch, and the MAXScript code can be grabbed once we have designed the interface to our liking.

FIG 9-34 The Visual MAXScript editor is relatively simple to work with and can provide us with some quick interfaces for our MAXScript tools.

I can see why this tool is appealing to those new at MAXscript or if a quick interface is needed to demonstrate or create a tool that is needed yesterday. However, I rarely use this tool, as the scripted output is not as clean as I would like and it has a few bugs that can be encountered every now and again. Or, maybe it is because I am a little controlling and would prefer just to do things myself!? It is worth taking a look at though, even if you decide it is not for you in the long run.

Practical Scripting

We have discussed the various tools available while creating MAXScripts, and we have written a few basic scripts to get us started on the scripting path. I think it is about time we sat down and wrote a couple of practical scripts that can enhance our workflows and expand our knowledge of more complex MAXscripting.

Before starting any script, we need to do a couple of things to make sure we are building something that is needed and that we are using the best solution possible.

- **Tool Identification**
 Each and every tool we write should be needed. After all, if we create something that is not needed, well, there was not really any point in spending the time on it, was there? Now, you may be thinking that

creating an interface for a button that creates a sphere is pretty much not needed, and you are totally right. However, the need for creating a sphere from a button may not be there, but what we created helped explain a few scripting techniques. So, for that purpose, it served us well.

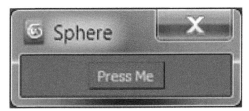

FIG 9-35 A graphical user interface (GUI) with a button may not really be needed when working with 3ds Max, but it did serve a purpose to help us understand a few scripting techniques a little easier.

There are plenty of ways to identify tools needed in the pipeline. First, asking yourself what you need to make your job easier is a good place to start. For instance, during the previous chapters, we covered a pretty big range of topics, and, during the rigging process, I sure felt like there could be a use for some extra tools that could have increased the speed of my workflow and really helped me out.

Second, using other software programs increases your knowledge of the tools that other applications have. Some of these tools may already be replicated in your current application, but I am sure you can find one or two that are missing and would be pretty handy to have.

Third, ask your peers. They may be working on different sections of the production, but I am guessing they still run into workflow issues that they could use your scripting help with. Of course, you may need to understand their role and what they do a little more in-depth, but that really expands us as a Creature TD and artist/technical person.

You may, of course, just be asked to fix a problem in the pipeline using your scripting skills. No matter where the identification for a needed tool comes from, doing a bit of research and development will help tenfold.

• **Solution**

Now that we know what the problem is, we need to come up with a solution. This is going to require a little research and some testing before we can come up with a solid solution.

We need to be as in-depth as we were about our creature rig, and it is also a good time to think about creating some pseudo code and seeing how things could fit together in the final solution. As always, researching and developing those ideas to fit what is needed is one of the most important steps.

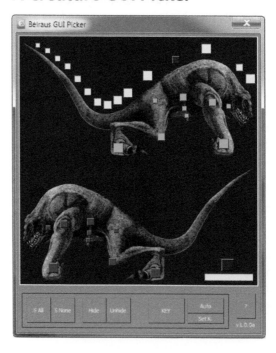

FIG 9-36 The research and development of a scripting project is as important as that of a creature rigging project. Take some time on this and be thorough to come up with the best possible solution.

I am not going to talk any more about research and development, as I think we covered its importance in Chapter 3. Get to it!

With the explanation of the preliminary steps we need to take for each script, we are ready to jump in with both feet.

A Creature GUI Picker

FIG 9-37 A creature GUI picker.

What we are going to create in this section is a creature GUI picker. This tool allows the animator to select the animation controllers of the creature without having to navigate the viewport. This makes his or her job easier, and, in turn, increases productivity. We can also add additional tools that may be beneficial to the user of the GUI picker, even things already available in 3ds Max could be useful if they are included on the picker. The script we will create for this tool can be optimized and improved on in many ways; however, let us do our best to keep within the realm of what we already know and understand and keep this script as basic as possible.

- **Tool Identification**

FIG 9-38 We can already manipulate the creature by using the viewport controllers, but productivity could be increased if we created a GUI picker.

Although the availability of selecting the creature's controllers in the viewport is there, many animators prefer to use an interface specifically designed for this job. By having the option of using viewport controllers, as well as a GUI picker, it can speed up animation production.

- **Solution**

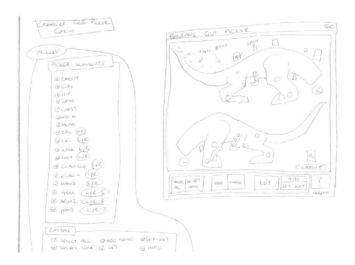

FIG 9-39 Once we know exactly what we need to include for this tool, we can quickly sketch out some functionality diagrams to work out the best user interface.

Our task is to create an interface that has buttons to access and select all of the available viewport controllers for the creature we rigged. Additional buttons could be used to help animation workflow; as such, the following tools will be accessible directly from the creature GUI picker interface:

- Help/Information
- Hide all controllers
- Unhide all controllers
- Select all controllers
- Deselect all controllers
- Key
- Auto key
- Set key

With our tool needs identified and a well thought out solution, we are ready to step into the world of MAXScript.

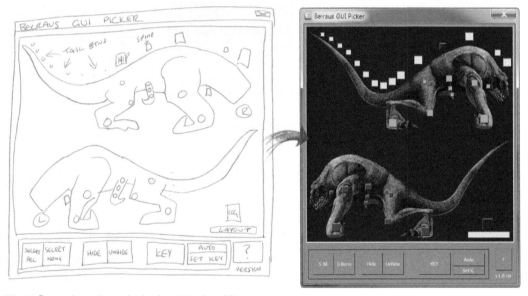

FIG 9-40 Time to take our diagram sketch and turn it into the real thing.

- **The Script**
 This script contains 294 lines of code with 1440 words. Yeah, this script is huge compared to the examples we previously completed. However, what is neat about this script is that it uses lots and lots of what we have already covered. There are some things here that could be a little

confusing, but, by completing the previous exercises, you should be able to read quite a lot of what is going on here. Take a look over the full script now, and we break things down in the next section so we can understand what is going on a little better. I am hoping some of the comments in the script help to not only break each main section into manageable compartments, but also inform what each compartment of the script is doing.

FIG 9-41 This full script contains 294 lines of code with 1440 words.

- **The Script Breakdown**
 This section hopefully demystifies anything you may be unsure of in the Creature GUI Picker script. By working through each compartment by line numbers, we can better understand how this script fits together.
 - **Line 1 to Line 22 (Header)**
 These lines form the header for the Creature GUI Picker script. This is the same header I use for all scripts I create, and it follows a set of guidelines I have used for some time now. You are free to create your own script headers, but, for me, this kind of header (although it takes up a number of lines) makes a lot of sense.
 The first and last lines of the header do not mean anything, but they create a nice "holder" for the heading information itself.

FIG 9-42 Lines 1 to 22 - Header.

As the header has no usable information for 3ds Max, we can run through from top to bottom relatively quickly. The first bit of information given in the header is the actual filename for the script, quickly followed by the current version number. Our next section in the header covers the author name, the Digital Rigging website address, and the date the script was first created. Following this is the usage instructions and any bugs, problems, or issues with the script. Notes for the script get their own section, as this is a good place to put any nuances that may be found for both the script users and the script editors. Last, the update log—this contains updated version information, dates, and brief descriptions of what updates were made.

FIG 9-43 This Header section can contain any information you like.

- **Line 26 to Line 27 (Global Variables)**
 As the comment states, these are the global variables for this script, and indeed other scripts (as they are global and accessible from

anywhere). We only have one global variable in this script, and that is an array. This array contains the names of all the creature's controllers, and this is going to be very helpful later.

- **Line 31 to Line 32 (Destroy Dialog)**
 This is something we have not covered before, but it is a pretty handy single-line piece of code to keep around.

```
try(DestroyDialog rolloutName)catch()
```

This section of script is checking to see if this rollout/dialog window we are about to create already exists, and, if it has, remove it before continuing with the following lines of code.

In other words, we are telling 3ds Max to *try* to *destroy* the specified *dialog* (in this case "sj_DCR_GUI"). If it cannot destroy the dialog (as it has not already been created), then this becomes an exception. We need to *catch* this exception and do nothing with it (indicated by the open and close brackets at the end of the line).

- **Line 35 to Line 293 (User Interface Creation)**

 This is the start of our GUI creation. Same formatting as before with the rollout creation and naming, the title for the rollout, and the width and height specified. We start the creation of the GUI elements with an open bracket, and close the GUI on the second to last line of the script with a closing bracket just as we did with the tutorials before.

FIG 9-47 The actual user interface code is found in lines 35 to 293.

FIG 9-48 The creature image is simply a bitmap placed correctly in the interface.

- **Line 38 to Line 39 (Creature Image (UI))**

 By using a bitmap, we are able to display images on our GUIs. The bitmap is assigned a unique identifying name, followed by the filename, and finally the width and height units. Nothing too difficult here, and switching out images is as simple as changing the assigned bitmap file.

- **Line 40 to Line 75 (Creature Control Selection Buttons (UI))**

 Easy! This section contains a number of buttons (each with their own unique identifier name) that, when pressed, select a specific controller for our creature. We get into the script for getting this selected in the scene shortly, but there is one difference with these buttons that we did not cover in our sphere creation GUI tutorial, and that is the position. The position information is pixel specific, using X (horizontal, left and right) and Y (vertical, up and down) coordinates. The best way to work out where you want something to be positioned is to experiment with these numbers. Oh, and just a warning, it can take a time and patience to get UI elements positioned exactly where you want them. I have also added an image for each of the buttons just so they have their own colors. This is totally optional of course.

FIG 9-49 All of the controls for the creature are simply colored buttons!

- **Line 77 to Line 91 (Bottom Bar Buttons (UI))**

 These buttons run across the bottom section of the interface and are included to make things a little easier on the animator using the creature rig. These kinds of helpful buttons are actually found within the 3ds Max default interface, with the exception of the help button, and it is a simple case of copying those existing tools to our new interface. Although we are using mostly buttons in this bottom section, there are three new features we have not yet covered. The first is the group

```
73    button legL_BTN "" width:10 height:10 pos:[200,390] images:#("C:/Users/Stu/Dropbox/_WO
74    button kneeL_BTN "" width:15 height:15 pos:[190,450] images:#("C:/Users/Stu/Dropbox/_W
75    button footL_BTN "" width:20 height:20 pos:[275,470] images:#("C:/Users/Stu/Dropbox/_WC
76
77    -- GUI Options
78    groupBox rigSectionGUI_GBOX "" width:425 height:75 pos:[10,515]
79    button selectAll_BTN "S All" pos:[20,530] width:50 height:50
80    button selectNone_BTN "S None" pos:[70,530] width:50 height:50
81
82    button hideAll_BTN "Hide" pos:[135,530] width:50 height:50
83    button unhideAll_BTN "Unhide" pos:[185,530] width:50 height:50
84
85    button key_BTN "KEY" pos:[270,530] width:75 height:50
86    checkButton autoKey_BTN "Auto" highlightColor:[255,0,0] pos:[350,530] width:75 height:30
87    checkButton setKey_BTN "Set K." highlightColor:[255,0,0] pos:[350,560] width:75 height:20
88
89    -- Information Area
90    button info_BTN "?" pos:[450,520] width:40 height:50
91    label version_LBL "v1.0.0a" pos:[450,575]
92
93    -- Execution
```

FIG 9-50 The bottom bar UI grabs interface elements that are common to the default 3ds Max interface. This keeps things clear and consistent.

box, which simply outlines the bottom section with a black border. This is relatively simple to create with the only additional properties being the width and height, of which we have already had some experience with when creating the actual rollout. The width and height for the group box dictates the size of the bordered outline.

```
73    button legL_BTN "" width:10 height:10 pos:[200,390] images:#("C:/Users/Stu/Dropbox/_WO
74    button kneeL_BTN "" width:15 height:15 pos:[190,450] images:#("C:/Users/Stu/Dropbox/_W
75    button footL_BTN "" width:20 height:20 pos:[275,470] images:#("C:/Users/Stu/Dropbox/_WC
76
77    -- GUI Options
78    groupBox rigSectionGUI_GBOX "" width:425 height:75 pos:[10,515]
79    button selectAll_BTN "S All" pos:[20,530] width:50 height:50
80    button selectNone_BTN "S None" pos:[70,530] width:50 height:50
81
82    button hideAll_BTN "Hide" pos:[135,530] width:50 height:50
83    button unhideAll_BTN "Unhide" pos:[185,530] width:50 height:50
84
85    button key_BTN "KEY" pos:[270,530] width:75 height:50
86    checkButton autoKey_BTN "Auto" highlightColor:[255,0,0] pos:[350,530] width:75 height:30
87    checkButton setKey_BTN "Set K." highlightColor:[255,0,0] pos:[350,560] width:75 height:20
88
89    -- Information Area
90    button info_BTN "?" pos:[450,520] width:40 height:50
91    label version_LBL "v1.0.0a" pos:[450,575]
92
93    -- Execution
```

FIG 9-51 The width and height of the 'groupBox' are defined by us, the script creator.

Oh, and you will notice that I have quotation marks with nothing in them. This is because I do not want to have a title for this area. Be sure to add something inside of those quotations if you wish to title any group boxes you create.

```
73    button legL_BTN "" width:10 height:10 pos:[200,390] images: # ("C:/Users/Stu/Dropbox/_WO
74    button kneeL_BTN "" width:15 height:15 pos:[190,450] images: # ("C:/Users/Stu/Dropbox/_W
75    button footL_BTN "" width:20 height:20 pos:[275,470] images: # ("C:/Users/Stu/Dropbox/_WC
76
77    -- GUI Options
78    groupBox rigSectionGUI_GBOX "" width:425 height:75 pos:[10,515]
79    button selectAll_BTN "S All" pos:[20,530] width:50 height:50
80    button selectNone_BTN "S None" pos:[70,530] width:50 height:50
81
82    button hideAll_BTN "Hide" pos:[135,530] width:50 height:50
83    button unhideAll_BTN "Unhide" pos:[185,530] width:50 height:50
84
85    button key_BTN "KEY" pos:[270,530] width:75 height:50
86    checkButton autoKey_BTN "Auto" highlightColor:[255,0,0] pos:[350,530] width:75 height:30
87    checkButton setKey_BTN "Set K." highlightColor:[255,0,0] pos:[350,560] width:75 height:20
88
89    -- Information Area
90    button info_BTN "?" pos:[450,520] width:40 height:50
91    label version_LBL "v1.0.0a" pos:[450,575]
92
93    -- Execution
```

FIG 9-52 Quotation marks with nothing inside of them allow us to create user interface elements that have no visible title.

Our second "new" feature is the check button. This is a button that the user can toggle on or off. There is nothing additional here that should cause you too much confusion. In fact, our only addition from the button is the highlight color that affects what color the button will be once enabled. We give the button a color by giving the parameter a red, green, and blue (RGB) value that runs from 0 to 255.

```
73    button legL_BTN "" width:10 height:10 pos:[200,390] images: # ("C:/Users/Stu/Dropbox/_WO
74    button kneeL_BTN "" width:15 height:15 pos:[190,450] images: # ("C:/Users/Stu/Dropbox/_W
75    button footL_BTN "" width:20 height:20 pos:[275,470] images: # ("C:/Users/Stu/Dropbox/_WC
76
77    -- GUI Options
78    groupBox rigSectionGUI_GBOX "" width:425 height:75 pos:[10,515]
79    button selectAll_BTN "S All" pos:[20,530] width:50 height:50
80    button selectNone_BTN "S None" pos:[70,530] width:50 height:50
81
82    button hideAll_BTN "Hide" pos:[135,530] width:50 height:50
83    button unhideAll_BTN "Unhide" pos:[185,530] width:50 height:50
84
85    button key_BTN "KEY" pos:[270,530] width:75 height:50
86    checkButton autoKey_BTN "Auto" highlightColor:[255,0,0] pos:[350,530] width:75 height:30
87    checkButton setKey_BTN "Set K." highlightColor:[255,0,0] pos:[350,560] width:75 height:20
88
89    -- Information Area
90    button info_BTN "?" pos:[450,520] width:40 height:50
91    label version_LBL "v1.0.0a" pos:[450,575]
92
93    -- Execution
```

FIG 9-53 Setting a highlight color for these 'checkButtons' require us to explicitly state the red, green and blue (RGB) values for them. These values run from 0 to 255 depending on their intensity.

Finally, our third new feature is the label. Labels are just that, labels. There is not much to it, but they do allow us to easily put text into our interfaces.

359

```
73    button legL_BTN "" width:10 height:10 pos:[200,390] images:#("C:/Users/Stu/Dropbox/_WO
74    button kneeL_BTN "" width:15 height:15 pos:[190,450] images:#("C:/Users/Stu/Dropbox/_W
75    button footL_BTN "" width:20 height:20 pos:[275,470] images:#("C:/Users/Stu/Dropbox/_WO
76
77    -- GUI Options
78    groupBox rigSectionGUI_GBOX "" width:425 height:75 pos:[10,515]
79    button selectAll_BTN "S All" pos:[20,530] width:50 height:50
80    button selectNone_BTN "S None" pos:[70,530] width:50 height:50
81
82    button hideAll_BTN "Hide" pos:[135,530] width:50 height:50
83    button unhideAll_BTN "Unhide" pos:[185,530] width:50 height:50
84
85    button key_BTN "KEY" pos:[270,530] width:75 height:50
86    checkButton autoKey_BTN "Auto" highlightColor:[255,0,0] pos:[350,530] width:75 height:30
87    checkButton setKey_BTN "Set K." highlightColor:[255,0,0] pos:[350,560] width:75 height:20
88
89    -- Information Area
90    button info_BTN "?" pos:[450,520] width:40 height:50
91    label version_LBL "v1.0.0a" pos:[450,575]
92
93    -- Execution
```

FIG 9-54 A 'label' allows us to simply write some text on the GUI.

- Line 93 to Line 93 (Execution Comment)
 The "Execution" area is where we make those UI elements actually do something. Everything from this point on does not change the visual appearance of the interface in any way, but enables the functionality of the interface.

FIG 9-55 As this is a comment it is not actually needed for the script to function correctly. It simply acts as a handy marker so we know where the interface 'execution' area is.

```
93     -- Execution
```

- Line 94 to Line 234 (Creature Controller Selection Buttons)
 This section of the script enables the buttons that select the various controllers of the creature rig. Every button has the same syntax with changes only occurring for the name of the button and the control that the button selects.

```
93     -- Execution
94     -- Create GUI picker buttons
95     on layout_BTN pressed do
96     (
97         select $CH_belraus_layout_CTRL
98     )
99     on cog_BTN pressed do
100    (
101        select $CH_belraus_COG_CTRL
102    )
103    on hip_BTN pressed do
104    (
105        select $CH_belraus_hip_CTRL
106    )
107    on spine_BTN pressed do
108    (
109        select $CH_belraus_spine_CTRL
110    )
111    on chest_BTN pressed do
112    (
113        select $CH_belraus_chest_CTRL
```

FIG 9-56 There are a lot of buttons that select various parts of the creature rig. These buttons all share similar code, with the only change being to the actual object name.

We have already covered how to make a button do something when we created the GUI for the sphere creation, and it is no different for these buttons we have in the creature GUI picker.

```
93      -- Execution
94      -- Create GUI picker buttons
95      on layout_BTN pressed do
96      (
97          select $CH_belraus_layout_CTRL
98      )
99      on cog_BTN pressed do
100     (
101         select $CH_belraus_COG_CTRL
102     )
103     on hip_BTN pressed do
104     (
105         select $CH_belraus_hip_CTRL
106     )
107     on spine_BTN pressed do
108     (
109         select $CH_belraus_spine_CTRL
110     )
111     on chest_BTN pressed do
112     (
113         select $CH_belraus_chest_CTRL
114     )
```

FIG 9-57 Simply copy this code for each button, making sure to change the button name, and the selection name.

What is different is what each of these buttons does. Instead of creating a sphere, as with the previous example, we tell the script to select an object in the scene. By using the built-in "select" command, 3ds Max understands that we want to select something. Then, by using the dollar symbol ($) followed by the name of the object in the scene, 3ds Max knows what to select. It is important to note that the dollar symbol ($) is needed to indicate to 3ds Max that this is an object that exists within the current scene and not anywhere else. Failure to include the dollar symbol ($) will cause the script to spit out an error, as it will think we are trying to select a variable that has not yet been defined.

FIG 9-58 Remember to include the dollar ($) symbol when trying to select objects which are in the scene or are not defined by a variable.

```
select $CH_belraus_layout_CTRL
```

Each button in this area of the script does the same thing and selects a specific controller by using its name. See how important it is to name elements in our scenes correctly?

- **Line 236 to Line 239 (Select All Button)**
The Select All button follows the same "on button pressed do" command we are getting used to. Once again, we use the built-in "select" command to tell 3ds Max we are going to select something, but, this time, we use the global variable we created at the beginning of the script.

```
232     (
233         select $CH_belraus_foot_L_CTRL
234     )
235     -- Lower section
236     on selectAll_BTN pressed do
237     (
238         select creatureCTRLS
239     )
240
241     on selectNone_BTN pressed do
242     (
243         deselect creatureCTRLS
244     )
245
246     on hideAll_BTN pressed do
247     (
248         hide creatureCTRLS
249     )
```

FIG 9-59 We use the 'creatureCTRLS' Global Variable to select all of the controls for the creature rig.

As this global variable contains an array of all of the creature controllers by name, by calling this variable after the "select" command, we select everything found in the array.

- **Line 241 to Line 244 (Select None Button)**

 The Select None button is exactly the same as the Select All button, except instead of calling the built-in "select" command we use the "deselect" command so this button deselects all of the objects found in the global variable array.

```
232     (
233         select $CH_belraus_foot_L_CTRL
234     )
235     -- Lower section
236     on selectAll_BTN pressed do
237     (
238         select creatureCTRLS
239     )
240
241     on selectNone_BTN pressed do
242     (
243         deselect creatureCTRLS
244     )
245
246     on hideAll_BTN pressed do
247     (
248         hide creatureCTRLS
249     )
```

FIG 9-60 We use the 'deselect' command to deselect all of the creature controls.

- **Line 246 to Line 249 (Hide All Button)**

 The Hide All button, just like the Select All and Select None buttons, follows the same syntax. The only thing we are changing here is the first command, of which, we are going to use the built-in "hide" command to hide everything in the variable.

```
241    on selectNone_BTN pressed do
242    (
243        deselect creatureCTRLS
244    )
245
246    on hideAll_BTN pressed do
247    (
248        hide creatureCTRLS
249    )
250
251    on unhideAll_BTN pressed do
252    (
253        unhide creatureCTRLS
254    )
255
256    on key_BTN pressed do
257    (
258        max set key keys
```

FIG 9-61 Once again we use the 'creatureCTRLS' Global Variable, but this time we use the 'hide' command to make sure the controls are not visible to the user.

- **Line 251 to Line 254 (Unhide All Button)**
 Yes, you guessed it! We use the built-in "unhide" command to unhide all of the creature's controllers.

```
241    on selectNone_BTN pressed do
242    (
243        deselect creatureCTRLS
244    )
245
246    on hideAll_BTN pressed do
247    (
248        hide creatureCTRLS
249    )
250
251    on unhideAll_BTN pressed do
252    (
253        unhide creatureCTRLS
254    )
255
256    on key_BTN pressed do
257    (
258        max set key keys
```

FIG 9-62 A similar command is used to show the controllers that have been hidden.

- **Line 256 to Line 259 (Key Button)**
 This button and the following two check-buttons replicate actions that can be found directly in the 3ds Max viewport. There is nothing special about these additions to our creature GUI picker. It just gives the animator easier access to some of the tools he or she will probably use over and over.

FIG 9-63 We use the built in 'max set key keys' for this key button.

As with the previous buttons, we tell 3ds Max to do something once it is pressed, and this time we use the built-in "max" command. This MAXScript command allows us to invoke 3ds Max menu and toolbar commands.

The "max" keyword command is followed by one or more words that describe a certain available command. There are a lot, I mean a lot, of these commands, and finding the right one can take some time. Luckily, the MAXScript help and reference files are fantastic, so, although it may take some time, you will be able to find what you are looking for eventually. We are using the "max set key keys" command to replicate that which can be found on the standard 3ds Max user interface.

FIG 9-64 These kinds of built-in commands come for free with 3ds Max. There are a lot of them though, so you may need to study the manual to find the one that best fits your needs.

- **Line 261 to Line 274 (Auto-Key Check Button)**

 The check buttons we created cannot be invoked by the "pressed" command; we need to use the "changed-state" command.

```
259    )
260
261    on autoKey_BTN changed state do
262    (
263        if state == true then
264        (
265            setKey_BTN.state = false
266            max tool animmode
267            set animate on
268        )
269        else
270        (
271            max tool animmode
272            set animate off
273        )
274    )
275
276    on setKey_BTN changed state do
```

FIG 9-65 'checkButtons' allow for their states (on or off) to be changed, rather than a normal 'button' which we only have the 'pressed' option.

Inside the "changed-state" area, we have the "if-then-else" statement. This statement reads just the way it does in English. If something happens, then do this, else, do something different. That is exactly what we have going on right here; if the check button is pressed (equal to "true"), then do these commands, else (if it is equal to "false"), do these commands instead.

```
259    )
260
261    on autoKey_BTN changed state do
262    (
263        if state == true then
264        (
265            setKey_BTN.state = false
266            max tool animmode
267            set animate on
268        )
269        else
270        (
271            max tool animmode
272            set animate off
273        )
274    )
275
276    on setKey_BTN changed state do
```

FIG 9-66 "If-Then-Else" statements are relatively simple to understand, but can be extremely powerful.

Inside the "true" statement, we first set the set key check button to false, just in case it is set to true, as we do not want both of these buttons enabled at the same time. Second, we use another "max" command to set the 3ds Max to animation mode. Finally, we set animate to an "on" value.

```
259    )
260
261    on autoKey_BTN changed state do
262    (
263       if state == true then
264       (
265          setKey_BTN.state = false
266          max tool animmode
267          set animate on
268       )
269       else
270       (
271          max tool animmode
272          set animate off
273       )
274    )
275
276    on setKey_BTN changed state do
```

FIG 9-67 The 'true' statement refers to the 'checkButton' being in the "Checked/Clicked/ON (1)" state.

If the check button is set to false (clicked off), we go back into the "max" command for animation mode and set animate to the "off" value.

```
259    )
260
261    on autoKey_BTN changed state do
262    (
263       if state == true then
264       (
265          setKey_BTN.state = false
266          max tool animmode
267          set animate on
268       )
269       else
270       (
271          max tool animmode
272          set animate off
273       )
274    )
275
276    on setKey_BTN changed state do
```

FIG 9-68 This 'else' statement area refers to the 'checkButton' being in the "Un-Checked/Un-Clicked/Off (0)" state.

- **Line 276 to Line 287 (Set-Key Check Button)**
 Similar to the Auto Key button, this button toggles the on and off of both this check button and the Auto Key button once pressed, so they are not both set to "on" at the same time.

```
273        )
274    )
275
276    on setKey_BTN changed state do
277    (
278        if state == true then
279        (
280            autoKey_BTN.state = false
281            max set key mode
282        )
283        else
284        (
285            max set key mode
286        )
287    )
288
289    on info_BTN pressed do
290    (
```

FIG 9-69 The Set-Key Check Button uses a similar statement to that of the Auto-Key.

We use another "max" command here that turns on key mode, and this finished the Set-Key Check button.

```
273        )
274    )
275
276    on setKey_BTN changed state do
277    (
278        if state == true then
279        (
280            autoKey_BTN.state = false
281            max set key mode
282        )
283        else
284        (
285            max set key mode
286        )
287    )
288
289    on info_BTN pressed do
290    (
```

FIG 9-70 Another built-in max command is used here.

- **Line 289 to Line 293 (Info Button)**

 The Info button creates a pop-up message box that gives the user some basic information. Notice we call the message box and put quotations around what we want displayed in the main interface. The backslash-n (\n) between the text allows us to jump down to a new line, similar to pressing the "enter" key when using a word processor.

FIG 9-71 The Info Button uses a 'messageBox' to popup and give the user some information relating to the script.

Finally, we give the message box a title, and we are all done with this final interface button.

- **Line 295 to Line 295 (Create Dialog)**
 This piece of code creates the rollout we just scripted.

```
279     (
280         autoKey_BTN.state = false
281         max set key mode
282     )
283     else
284     (
285         max set key mode
286     )
287   )
288
289   on info_BTN pressed do
290   (
291       messageBox "Website: www.DigitalRigging.com\nVersion: 1.0.0b\n\n\nTo be u
292   )
293 )
294
295   createDialog sj_DCR_GUI
```

FIG 9-72 The 'createDialog' command creates the specific dialog that we tell it to.

- **Additional Notes**
 Please be aware that this script is not fool proof. There are times that this script may error out or not behave as expected, and there are solutions to fixing these problems. However, these solutions are for another time, another place, another day, and another book.

Adding Custom Attributes

We have already covered how to add custom attributes to objects within 3ds Max by using the built-in tools, such as the Parameter editor, but being able to script this process can save us some time in the future. It is also worth noting that, by scripting custom attributes, rather than using the 3ds Max interface, we gain slightly more control over the layout of the rollout, or rollouts, we create for the custom attributes, and also the types of controls we create for each custom attribute, if any at all. That is right, we can create a custom attribute that has no interface attached to it but is still accessible via other methods

- **Tool Identification**

FIG 9-73 This script helps us, as Creature TDs, directly.

We are able to add custom attributes directly from the 3ds Max user interface. That is no secret. However, as our job often requires us to create custom attributes, it is easier for us to have a script we can quickly edit and add multiple attributes to all at the same time. Additionally, a scripted custom attribute interface is much easier to create, or not create, should we need a custom attribute that has no UI elements.

- **Solution**

FIG 9-74 This custom attribute script does not need a user interface, as it is only us using it and we do not need things to look pretty to be functional.

The script we need to create for the custom attribute creation is extremely different from that of the creature GUI picker in the previous example. This script requires no user interface, as we will execute the script directly from the MAXScript window, and, as no one else is using it, we do not have to spend the time and worry making it look pretty. The script itself still needs to be "clean" and readable so we can edit and re-use the same or similar code easily. We should think about adding more comments into this script, or at least including a good description of its uses in the header section so, when we come back to it later, we understand exactly what needs done to execute the script and create custom attributes for our rigs.

- **The Script**

 This small script is only the shell that we can add to at a later date. In total, it weighs in at a mere 29 lines of code with only 69 words. As we set out to do in our solution analysis, the script itself is relatively straight forward and very simple to edit as needed. It does, however, cover a few new concepts we have to try to understand for this script to make sense.

 Once again, we take a look at the completed script now and break everything down in the next section so we can get an understanding of what the script is doing. You will also notice that there are no comments in the main section of this script. This is because this script is so small and relatively simple to understand that it is not really needed. Also, the main interface, parameters, and attributes are not set by this script, as it is only a "shell" at the moment.

FIG 9-75 With no parameters and no rollout elements, this is a very small script!

- **The Script Breakdown**
 - **Line 1 to Line 16 (Header)**

 Once again, the first lines of our scripts form the header section, and, yes, it is pretty much identical to the header used for the Creature GUI Picker script.

FIG 9-76 Once again the Header section of the script creates some basic information that is only applicable to the person reading through the script at a later point.

- **Line 20 to Line 20 (Global Attribute)**
 Our first readable piece of script by 3ds Max is the creation of a global attribute that uses the "attributes" command to assign attributes to the variable.

FIG 9-77 Custom attributes are added to the 'custAttrs' variable.

- **Line 22 to Line 24 (Parameters Creation)**
 This section of the script creates a parameter block to store the tracks of animation. We also assign a rollout it will correspond with.
- **Line 25 to Line 27 (Rollout Creation)**
 This is the rollout that the parameter block corresponds with. By creating a rollout in this script, we give the custom attributes (in the parameter block) an interface that will show up in the modifier panel of the

371

FIG 9-78 The parameters sit right in this area.

object we assign this to. Should you not want to have an interface for these custom attributes, simply remove the rollout and un-assign it in the parameters block.

FIG 9-79 Rollout (GUI) elements are placed inside of this section.

- **Line 29 to Line 29 (Assign Custom Attributes)**
 This section of the script assigns the custom attributes to a specified object. We use the "custAttributes.add" command to assign the custom attributes to the selected object ($). We then specify which custom attributes to assign at the end of this line. Should you want to assign these custom attributes to a specific object or node in the scene, simply replace the dollar symbol ($) with the object name of your choice ($objectNameOfYourChoice).

FIG 9-80 This line of code adds custom attributes to the selected object's first modifier. It's probably best to have an 'Attibute Holder' in place when adding custom attributes to keep things clean and tidy on the rig.

- **Additional Notes**

 As this script is a little different from what we have written before and how we interact with it, a look at the script in "action" is probably a smart thing to do. The following script takes the custom attributes script "shell" and adds both parameters and rollout elements that can be added to an object within the 3ds Max scene. It is important to note that, in the custom parameter "ui" section, I have added both a spinner and a slider, allowing them to control one another. A final additional button has been added to reset both the slider and spinner to zero (0) at the bottom of the interface.

FIG 9-81 A quick example of some UI elements that relate to a parameter and can be directly added to an object's first modifier.

FIG 9-82 The custom scripted attribute applied to a Sphere with an 'Attribute Holder'.

Expanding Individual Scripts into a Toolset

First, congratulations on creating two pretty handy scripts. I am sure by now you are aware of how much time, effort, thought, planning, and dedication goes into writing each and every tool that many may take for granted

Creating a new scripted tool that benefits you, as well as others, is an extremely challenging task, but the rewards and benefits are high. The compilation of multiple scripts, combined into a larger "bundle" of scripts and "packaged" to work together, is what is often called a "toolset" or "toolkit." This kind of thing can take a lot of extra work, but, once again, there are extra benefits that can be gained from doing so.

We have already covered a lot when it comes to your first steps with scripted tools, and jumping into the creation of a scripted toolset is not really practical at this point. Maybe some other time, just not right now. That is not to say we cannot take a quick look at what goes into the creation of a solid, robust, and practical toolset that is beneficial for an individual, a team, and a company.

- **Planning**
 Yes, we are back to it again, but, with everything we do, planning is half the battle, and, with a good battle plan, failure is just not an option.

FIG 9-83 The creation of a scripted toolkit can be a complicated and daunting task, but there are some big rewards for teams big and small.

- **Structure**

FIG 9-84 The structure is one of the most important aspects of a scripted toolset, as it dictates how everyone accesses, changes, and uses the tools available.

The structure forms the foundation of our scripted toolkit. We need to think about where this will be deployed, how it is accessed, and what happens if something goes wrong. Changes to the structure of

a scripted toolset that users already have access to can cause massive problems for a production pipeline. As this can be such a big deal, it is often left up to more senior staff to make sure this all works correctly before rolling it out to the various teams working on a production.

- **Branding**

FIG 9-85 Time to get creative and give the toolset a brand identity.

Branding may not be something that comes to mind when first thinking about a scripted toolset, but it can be important for both aesthetics and usability. From a usability point of view, a brand can streamline the look and feel of the tools we create. For instance, if the tools we create always need a help button in the top-right corner, forgetting to put that feature into one of the tools can confuse the user looking for the help button to guide him or her in the uses of the tool. Another point that branding a toolset can help with is dialog between team members. Say we have our own Morpher modifier built into the toolset that works with the current pipeline. Should a team member come to us and say, "Hey, the Morpher modifier is not working." We have no idea if it is our Morpher modifier or the built-in Morpher modifier that ships with 3ds Max as standard. But, if we brand our toolset as "Armadillo," it is easier for us to understand our colleague when he or she says, "Hey, the Armadillo Morpher modifier is not working." We know exactly which tool it is and to which toolset it belongs to

- **Headers**

```
1   -- /////////////////////////////////////////////////////////////////////
2   --    SCRIPT:
3   --    VERSION:
4   --
5   --    AUTHOR:
6   --    DATE:
7   --
8   --    USAGE:
9   --    BUGS:
10  --    NOTES:
11  --
12  --
13  --    UPDATE LOG:
14  -- /////////////////////////////////////////////////////////////////////
```

FIG 9-86 Headers can help keep everyone who is working on the scripts for the toolset understand what each tool does and how it works.

As we have already seen in our previous scripting examples, headers give us a quick overview of what the script does, how it works, who originally wrote it, any bugs or nuances, and any additional notes that could be important. Generally, each scripter will have his or her own way of laying out a header in the scripts. It can be beneficial to consolidate all of these different approaches to header formatting and come up with a universal header format that everyone must follow. This can make working with and reading scripts created by various team members a little easier. Additional things, such as a document reference, can help a user find sections of the script quickly.

- **Scripting Layouts**

```
1   -- /////////////////////////////////////////////////////////////////////
2   --    SCRIPT:
3   --    VERSION:
4   --
5   --    AUTHOR:
6   --    DATE:
7   --
8   --    USAGE:
9   --    BUGS:
10  --
11  --    NOTES:
12  --
13  --    UPDATE LOG:
14  -- /////////////////////////////////////////////////////////////////////
15
16
17
18  -- /// OPEN EXTERNAL CONNECTORS \\\
19
20  -- /// CHECK LICENSING \\\
21
22  -- /// GLOBAL VARIABLES \\\
23
24  -- /// INCLUDE SCRIPTS \\\
25
26  -- /// EXTERNAL REFERENCING \\\
27
28  -- /// STRUCTURES \\\
29
30  -- /// FUNCTIONS \\\
31
32  -- /// DESTROY PREVIOUSLY CREATED GUI \\\
33
34  -- /// GUI CREATION \\\
35
36  -- /// ADDITIONS & EXTRAS\\\
```

FIG 9-87 Similar to the header layout, a script layout can give the reader more clarity about what the script is doing and where each section can be found.

As with the consolidation into one type of header format, scripts themselves can be formatted so each script must follow a similar layout. Again, this can help each user who is working on the scripts have a clearer understanding of what each section or portion of the script does.

- **Deployment**

The deployment of our toolset refers to how the scripted toolset is distributed between all of the team members. There are a number of ways to do this, and each has its own positives and negatives. These kinds of decisions are usually left to more senior staff members, as they more than likely have more experience using different toolsets and have a better understanding of which deployment system works best. Three common options for toolset deployment include:

- **Manual**
A manual installation of the toolset gives full control to each user. We can deliver each script and the toolset to each individual user and leave the installation process up to them. This can work fine, but this method can be a little too confusing for any users not technically inclined.

Organize ▼	Open	Burn	New folder			
	Name		Date modified	Type	Size	

☆ Favorites				
🖥 Desktop	📁 bin	09/05/2012 21:34	File folder	
📥 Downloads	📁 CachedThumbnails	15/05/2012 14:36	File folder	
📂 Dropbox	📁 CER	09/05/2012 21:34	File folder	
🖼 Recent Places	📁 CivilViewPlugins	09/05/2012 21:34	File folder	
	📁 Cloth	09/05/2012 21:34	File folder	
📚 Libraries	📁 Defaults	09/05/2012 21:34	File folder	
📄 Documents	📁 dlcomponents	09/05/2012 21:34	File folder	
🎵 Music	📁 drivers	09/05/2012 21:34	File folder	
🖼 Pictures	📁 en-US	09/05/2012 21:34	File folder	
🎬 Videos	📁 fonts	09/05/2012 21:34	File folder	
	📁 hair	09/05/2012 21:34	File folder	
🏠 Homegroup	📁 hardwareshaders	09/05/2012 21:34	File folder	
	📁 help	09/05/2012 21:34	File folder	
💻 Computer	📁 html	09/05/2012 21:34	File folder	
	📁 Inventor Server	09/05/2012 21:34	File folder	
🖧 Network	📁 JSR	09/05/2012 21:34	File folder	
	📁 maps	09/05/2012 21:34	File folder	
	📁 materiallibraries	09/05/2012 21:34	File folder	
	📁 MC3	09/05/2012 21:34	File folder	
	📁 mentalimages	09/05/2012 21:34	File folder	
	📁 Network	09/05/2012 21:34	File folder	
	📁 Network_IPV6	09/05/2012 21:34	File folder	
	📁 plugcfg	09/05/2012 21:35	File folder	
	📁 plugins	09/05/2012 21:34	File folder	
	📁 plug-ins	09/05/2012 21:34	File folder	
	📁 renderAssets	09/05/2012 21:34	File folder	
	📁 RenderElements	09/05/2012 21:34	File folder	
	📁 renderpresets	09/05/2012 21:34	File folder	
	📁 sceneassets	09/05/2012 21:34	File folder	
	📁 Scripts	09/05/2012 21:34	File folder	
	📁 Setup	09/05/2012 21:34	File folder	
	📁 stdplugs	09/05/2012 21:50	File folder	
	📁 UI	09/05/2012 21:34	File folder	
	📁 UPI	09/05/2012 21:35	File folder	
	📁 UserDataCache	09/05/2012 21:34	File folder	
	📁 WebServices	09/05/2012 21:34	File folder	
	3dsmax.branding.dll	22/02/2011 23:36	Application extens...	5,264 KB
	3dsmax.exe	21/09/2011 11:15	Application	11,540 KB
	3dsmax.exe.config	22/02/2011 20:53	XML Configuratio...	1 KB
	3dsmaxcmd.exe	23/02/2011 00:41	Application	15 KB
	3dsmaxWatch.bat	22/02/2011 21:10	Windows Batch File	1 KB
	ac1st18.dll	14/01/2011 02:12	Application extens...	92 KB
	acadauto.chm	06/01/2009 10:28	Compiled HTML ...	1,913 KB

Manual Install?!?!

FIG 9-89 Send out your toolset, and let the team install things manually.

- **Installer**

FIG 9-90 An installer. We have probably all seen one of these before.

By creating an installer for our toolset, we can dictate where everything is deployed. This usually keeps the scripts local to each user, and it removes the risk of things not being installed to the correct locations. Of course, this method still requires some user input, but it is a lot less likely to break. This is also a great method to get tools to team members who may work off-site in other locations.

- **Network**

FIG 9-91 Networking time... with the computer, not people.

This is possibly the most complicated technique and requires an understanding of the networking and systems we have on our current production. There is a benefit to the extra work, and that is every user will get the deployed toolset without having to lift a finger. One

minute it is not there, and the next time the user turns on, voila! A deployed toolset is available for use. It may not happen exactly like that, but you get the idea.

- **Updates**

Version: 4.6.1a

Status: OK
Date: 15/03/2011

Update Log:
 > Added
 - DCR GUI Picker
 - Centerizer
 - Custom resource collector
 > Updated
 - Diagnostics
 - GEO Cache
 - DCR Creature pathing
 > Fixed
 - R&D Area
 - Script Headers
 - Script Pathing
 - Plugin Pathing
 - Utilities Error Checking

FIG 9-92 As if it was not already good enough, it is time to update to something better.

At some point or another, we are going to be expanding, implementing additional options, and making changes to the functionality of the tools we have in our toolset. We need some way of making these updates without disrupting everyone's workflow, and possibly derailing a project. That, as you can guess, would not be fun.

- **Research and Development Area**

FIG 9-93 This is a special place. A place for mad scientists to experiment and create genius... or disastrous failures... all without affecting anyone else.

It is important to have a separate research and development area for those of us who will be adding, editing, and changing the toolset on a regular basis. These additions, edits, and changes should not affect anyone else who is using or working on the toolset and should be there on a per-person basis. This section can be used collaboratively between members who wish to test new scripts and tools they want to eventually rollout to the whole team. Giving everyone access to this section is a bit pointless and could cause more problems than it is worth, so keep this on a "need to know basis."

- **Sign Off**

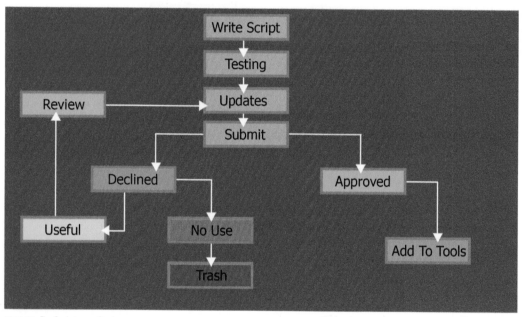

FIG 9-94 The final stages of tools development require us to get the A-OK clearance from those boss-type people!

Once testing has been done in the "restricted area," also known as the research and development area, we need to open this access to only a few members of staff so they can test, ask for changes, or sign-off with the A-OK for the tools we have been creating. From that point, we know the tool is usable and worthy of being released into the wild, or at least to the rest of the team in the usual deployment areas.

- **Cross-Project Development**
 We should always strive to make tools for the whole community of CG-folks, although there will be times that project-specific tools will be needed. These project-specific tools need their own space in that project. Once a project is over, we should be able to take a look at these scripts and see if they can be developed into something that everyone could use.

FIG 9-95 We are all one big happy family with a community of tools we should all be able to share, at least most of the time.

MAXScript Quick Reference Guide

Now that you are able to harness the power of MAXScript, I am sure that, with a little time and dedication, your scripting skills will advance by leaps and bounds relatively quickly. It is important to never forget the basics, even when you are creating complicated scripts and toolsets at a production level.

Sometimes, the simplest solutions are the best, and it is often those simple solutions we forget about. Hopefully, this chart can help guide you into more advanced scripting and serve as great reference for MAXScript in general.

Entering MAXScript Commands	
MAXScript Listener	MAXScript > MAXScript Listener (F11)
MAXScript Editor	MAXScript > New Script

Commenting & Headers	
-- Insert comment here	Single line comments
/* Insert comment here */	Multiple line comments

Object Selection & Wildcards	
$	Current selection
$Sphere01	Object with the name "Sphere01"

(Continued)

*	Wildcard character
$GEO_*	All objects with a "GEO_" prefix
$*	All objects

Object, Modifier and Material Creation

Sphere()	Create a sphere at world origin
Sphere pos:[10,0,0]	Create a sphere at position [10,0,0]
addModifier $ (Bend())	Apply a Bend modifier
addModifier $ (Bend angle:70)	Apply a Bend modifier with an angle of 70
$.material = StandardMaterial()	Apply a standard material
$.material.diffuse = color 0 255 0	Change the diffuse color to green

Outputting Values

print $.position	Print the position of the current object
format "% objects selected." selection.count	Output the number of selected objects

Transforming Objects

move $ [50,0,0]	Move relatively by 50 units in X
rotate $ (eularangles 90 0 0)	Rotate relatively by 90 degrees around X
scale $ [2,2,1]	Scale twice in X and Y, Z is unchanged
$.position = [10,0,0]	Set a new absolute position
$.position.y = $.position.y + 30	Move object by 30 units in Y
$.rotation = (eularangles 0 90 0)	Rotate by 90 degrees in Y
$.scale = [2,1,1]	Set a new scale value; twice as long in X

Data Types

string	Alphabetical
integer	Numerical (Whole)

float	Numerical (Decimal)
array	A collection of values and objects of arbitrary types

ObjectSets

These are collections of the current scene objects divided into the main 3ds Max object type categories and classes.

objects	All objects in the scene
geometry	Primitives and geometric objects
lights	Lights
cameras	Cameras
helpers	Helpers
shapes	Splines and shapes
systems	Any systems
spacewarps	All spacewarps
selection	Current selection

MAX Commands

There are a number (a lot) of MAX commands that allow us to invoke 3ds Max menu and toolbar commands from within scripts using the max construct.

max<command_name>	General syntax

The keyword "max" is followed by one of more words that describe the desired command.

max?	Shows all "max" available commands (there are plenty of them)
max<command _name>?	Shows all "max" commands relating to the command name specified

Outro

"Now this is not the end. It is not even the beginning of the end. But it is, perhaps, the end of the beginning."

Winston Churchill

Well, we are here, right at the end of the digital creature rigging journey, and, wow, we have covered a lot of ground throughout these ten chapters. Let us take a quick look and recap what we have been up to.

- Chapter 1 introduced you to this book, who should read it (that is you!), and who should not read it (those other people!). It also looked at custom rigs versus auto-rigs and discussed the qualities of a good rig and a good rigger, as well as provided a brief explanation of the upcoming chapters we have now covered. Oh, and it talked about the best piece of advice, ever.
- Chapter 2 looked at the foundations of the art and science that is creature rigging, or indeed CG setup in general. In it, we came up with our own set of "Rigging Principles" and took a look at the tools and workflows we are now skilled in.

- Research and development took over Chapter 3. We took a look at the theoretical side of rigging and were introduced to Belraus. Anatomy, geometry, and display layers are just a few of the topics covered in Chapter 3.
- Chapter 4 is where we got our hands dirty and started to rig our creatures. This important stage consists of joints and bones, basic skinning, and the exporting and saving of our creatures ready for the rest of the production.
- The animation rig was the focus of Chapter 5; everything that an animator can control was set up in this chapter.
- The creature's face was our discussion in Chapter 6. Dr. Paul Eckman helped us with his research into human facial expressions (Facial Action Coding System (FACS)) of which we can take Action Units (AU) and apply that theory to our character and creature face rigs.
- Chapter 7 was all about flesh-surface deformation: expanding on our base skinning, then extending the believability of the creature's skin by using more advanced techniques.
- Completion of the creature rig was the focus of Chapter 8, along with a few other more advanced techniques, such as dynamics, cloth, hair, and fur, all of which are optional for your creature, but are incredibly handy to know.
- Chapter 9 covered streamlining and automation by using MAXScript as a means to simplify and extend our workflows and toolsets.
- Finally, you are reading Chapter 10 now.

It is kind of daunting and somewhat amazing that, even though our creature rigging adventure is at an end, there are still so many areas we have not even looked into, and we are only just starting to dig into the areas discussed throughout this book.

Remember to keep this book close by for reference, and, if you did not already, go and get yourself a notebook. It really is an invaluable resource you can depend on.

Additional Workflow Enhancements

Without digging deeper into more advanced creature rigging concepts and techniques, we cannot really take our rigs or pipelines any further. 3ds Max offers a number of ways of working with its tools, and with some simple knowledge we can enhance and speed up our own personal workflows. Here are a few shortcuts I like to keep in mind while working with the application (this list does not cover all of the shortcuts found in 3ds Max).

3ds Max General Shortcut Keys

F1	Opens the 3ds Max reference (Help)
F2	Shade selected face toggle
F3	Toggle between Smooth and Wireframe
F4	View edged faces
F10	Render scene window
Q	Select
W	Select & Move
E	Select & Rotate
R	Select & Scale
I	Pan view (follow cursor)
O	Adaptive degradation toggle
A	Angle snap toggle
N	Auto key mode toggle
M	Material editor window
D	Disable viewport
G	Show/Hide viewport grid
J	Selection bracket toggle
H	Select by name
Spacebar	Lock selection
1 to 5	Sub object level selection
7	Statistics toggle (Polygon count)
8	Environment toggle
9	Advanced lighting toggle
0	Render to texture dialog toggle
Ctrl+C	Convert Perspective View into a Camera
Ctrl+V	Clone objects
Ctrl+F	Selection type toggle
Ctrl+L	Lighting toggle

(Continued)

3ds Max General Shortcut Keys	
Ctrl+A	Select all
Ctrl+D	Deselect all
Alt+A	Align
Alt+B	Viewport background
Alt+C	Cut
Alt+L	Select edge loop
Alt+S	Active snapping
Alt+X	See-through toggle
Alt+Q	Isolation mode
Shift+A	Quick Align

Viewport Shortcut Keys	
F	Front viewport
T	Top viewport
L	Left viewport
R	Right viewport
P	Perspective viewport
B	Bottom viewport
C	Camera viewport/Camera selection
V	Viewport shortcut menu
X	Transform gizmo display on/off
Z	Zoom in on current selection
+ and −	Increase/Decrease gizmo size
Ctrl+X	Expert mode toggle
Shift+Y/Shift+Z	Redo/Undo viewport operation

Chris Rocks

Website: www.tartanpimpernel.com

Without a doubt, this book would not have been possible without the help, support, and amazing skills and talents of Chris.

From my first approach to him about the possibilities of creating a creature for a possible rigging book, he has been nothing but passionate, determined, and dedicated to creating something that fits exactly what was needed. Belraus would not be here without him, and it is amazing to see the progress a simple scribble/sketch has made from paper to screen. Instead of me rambling on about everything, let me hand over this final section to Chris as he ~~informs~~ discusses his tricks and techniques to create the model and surfacing of Belraus.

Modeling and Surfacing Workflow—Chris Rocks

Stewart has generously allowed me some pages to take you through my process of designing and modeling this creature. We use the sculpting tool ZBrush for this, but the same basic principles and techniques can be applied in other programs like Mudbox. I assume the reader of this book understands the basic ZBrush toolset (or equivalent program) and modeling principles. This is not a step by step account or a how-to, but merely an overview of the key stages in my workflow for this project.

- **Concept**
 The initial idea to best demonstrate the rigging process was a basic quadruped with a heavily muscled upper torso along the lines of a gorilla, lion, tiger with slender but powerful legs, as well as a tail for balance. Several films, TV series, and nature websites were referenced to populate a mood board of ideas and design directions, which helped finalize the basic structure of the creature. The overall look was of a predator, combining elements of various real world animals and fantasy beasts.

- **Z-Spheres**
 To get a basic form blocked out, I opted to use ZBrush and Zspheres, this part of the process is down to personal preference with some artists preferring to block out a basic model in their chosen 3D package to then bring into ZBrush.
 The reason I use Zspheres is that I can, within a very short time, have a very quick symmetrical form blocked out without having to worry about final geometry density or edgeflow (that will come later). It also allows me to experiment with different concept directions without having to create endless base meshes outside of ZBrush.
 I always think of this like a digital clay maquette that purely serves as a proof of concept and is easy to modify as the design evolves after feedback or I go off on a concept tangent I like. Too many times, I have mocked up a quick model in a 3d program to bring it into Zbrush as a base then found myself fighting with the geometry when trying to make large form changes. Obviously, if you are working off a finalized concept, you are not going to be making such changes in form.

FIG 10-1 Basic ZSphere structure.

You can see in the screenshot that I have blocked out the quick basic form, checking while I drew out the Zspheres that the geometry resolution is roughly consistent at this stage. Remember this is purely a base for you to block out the basic form and design, we will retopoing the entire model later in the process. That joints are all in the approximate positions, but, if you feel once you see the basic form in 3D that changes need to be made to help with proportions and/or to help with the neutral pose weight of the creature, then try some variants.

Do not spend too much time worrying about the finer details of your concept and trying to accomplish them in Zspheres. I used to spend sizeable amounts of time Zsphering out eyes and mouths, only to find that putting that amount of detail in this early in the process only makes life more difficult further down the concept production line.

Once I have the Zsphere mesh how I want, I turn it into a mesh and get ready to start sculpting.

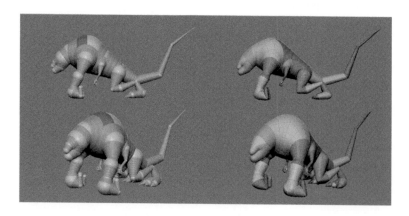

FIG 10-2 Final ZSphere model.

- **Z-Sculpt (Part I)**

 When I start a creature or character sculpt, I always start with the basic form and underlying muscle structure. In this case, we do not have a definitive source for our reference and will have to incorporate a bit of this and a little bit of that. When initially concepting out the idea for this creature, I came up with a mood board of animals and reptiles I used for reference. Now it is time to start another reference search for images to help show the musculature and underlying form of the various reference images. Thankfully, because of Google/Bing, this is a relatively painless task compared to 10 years ago when you would have been forced to head over to the local zoo or library for reference.

 I also amassed some random images I happened upon but thought could become useful. There were some images from a veterinary website, as well as some fantastic horse musculature anatomy sketches that really helped. Armed with some good reference images, it is well worth referencing artists, such as Scott Eaton, Andrew Cawrse, and Carlos Huante, among many others, for their approaches and workflow. They make you see anatomy in a whole different light, as well as how to use that for your own sculpting to maximize results.

 With this creature being of such mixed musculature, I opted to keep the rear section quite reptile-like and almost dinosaur in approach, whereas the front section, especially the shoulders and arms, are very gorilla-like.

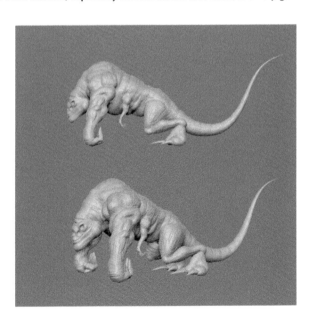

FIG 10-3 Creature form structure.

It was then a case of identifying the major muscle groups, then increasing their size depending on function. The arms are so highly developed with this particular creature, as the majority of his weight is supported by his arms, which are also his primary methods of combat.

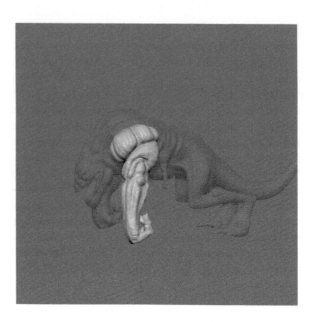

FIG 10-4 Big arms!

So, as you can see in the following images, using the clay brush, we progressively start building up the form for the model as a whole, then keep working into and developing the whole model in stages, rather than focusing on one area and working that to completion.

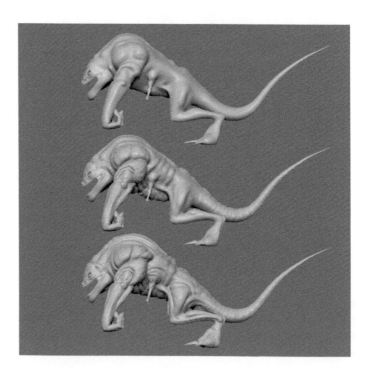

FIG 10-5 Basic muscle build-up.

Because we did not have a concept artist lock down the look and feel with this model, there was an evolution to the model. As you are working, you will also find yourself experimenting with sculptural details or subtle changes in form, which is why, at the start, we opted to use ZSpheres so as not to constrain us.

Now the model is getting to the stage at which we have a good solid sculpt with all the muscle groups laid out.

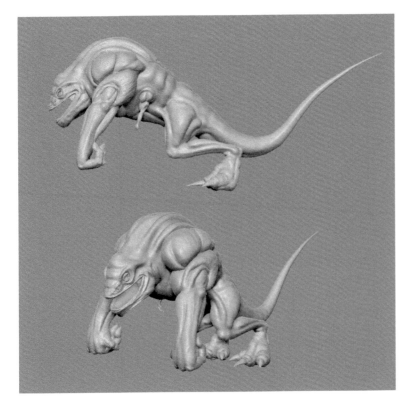

FIG 10-6 Final muscle structure.

Even at this stage, I was still somewhat undecided as to the look and finish of the jaw line, so you will notice this area changes in form quite a lot as the model progresses, especially once I added in the gum and teeth models, but more on that later.

Just before I readied the model for retopo, I quickly posed the model with the hands open and the fingers spread, as opposed to balled into fists for his default stances. I do this to make my life easier while retopoing.

- **Re-Topology**
You have multiple choices for retopologizing a mesh: you can use ZBrush itself, major 3D applications, such as 3ds Max, Maya, and XSI, or one of the growing number of standalone programs, such as 3DCoat, Topogun, etc. It all comes down to personal preference.

For this creature, I decided to use 3DCoat, because I prefer its toolset and workflow to the other options available. When it comes to retopologizing I tend to break the topology into areas, starting with the element that has the greatest radial edge loop density (the largest number of edge loops that translate into other parts of the model), which, with this model, was the character's arms. Again, this is personal preference. I know some artists who prefer to block out a low resolution retopolo mesh, then add in the loops to the areas that need it, and then disperse that detail out.

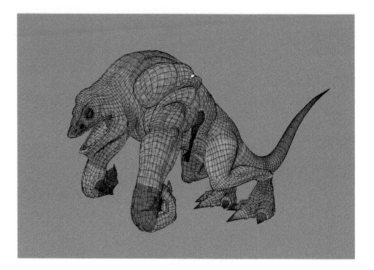

FIG 10-7 Topology component elements.

So, as you can see here, I started to draw out the edge loop islands for the major muscle groups on the creature's arms.

FIG 10-8 Arm muscle edge loops.

The edge loops need to follow these muscle groups to make Stewart's rigging as accurate as possible. Model topology varies depending on the final use. For in-game models in computer games, the edge loops tend to follow a grid pattern on the whole (faces and hands aside) to keep the polycount for models acceptable. For higher resolution models for game cutscenes, TV, and film, the models topology follows the surface form. Wherever possible, try to maintain a quad surface. With enough time and patience, this is achievable. Because of my timetable for this model, there are a few triangles, but I tried my best to keep them to a minimum and placed in areas that do not see large movement or animation.

Another practice to keep is to maintain a constant edge loop density over the model. There were times with this model that I had far too many edge loops in the arms.

FIG 10-9 Before/after arm edge loops.

With keeping the edge loops following the muscles, it is quite simple to extract any excess loops you do not actually need.

After finishing off the arms, I moved onto another retopo layer and started with the hands. I exported the model out of ZBrush with open hands to make life easier. Most of the time, your models will not have a default stance with posed hands, but, for this creature, I retopo'd the hands open and then posed the new hand geometry once the new model was back in ZBrush. I opted to include the claw shape in the topology, so I could use its geometry to help with texture boundaries later.

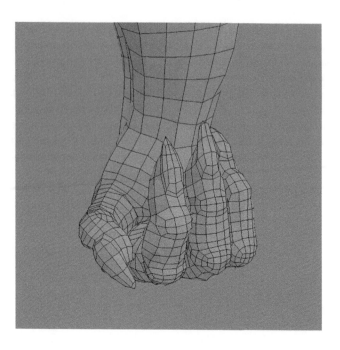

FIG 10-10 Close-up on hand/claw topology.

I moved onto the head next, running the major edge loops for the mouth and jaw, which are needed for opening and animating the mouth, then moved onto the eye sockets with loops added above the sockets to aid with facial animation.

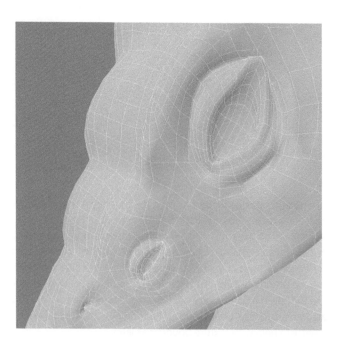

FIG 10-11 Major head edge loops.

Next, I moved onto the legs, again letting the muscles dictate my major edge loops, along with areas like the footpad and talons, which have their own definitive boundaries.

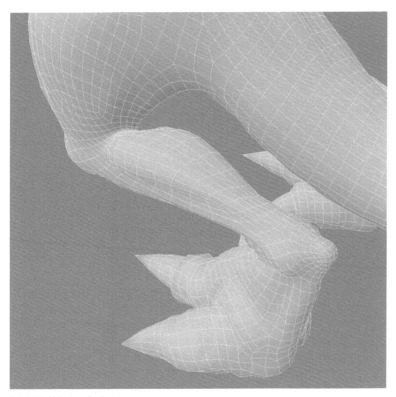

FIG 10-12 Major leg edge loops.

Now, I started on the body, having modeled each of my creature's retopology components on a separate layer, I could switch each part on, in turn, to see the flow of their boundary edge loops and how they run into the body component. Having ran all the boundary loops from the arms, legs, and head through the body, I then started to add in the major muscle groups and key edge loops needed for the body.

Finally, there was the tail. I opted to do this last, purely because I would know by then what edge loops ran the length of the creature and what I would have to play with in terms of loops for structuring the tail.

Once happy with each of the components, I combined them all into one layer and proceeded to do a flow check to make sure that edge loops that were shared between components worked as they should.

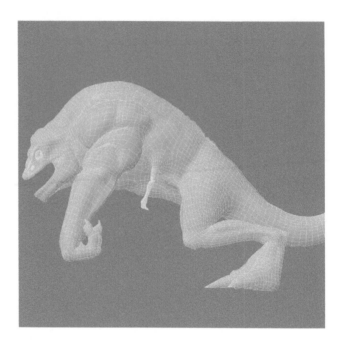

FIG 10-13 Edges flow.

- **U/V**

 Now that the geometry was finished and before I headed back to
 sculpting, the model needed UV mapped. Again, using your program of
 choice, layout your UVs. I opted to UV mirror this model purely to maximize
 the UV space. I also did not have any requirements beyond a nice model
 for rigging. You have to evaluate your UV options should you need a
 non-symmetrically detailed model. I initially started out with perfect 1:1
 pixel ration (throw a check map onto your model during the UV mapping
 process to check your pixel/polygon ration) but skewed that to bias areas I
 knew would have more surface detailing and need the extra UV space.

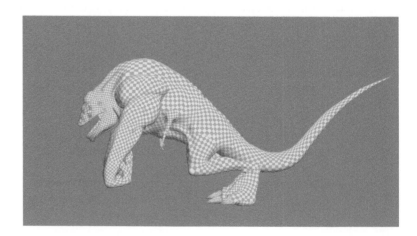

FIG 10-14 Biased UV space where
it is needed.

- **Z-Import**

 At this point, it was time to get my retopo'd and UV'd model back into ZBrush. I imported the model in, created a morp target, then subdivided the geometry to say 6 (I always subdivide the model to one level less than my machines maximum resolution). Once this was done, I stepped back to my initial level and reloaded the morph target, as I found this is a good way to push the model back into shape after the smoothing effect subdividing has on the mesh. Now, when I step the geometry levels up and down, the model boundaries stay where they should.

- **Z-Sculpt (Part II)**

 Finally, we are ready to really get started! First step was to create a new morph target of the lowest geometry level (this is purely an old habit, but I find it helpful should my sculpting push the geometry too far and I need to bring it back on track to avoid UV blooming). Once this was done, I created a new layer, which I called "Base." I then proceeded to use the "project all" function to transfer the blocked out muscles and form from my old ZSphere model onto this new model. Because I traced my edge loops over the muscle forms when retopoing, transferring the form back over was a relatively painless process.

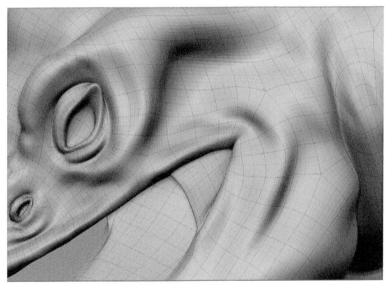

FIG 10-15 Form and edge loops line up.

Depending on the complexity of your model or the proximity of limbs to the body for example, you might find you need to adjust the settings of the "project all" function, or even project the model in component stages to avoid any problems. I had to do this for the arms and feet for this model because of their complexity and layout.

FIG 10-16 Splitting off components can make things easier.

Now that I had the bulk of our creature's form sorted out, it was time to do the last few bits before I moved onto the surface detailing and tightening up the form in a few areas.

For example, I brought in a couple of simple sphere shapes to help me sculpt the eye sockets and brow area to look like they could hold an eyeball, as opposed to just wedging the eye object into the geometry.

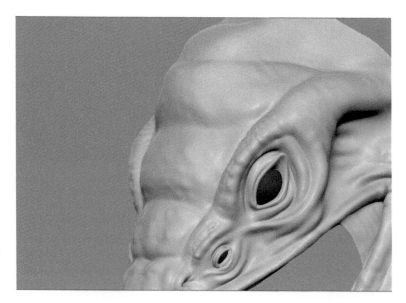

FIG 10-17 Simple sphere shapes can help when sculpting the eye sockets and brow area.

• **Detail Pass**

It is at this stage that I am now into the final stage in terms of sculpting in ZBrush. This is when you can really go to town in putting on surface detailing and bringing everything together. I usually start with a final tweak to the form, tightening up areas and bringing out the form further. An example of that is the creature's lips: before starting on the detailing for the lips, I brought in my gums and teeth geometry so I could "fit" them into the head correctly, making the necessary adjustments to the lip shape and lip form to get the best effect and to make sure the edge loops were sitting in the correct position on the lowest level of the model.

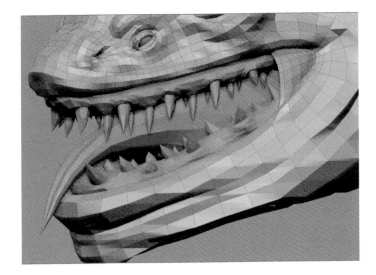

FIG 10-18 Final adjustments to the lips.

There were a few other areas that I tweaked, such as the fingernails, knuckles, foot pads, and mini hands, just to get the form I wanted. Best not to get too carried away with this, as you could keep tweaking forever. At this point, I started on the detailing. I usually split this between detailing done with the standard ZBrush sculpting brushes and detailing that comes with using tiled alpha maps stamped over the surface (skin pores, scales, etc.).

For this creature, I started with the head, as it was the area where most of my time was going to be spent, bringing out the detail in the lips and around the eyes primarily, as well as adding creases and folds to help bring the creature to life. This part of the process should not involve any drastic displacement of the geometry, as this will adversely affect the UV's laid out. You should also get into the habit of double checking that your UV's are OK after this stage and before starting on texturing.

Next, I spent some time working on the hands (primary and secondary), bringing out a little more detail in the knuckles and general finger shape, as well as refining the talons.

403

It is well worth after each area you work on, zooming out and seeing the model as a whole to see if your changes work and then see any areas that stand out as needing more work. I tend to work on various passes on the overall model. In doing that, should you run out of time, you will at least have a model that is uniform all over in detail, as opposed to spending all your time on the head and then having to hand it over with the rest of the model barely detailed.

The last area I spent time working on was the legs and feet. I wanted to better define the shape and form, making them look stronger and more powerful, as they were somewhat overwhelmed by the creature's upper torso. I pulled out some form in the shin and calf areas, as well as tightened up the shape of the toes and foot pad.

- **Custom Alphas**

This is the last step for the detail pass using alpha brushes. My primary use of alphas on this model was for tiling surface textures, and for that I used several of the default ZBrush alphas, as well as some custom alphas I created myself or found online for skin detailing, which I use for pores, lumps, bumps, scales, creases, and general gnarl.

I use this effect just to break up some of the large expanses of skin areas and to add a little interest.

Areas I primarily used this on were the creature's back, legs, hands, feet, and a little on the forehead. It is best not to go too crazy using tiled alphas, as they can sometimes conflict, resulting in an interference pattern that looks strange.

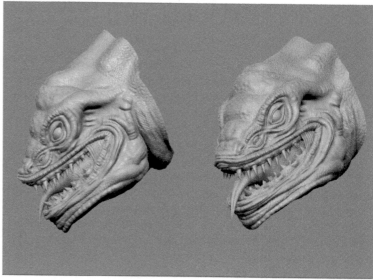

FIG 10-19 Detail pass complete (head).

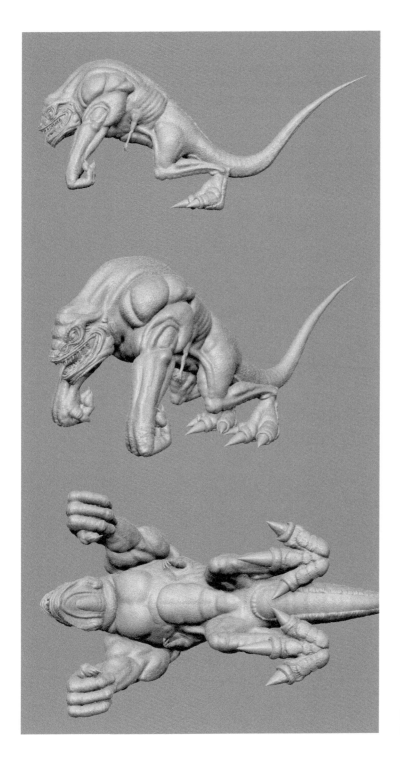

FIG 10-20 Detail pass complete
(body).

Because the ZBrush model was always going to be used to generate detail passes for our low polygon version, I limited the extent of the fine detailing on the model for a number of reasons, but it should be noted that a percentage of very fine detailing can be lost when generating the various passes, unless you utilize huge texture pages, which in this example we did not.

- **Texture Creation**

 The next stage in the pipeline for this model was to create all the various texture map passes needed. For this creature, I created a Diffuse, Normal, Specular, Bump, Shadow, and Ambient Occlusion map.

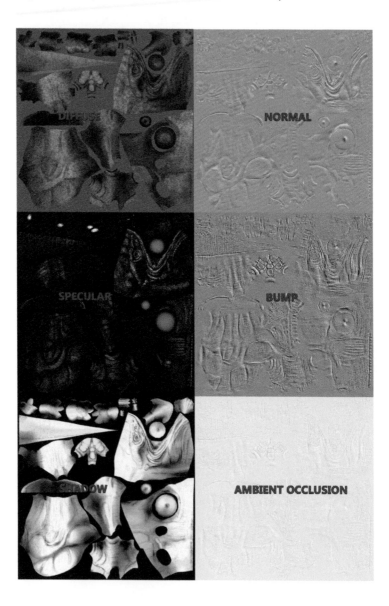

FIG 10-21 All of the texture map passes needed for Belraus; Diffuse, Normal, Specular, Bump, Shadow and Ambient Occlusion.

You have various options for the creation of these maps: high/low geometry models, ZBrush itself, 3D packages like 3ds Max and Maya, or one of a number of standalone packages like XNormal.

I use XNormal, as I have used it for years. I like its features. It gives me great results. It is extremely quick, and, to top all that off, it is completely free. The majority of the passes I needed for this model were created with XNormal, with a few exceptions.

For the diffuse map, I painted the model entirely in ZBrush, but, again, this is personal preference, with many people preferring to use Photoshop, 3D paint, or a combination of programs. There is no default program. Use what you feel most comfortable using and what gives you the best results.

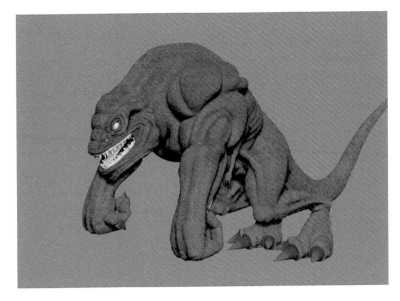

FIG 10-22 Painted diffuse pass.

Again for the specular map, the majority of that was done in ZBrush, baking a material shader into a 2D map, as I like to have a default low specular pass, which is generated procedurally, and then I go in and paint in the areas I want to lift a little more specular strength out.

- **Putting It All Together**

Once you have all of your passes complete, it is time to compile everything together in the 2D program of your choice.

For this particular project, I overlaid my ambient occlusion (AO) and shadow passes onto my diffuse map and played around with the overlay percentages until I found something I liked. With the AO pass, I usually do two versions and then combine them: the default version and a version I have blurred slightly just to give a little fallout to the AO effect. Depending on how your AO pass renders out, you may not need this. I always prefer to have my AO passes pin sharp to catch details like creases, folds, and wrinkles.

407

Because I opted to flip the majority of this model, I needed to be wary of putting too much detail close to the seam in area that have a flipped seam, obviously, as I could have ended up with a repeated pattern on my map, which looks strange.

A few of the passes that had artifacts or glitches when they rendered out, I applied to the low polygon version in ZBrush, painted out the errors, and did any little tweaks or fixes needed.

Once we have our model into a 3D program in a lit and prepared render scene, it is just a simple case of loading the various maps into their correct shader slot, tweaking some values in the normal/bump and specular channels, and finally tuning and color correcting the diffuse map to give the desired look.

The final step was posing the creature into a suitable pose and pressing "Render!"

- **That Is All Folks!**

 I hope you have enjoyed following my pipeline in the creation of this creature. Although not a step-by-step tutorial and in no way a definitive process, I like to think it may have thrown up a few new approaches to the way you currently work and given you some ideas for how to tackle your next project.

 —Chris Rocks

The End

Thank you for making it this far, and I hope you enjoyed reading through the book and the additional workflow information from Chris. This is the end of the beginning of our creature rigging adventures. It is time to start a new chapter, but, sadly, the next chapter is one not found in this book!

Index

Note: Boldface page numbers refer to figures and tables.

Printed and bound by CPI Group (UK) Ltd, Croydon, CR0 4YY

23/10/2024

01778251-0006